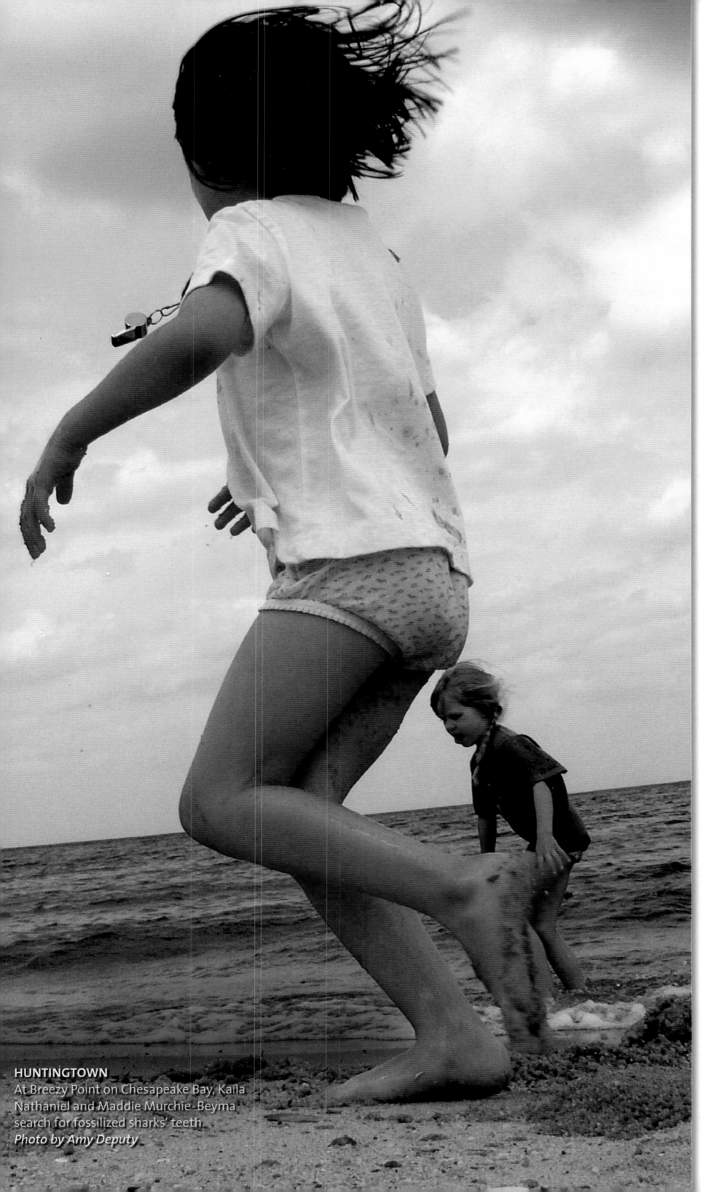

HUNTINGTOWN
At Breezy Point on Chesapeake Bay, Kaila
Nathaniel and Maddie Murchie-Beyma
search for fossilized sharks' teeth.
Photo by Amy Deputy

Maryland 24/7 is the sequel to *The New York Times* bestseller *America 24/7* shot by tens of thousands of digital photographers across America over the course of a single week. We would like to thank the following sponsors, the wonderful people of Maryland, and the talented photojournalists who made this book possible.

Adobe

OLYMPUS

LEXAR
Media

snapfish

jetBlue
AIRWAYS

WEBWARE

Google

DIGITAL
POND

ebay

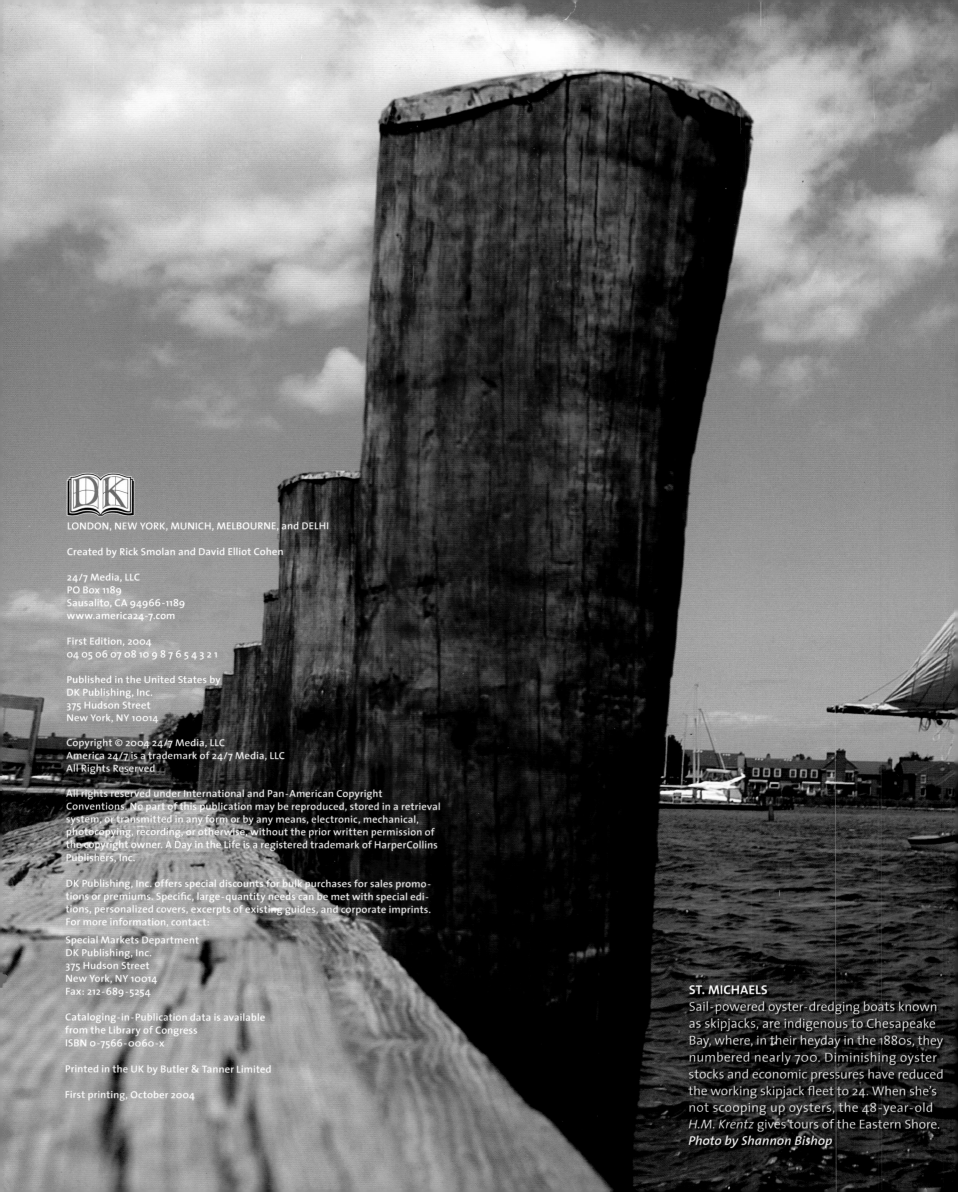

DK

LONDON, NEW YORK, MUNICH, MELBOURNE, and DELHI

Created by Rick Smolan and David Elliot Cohen

24/7 Media, LLC
PO Box 1189
Sausalito, CA 94966-1189
www.america24-7.com

First Edition, 2004
04 05 06 07 08 10 9 8 7 6 5 4 3 2 1

Published in the United States by
DK Publishing, Inc.
375 Hudson Street
New York, NY 10014

DK Publishing, Inc. offers special discounts for bulk purchases for sales promo-
tions or premiums. Specific, large-quantity needs can be met with special edi-
tions, personalized covers, excerpts of existing guides, and corporate imprints.
For more information, contact:

Special Markets Department
DK Publishing, Inc.
375 Hudson Street
New York, NY 10014
Fax: 212-689-5254

Cataloging-in-Publication data is available
from the Library of Congress
ISBN 0-7566-0060-x

Printed in the UK by Butler & Tanner Limited

First printing, October 2004

ST. MICHAELS
Sail-powered oyster-dredging boats known
as skipjacks, are indigenous to Chesapeake
Bay, where, in their heyday in the 1880s, they
numbered nearly 700. Diminishing oyster
stocks and economic pressures have reduced
the working skipjack fleet to 24. When she's
not scooping up oysters, the 48-year-old
H.M. Krentz gives tours of the Eastern Shore.
Photo by Shannon Bishop

MARYLAND 24/7

24 Hours. 7 Days.
Extraordinary Images of
One Week in Maryland.

Created by Rick Smolan and David Elliot Cohen

DK Publishing

About the America 24/7 Project

A hundred years hence, historians may pose questions such as: What was America like at the beginning of the third millennium? How did life change after 9/11 and the ensuing war on terrorism? How was America affected by its corporate scandals and the high-tech boom and bust? Could Americans still express themselves freely?

To address these questions, we created *America 24/7*, the largest collaborative photography event in history. We invited Americans to tell their stories with digital pictures. We asked them to shoot a visual memoir of their lives, families, and communities.

During one week in May 2003, more than 25,000 professionals and amateurs shot more than a million pictures. These images, sent to us via the Internet, compose a panoramic yet highly intimate view of Americans in celebration and sadness; in action and contemplation; at work, home, and school. The best of these photographs, more than 6,000, are collected in 51 volumes that make up the *America 24/7* series: the landmark national volume *America 24/7*, published to critical acclaim in 2003, and the 50 state books published in 2004.

Our decision to make *America 24/7* an all-digital project was prompted by the fact that in 2003 digital camera sales overtook film camera sales. This techno-logical evolution allowed us to extend the project to a huge pool of photographers. We were thrilled by the response to our challenge and moved by the insight offered into American life. Sometimes, the amateurs outshot the pros—even the Pulitzer Prize winners.

The exuberant democracy of images visible throughout these books is a revela-tion. The message that emerges is that now, more than ever, America is a supersized idea. A dreamspace, where individuals and families from around the world are free to govern themselves, worship, read, and speak as they wish. Within its wide margins, the polyglot American nation manages to encompass an inexplicably complex yet workable whole. The pictures in this book are dedicated to that idea.

—*Rick Smolan and David Elliot Cohen*

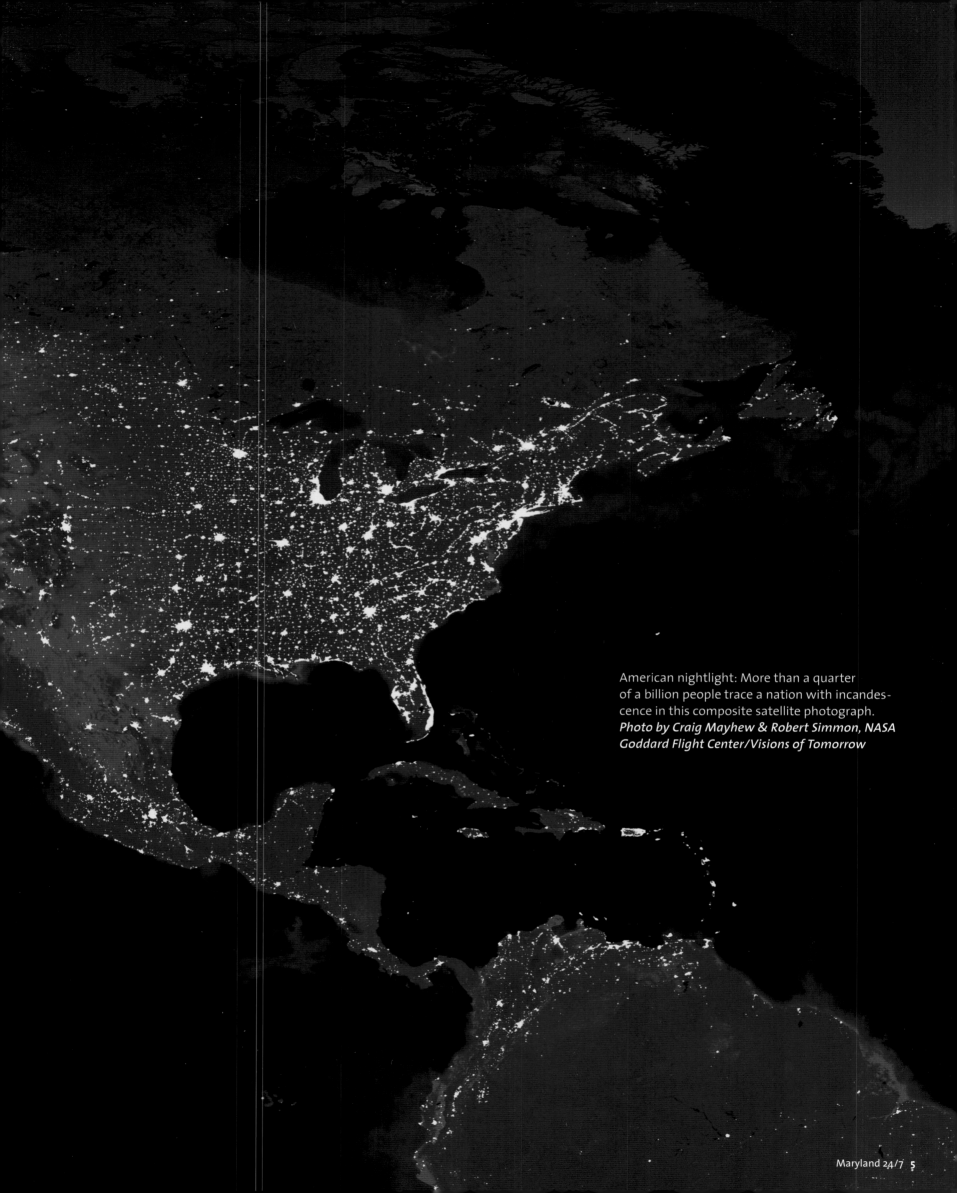

American nightlight: More than a quarter
of a billion people trace a nation with incandes-
cence in this composite satellite photograph.
*Photo by Craig Mayhew & Robert Simmon, NASA
Goddard Flight Center/Visions of Tomorrow*

The Infinite Shore

By Jean E. Thompson

What makes Marylanders tick? To find out, a cultural anthropologist might examine the contents of closet and cupboard: Navy blue blazer. Crab cake recipe. Rock salt. Insect repellent. Hair spray. Fear the Turtle sweatshirt. Straw hat. A paddle and a lacrosse stick.

A political scientist might parse Maryland rhetoric: Preserve the Chesapeake Bay. Link far-flung towns and burgeoning bedroom communities with new transit, new highways. Support public education. Create jobs. Pay a living wage. Hold on—who's going to pay for that?

Of course, a brutally honest assessment would come from a Fells Point manicurist. Take the boat out yesterday, did you? Cut your own Christmas tree? Crab feast last weekend? Putting in the tomatoes? The hands don't lie: Marylanders rarely stray far from the embrace of river, bay, or harbor, or from the warmth of the land that defines us. Our souls may have wings, but our roots are pure country. It's the subtext of so many stories—of the Baltimore cop who moonlights as a sunflower farmer; the executive who abandons the boardroom to sail around the world; the prosperous and poor alike who flock, in spite of flood risk, to communities along the state's infinite shore.

The tiller of the soil, the toiler on the water: our twin muses. While rapidly paving over once-pastoral vistas to accommodate explosive growth, we miss our folkways and yearn for bygone gentility. In a century, half of the state's 48,000 farms vanished. Pastures yielded to townhouses and technology parks. Condos and tourist malls replaced the shipyards. Still, Marylanders want to get dirty or wet on the weekend—even city dwellers, who flock to the Inner Harbor, to community

DORCHESTER COUNTY
Navigable from Chesapeake Bay to Seaford, Delaware, the Nanticoke River and its many feeder streams support boaters and barge and commercial traffic. Extensive marshes are home to bald eagles, great blue herons, and ospreys.
Photo by Perry Thorsvik

gardens and farmers' markets, to the State Fair and maritime festivals.

The land and the Bay define our history. Every schoolchild learns that "The Star-Spangled Banner" was drafted on a warship in Baltimore Harbor. Flags always have been fashionable in Maryland.

Harder to reconcile are our feelings about the Civil War. Maryland was a divided state, and hasn't gotten over it. Today, most descendants of slave and freeborn, slaveholder and abolitionist make polite neighbors and try to relegate the harsher memories to museum vaults.

There are other, more pressing problems. Schools and housing are needed as immigrants from Central America, Mexico, Africa, Asia, and the Caribbean arrive in the suburbs and cities. Mill towns like Luke are dying; crime threatens the jewel that is Baltimore. The new money is in electronic game design and biotech, not Beth Steel. Uncle Sam helps, by keeping us employed at Social Security, the Naval Academy, the National Security Agency, and various other bureaucracies tucked into wooded office parks. Sustaining Maryland's prosperity is our common challenge, from the far western Appalachian panhandle to the sand-swept Atlantic shore towns.

Still, it takes more than this to unite so diverse a people.

At the heart of the matter, it takes shared experience and shared memory—a collective appreciation for the golden promise of a Westminster cornfield; for the steely gray Potomac paved with ice; for spring's first crocuses blooming in a recycled tire cachepot on a Baltimore sidewalk and crimson crab shells discarded on butter-stained newsprint; for the silvery glint of Smith Island skipjacks clutching the wind on Chesapeake Bay.

JEAN E. THOMPSON *is an associate editor of the editorial page at* The Baltimore Sun. *She collects vintage labels from Maryland canneries.*

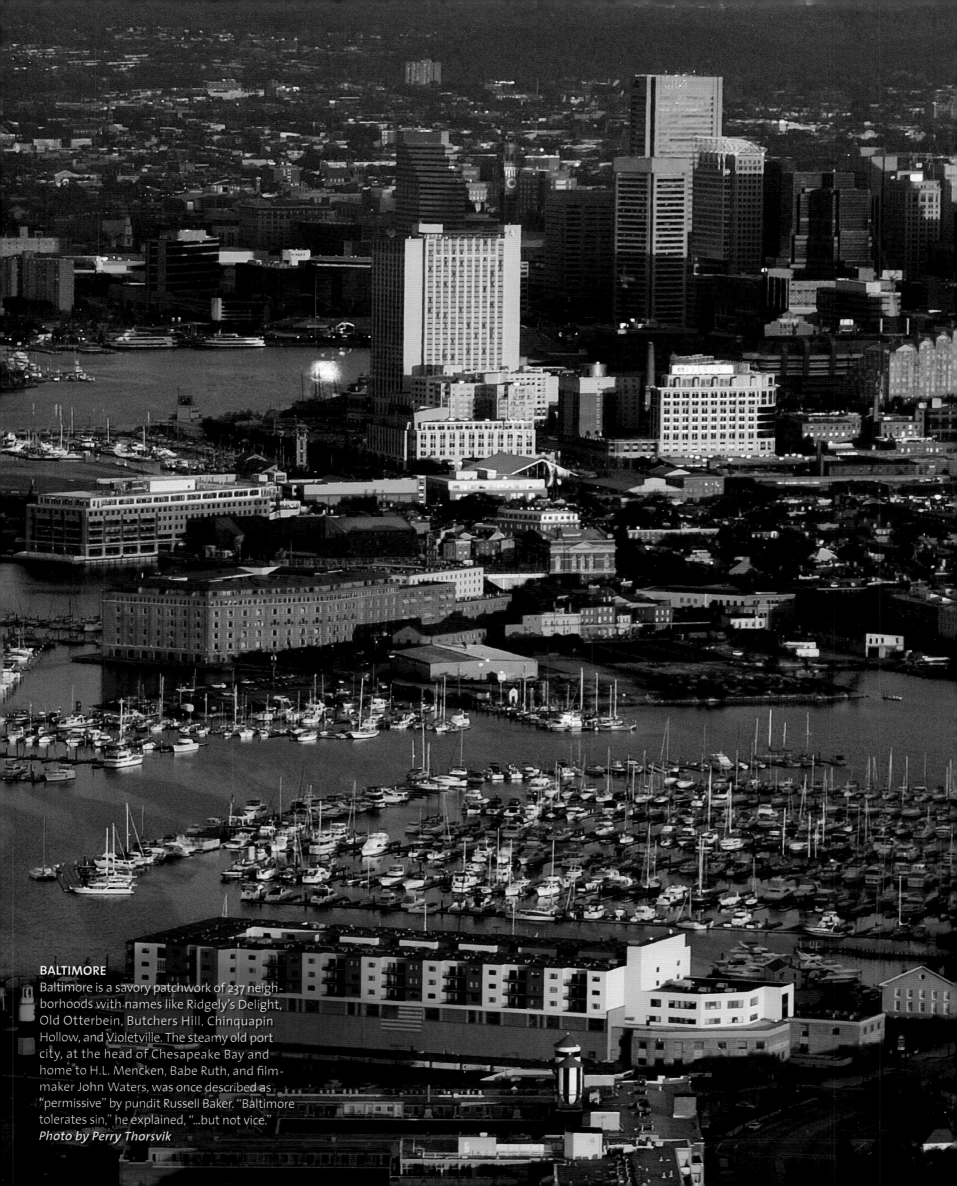

BALTIMORE

Baltimore is a savory patchwork of 237 neighborhoods with names like Ridgely's Delight, Old Otterbein, Butchers Hill, Chinquapin Hollow, and Violetville. The steamy old port city, at the head of Chesapeake Bay and home to H.L. Mencken, Babe Ruth, and filmmaker John Waters, was once described as "permissive" by pundit Russell Baker. "Baltimore tolerates sin," he explained, "...but not vice."
Photo by Perry Thorsvik

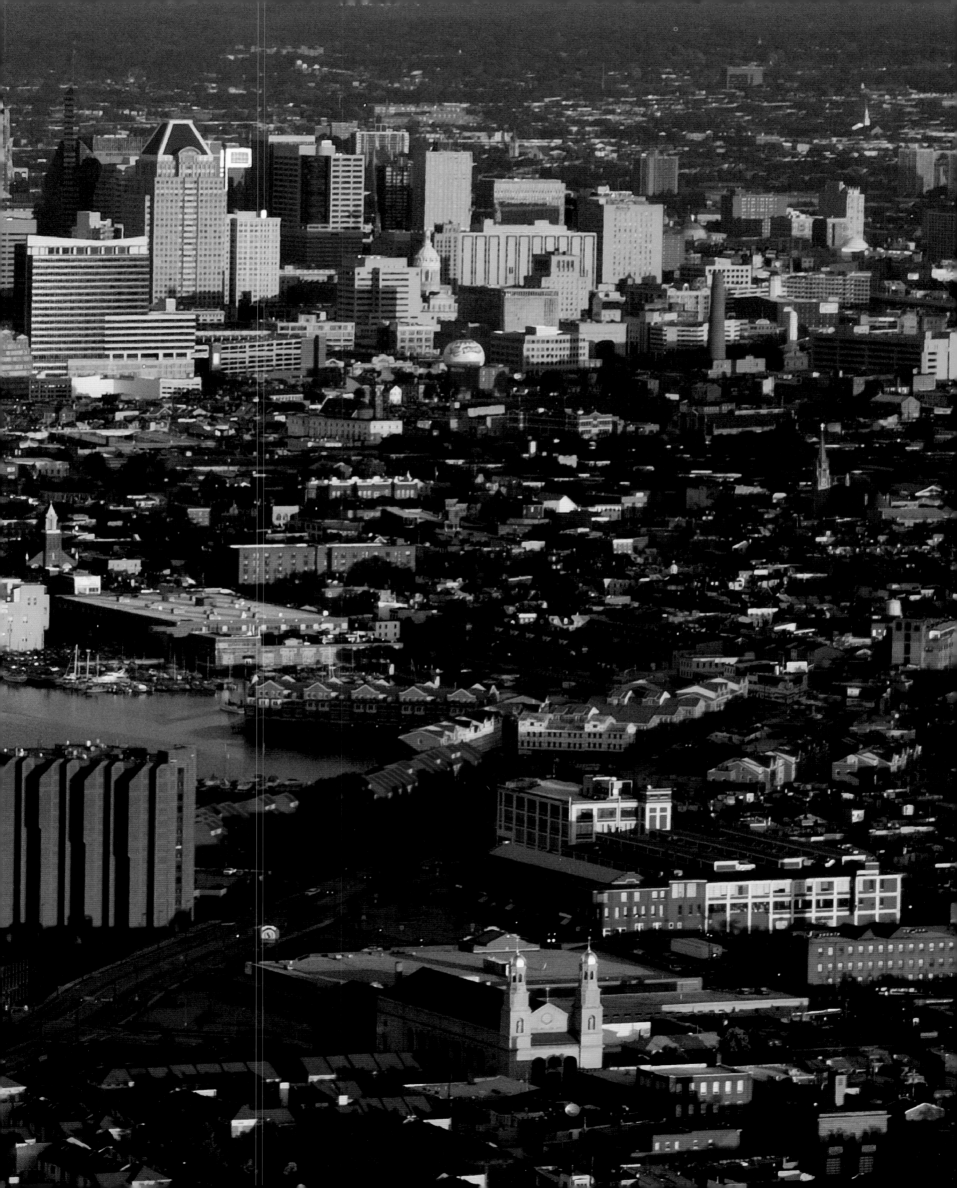

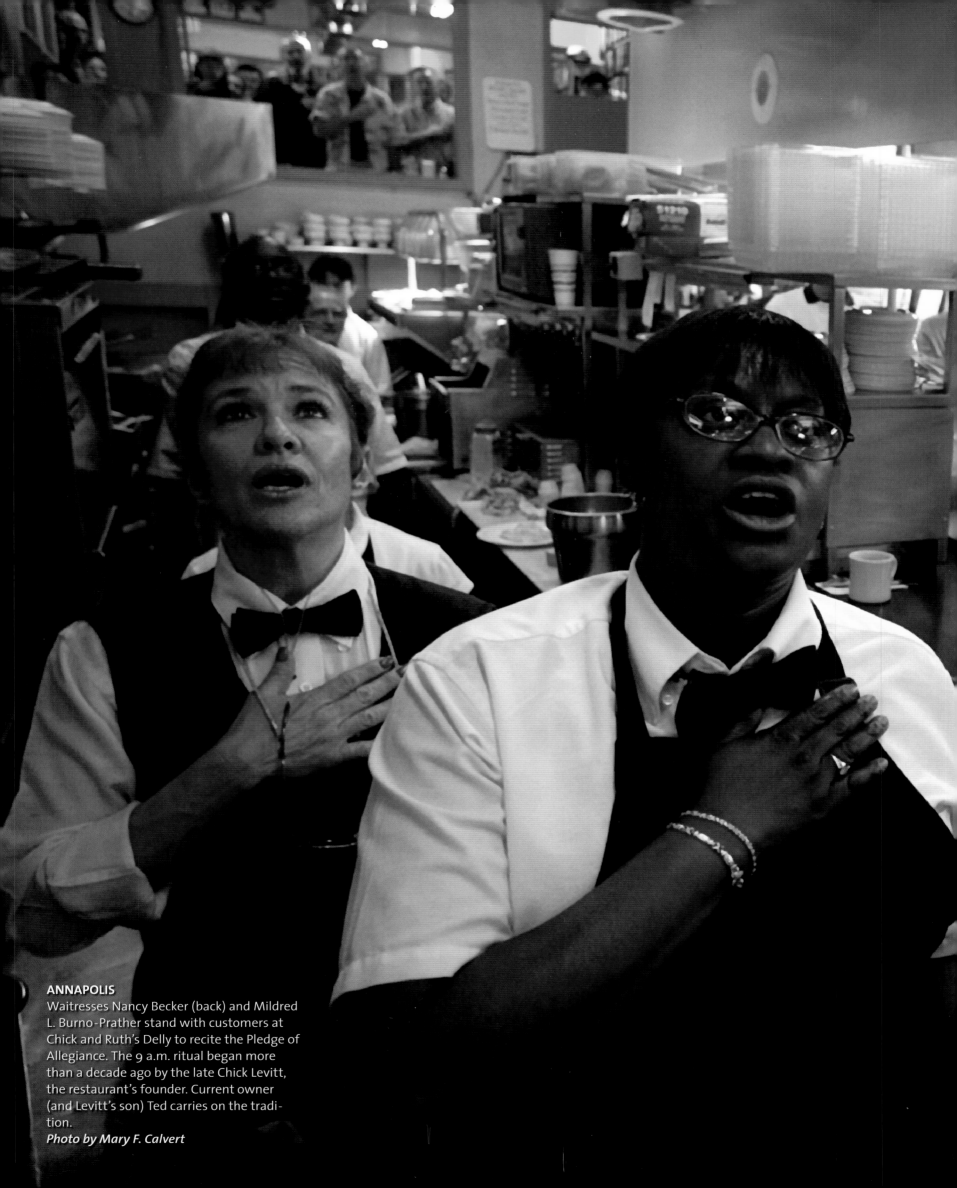

ANNAPOLIS
Waitresses Nancy Becker (back) and Mildred L. Burno-Prather stand with customers at Chick and Ruth's Delly to recite the Pledge of Allegiance. The 9 a.m. ritual began more than a decade ago by the late Chick Levitt, the restaurant's founder. Current owner (and Levitt's son) Ted carries on the tradition.
Photo by Mary F. Calvert

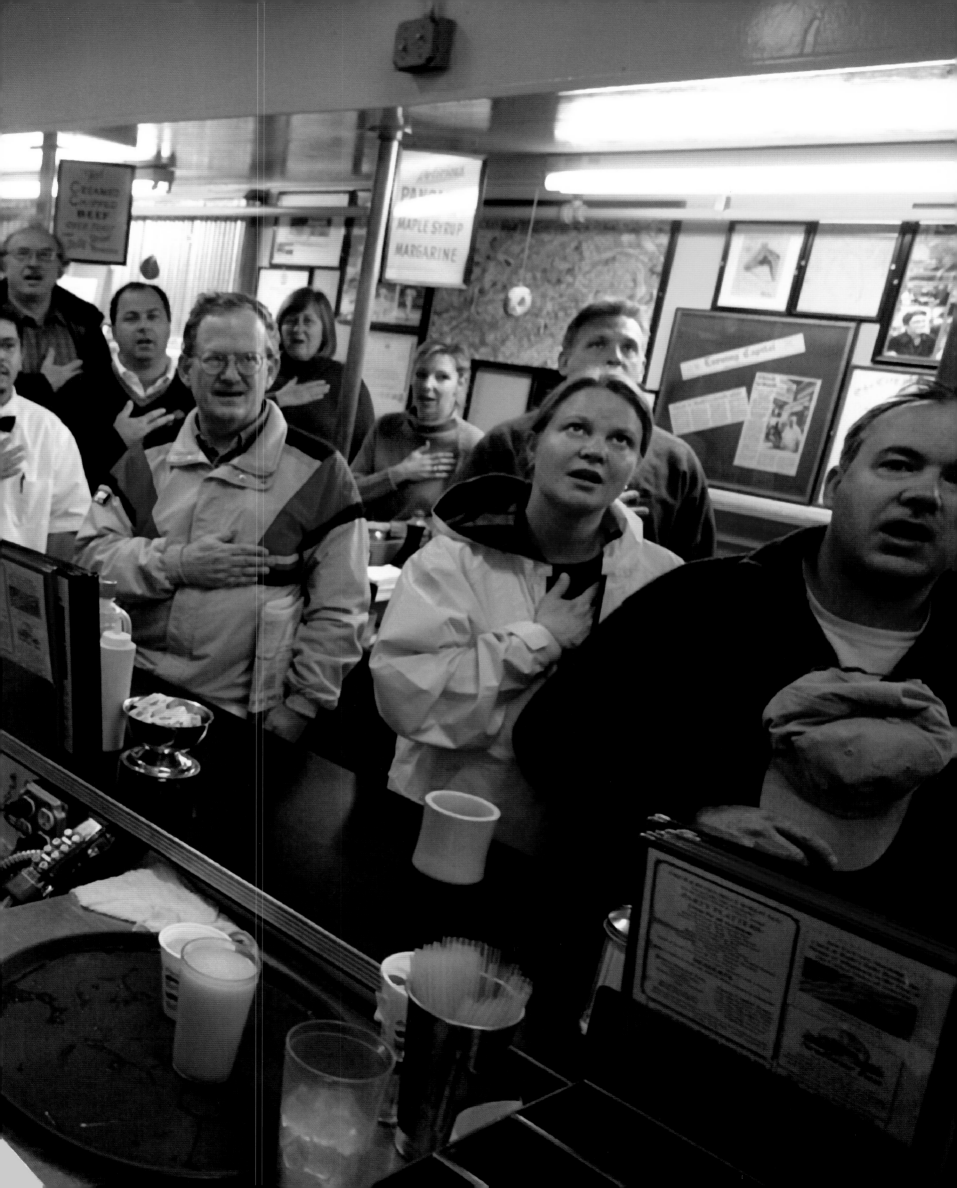

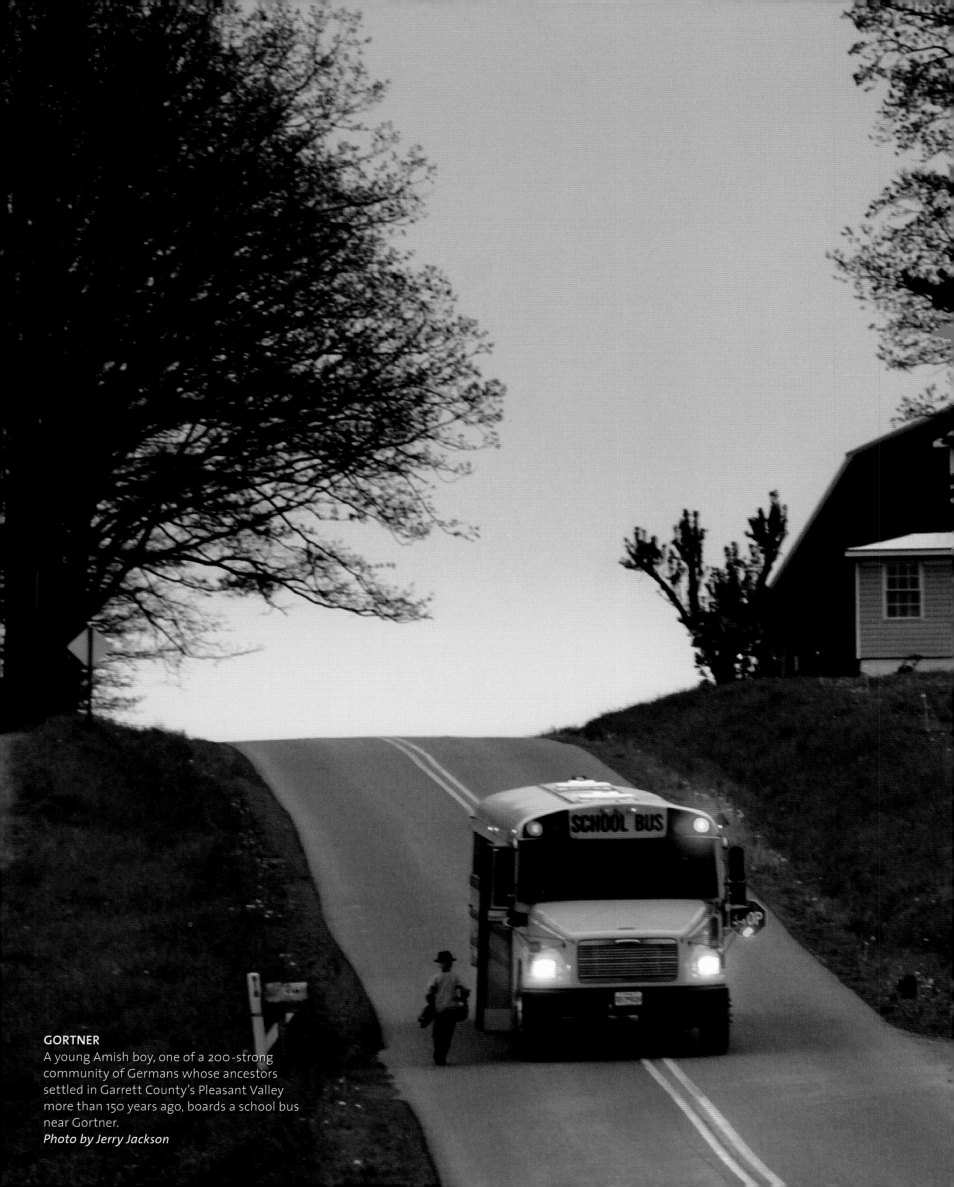

GORTNER

A young Amish boy, one of a 200-strong community of Germans whose ancestors settled in Garrett County's Pleasant Valley more than 150 years ago, boards a school bus near Gortner.

Photo by Jerry Jackson

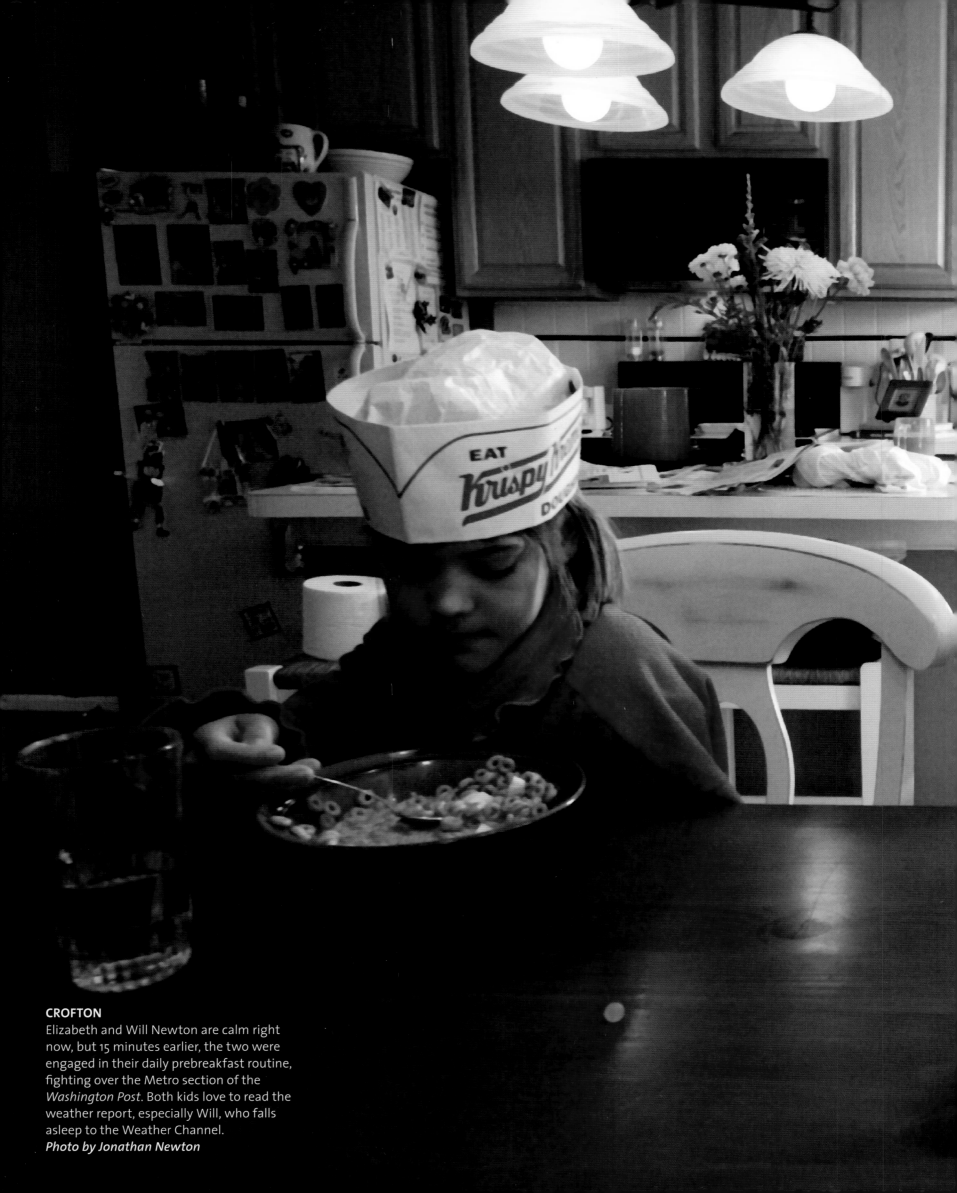

CROFTON
Elizabeth and Will Newton are calm right now, but 15 minutes earlier, the two were engaged in their daily prebreakfast routine, fighting over the Metro section of the *Washington Post*. Both kids love to read the weather report, especially Will, who falls asleep to the Weather Channel.
Photo by Jonathan Newton

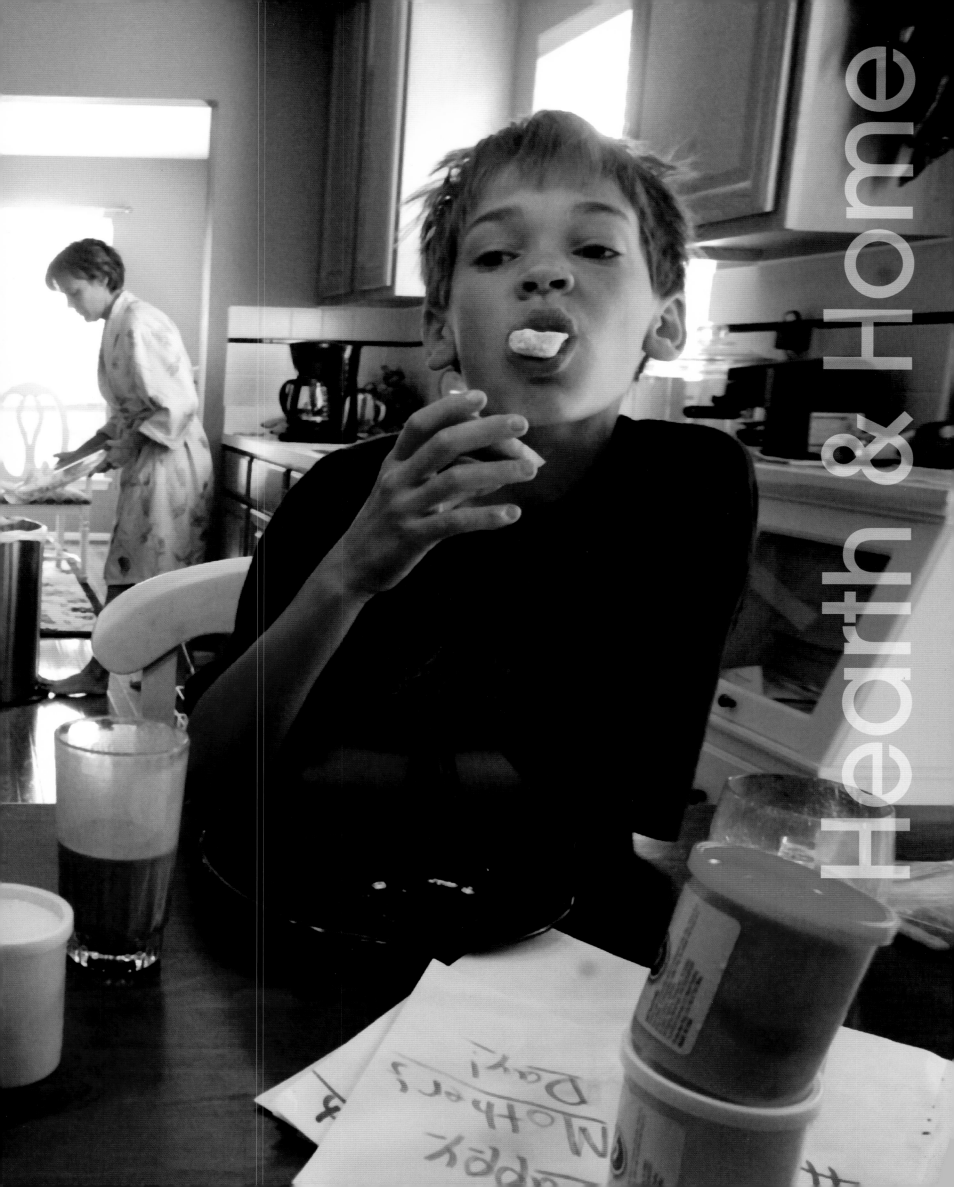

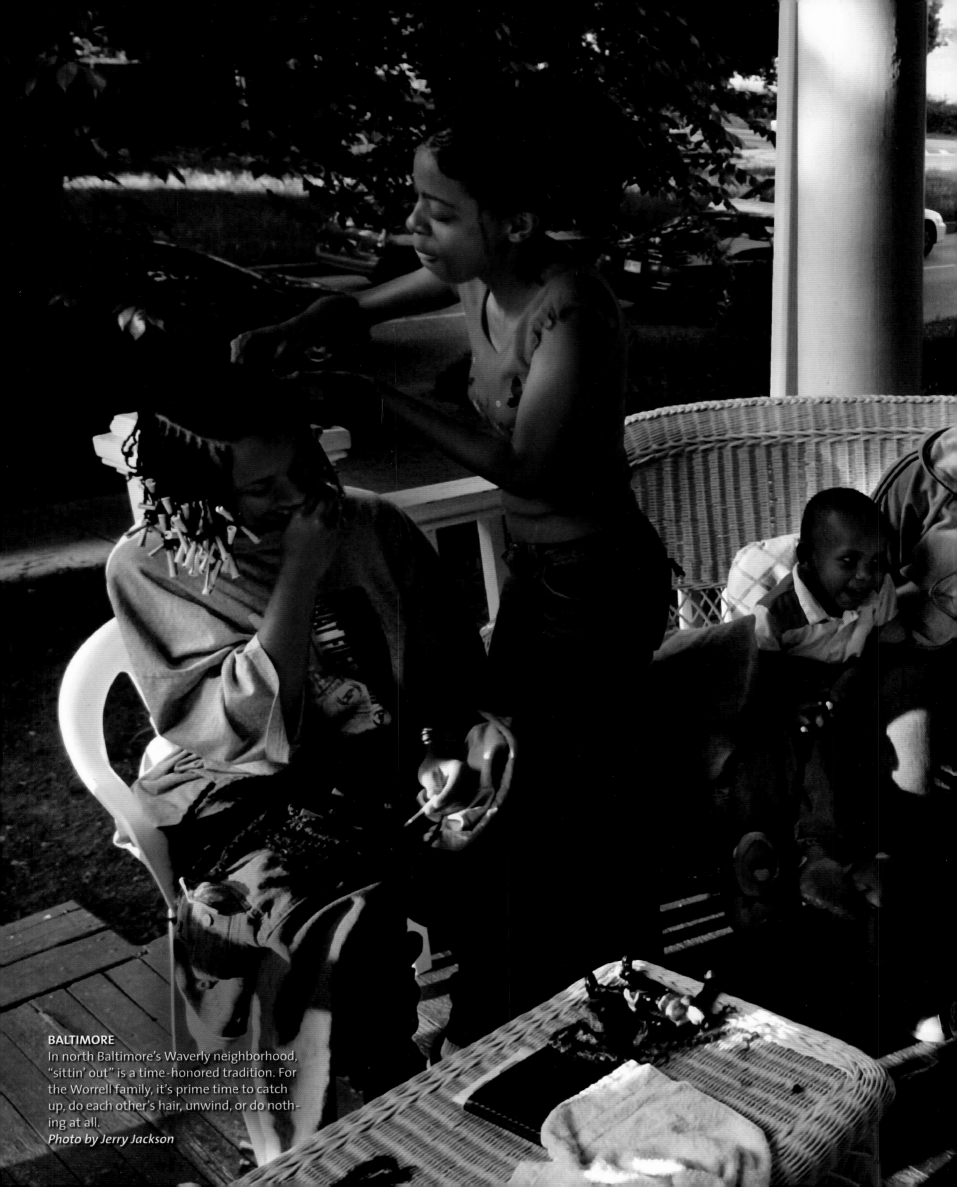

BALTIMORE
In north Baltimore's Waverly neighborhood, "sittin' out" is a time-honored tradition. For the Worrell family, it's prime time to catch up, do each other's hair, unwind, or do nothing at all.
Photo by Jerry Jackson

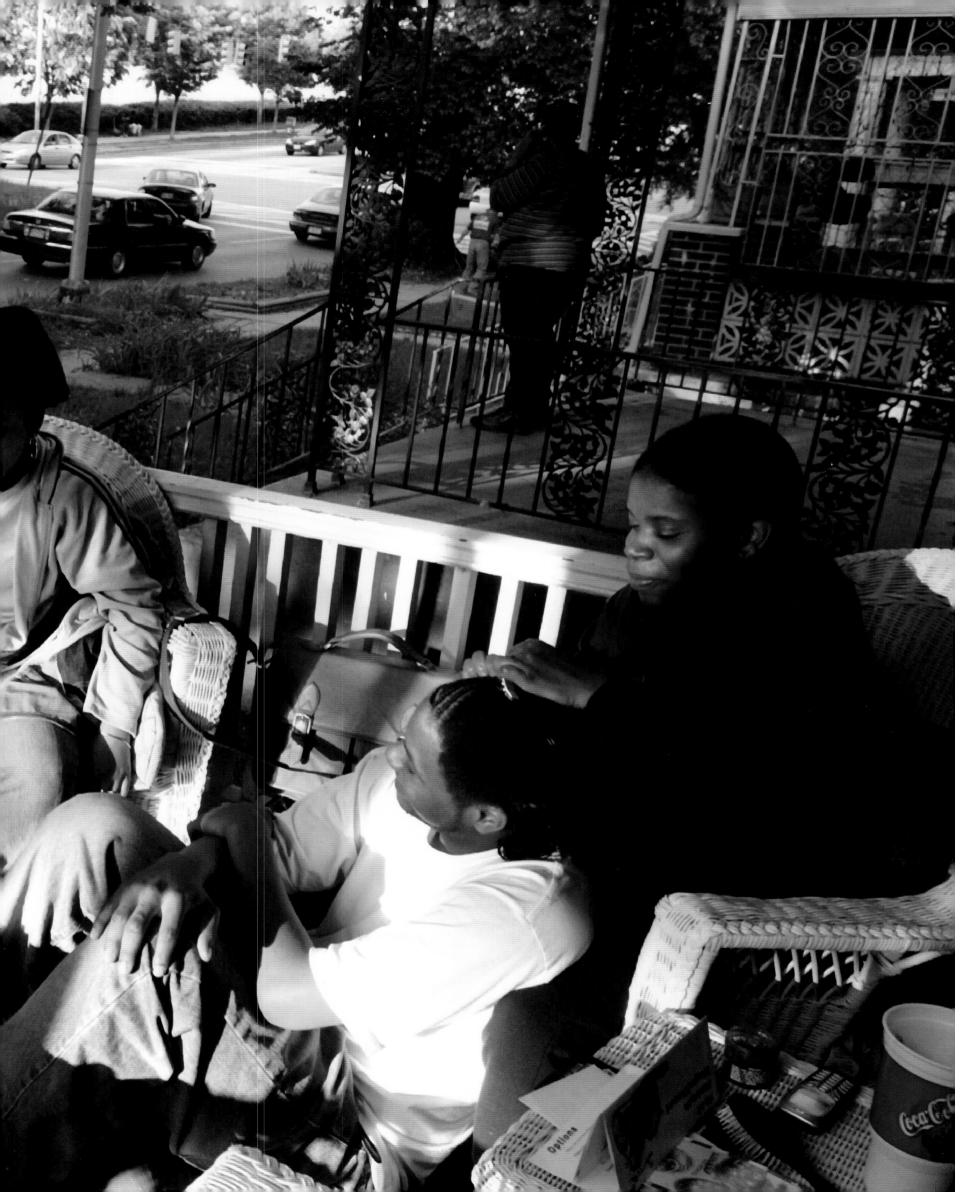

CROFTON

Metal-mouth no more: Matthew Newton, 13, has something to smile about. After a year and a half, his orthodontist has just removed his braces. The results? Look for yourself.

Photo by Jonathan Newton

BALTIMORE

Throwing open the shutters of her backyard playhouse, Audrey Jackson can't wait another second to reveal herself in a game of hide-and-seek.

Photo by Karen Jackson

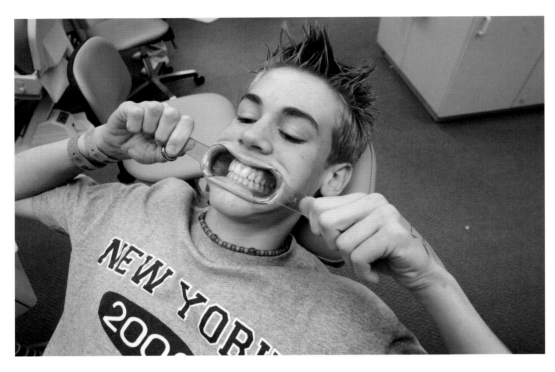

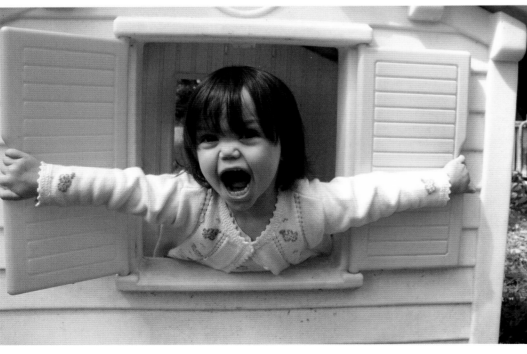

SYKESVILLE

Green with envy? Probably not, but 9-year-old Jesse Lee of Haddonfield, New Jersey, is curious to see what the inside of a frog sandbox looks like. He's visiting his cousin Luke Apanavage for the toddler's first birthday.

Photo by Tom Gralish, The Philadelphia Inquirer

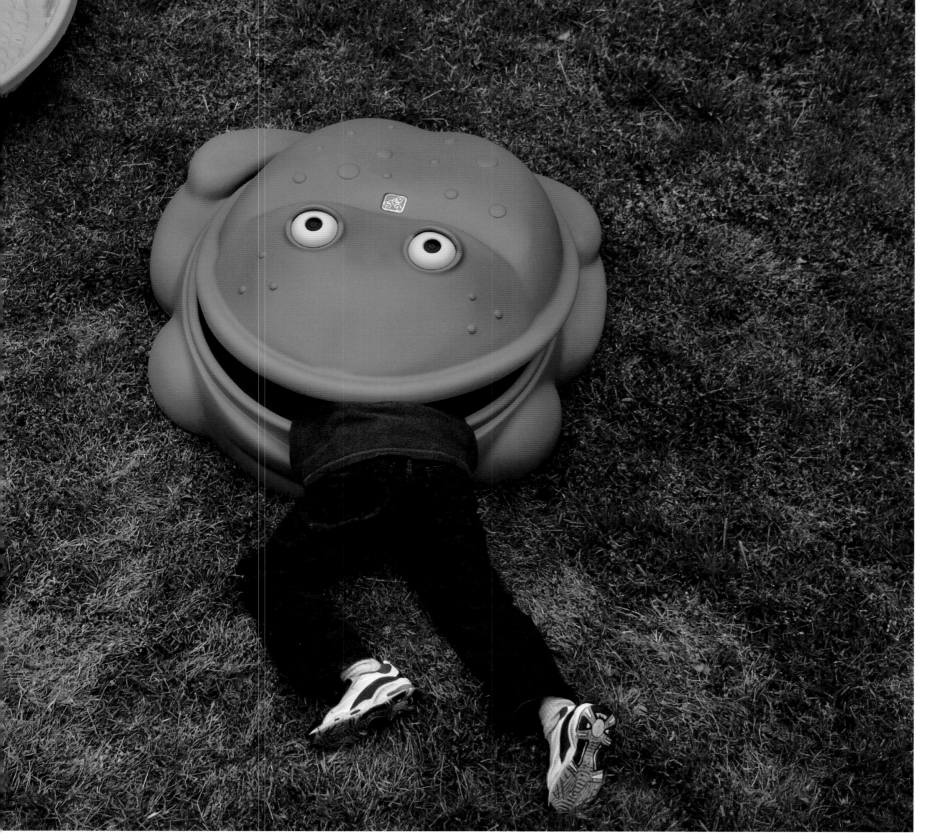

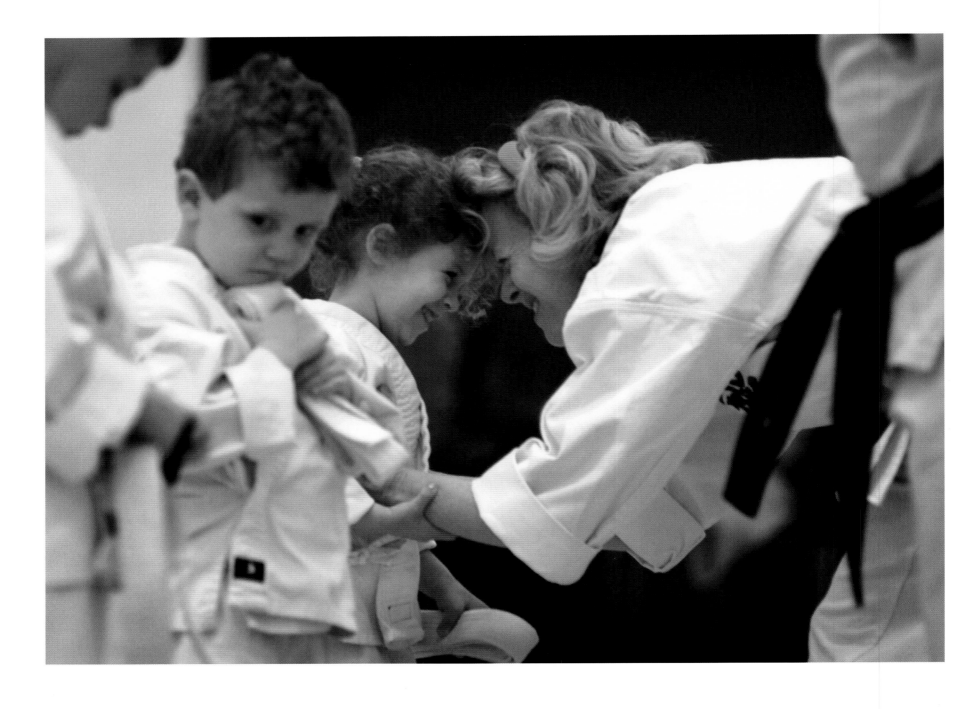

TOWSON

Seido karate teacher Karen Kells-Pamfilis awards
Rachel Fisher an advanced white belt, while
Michael Sassano awaits his blue belt. "The sin-
cere way of karate," Seido was brought from
Japan to New York in 1976 and has since expand-
ed worldwide. Combining Zen meditation with
movement, the kids meditate before and after
class by taking three deep breaths.
Photo by Jerry Jackson

DEALE

Spiritual writer and teacher Sandi Wolfe snuggles with her granddaughter, Ashleigh Jordan Stup, under their favorite maple tree in Wolfe's backyard. The two pass many weekend afternoons conversing with each other and with Frances, as Wolfe has named the tree.
Photo by Shell M. O'Connor

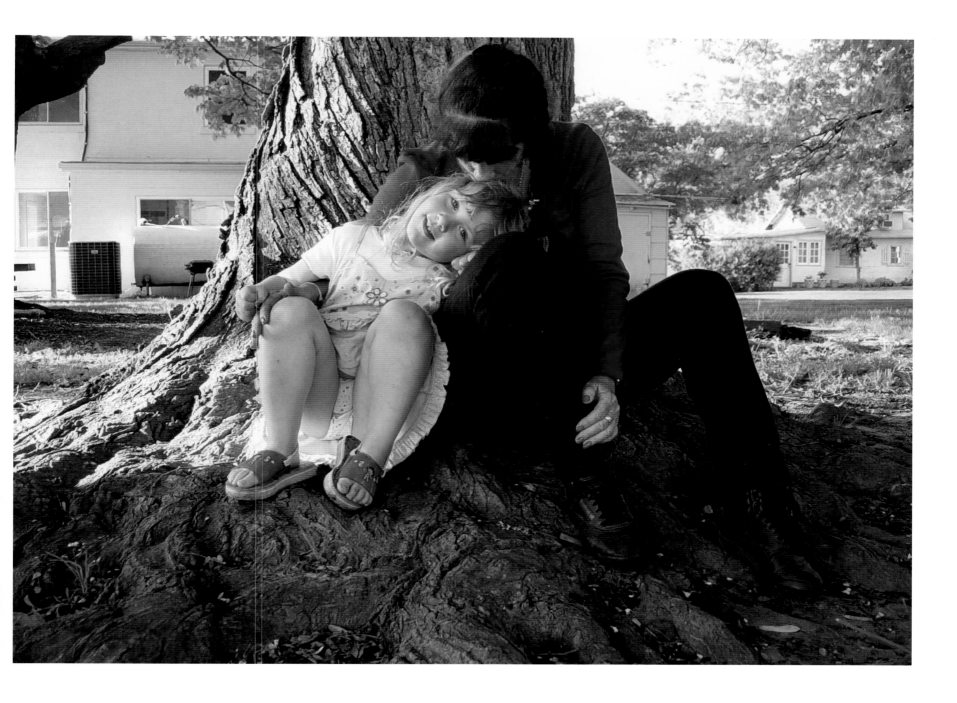

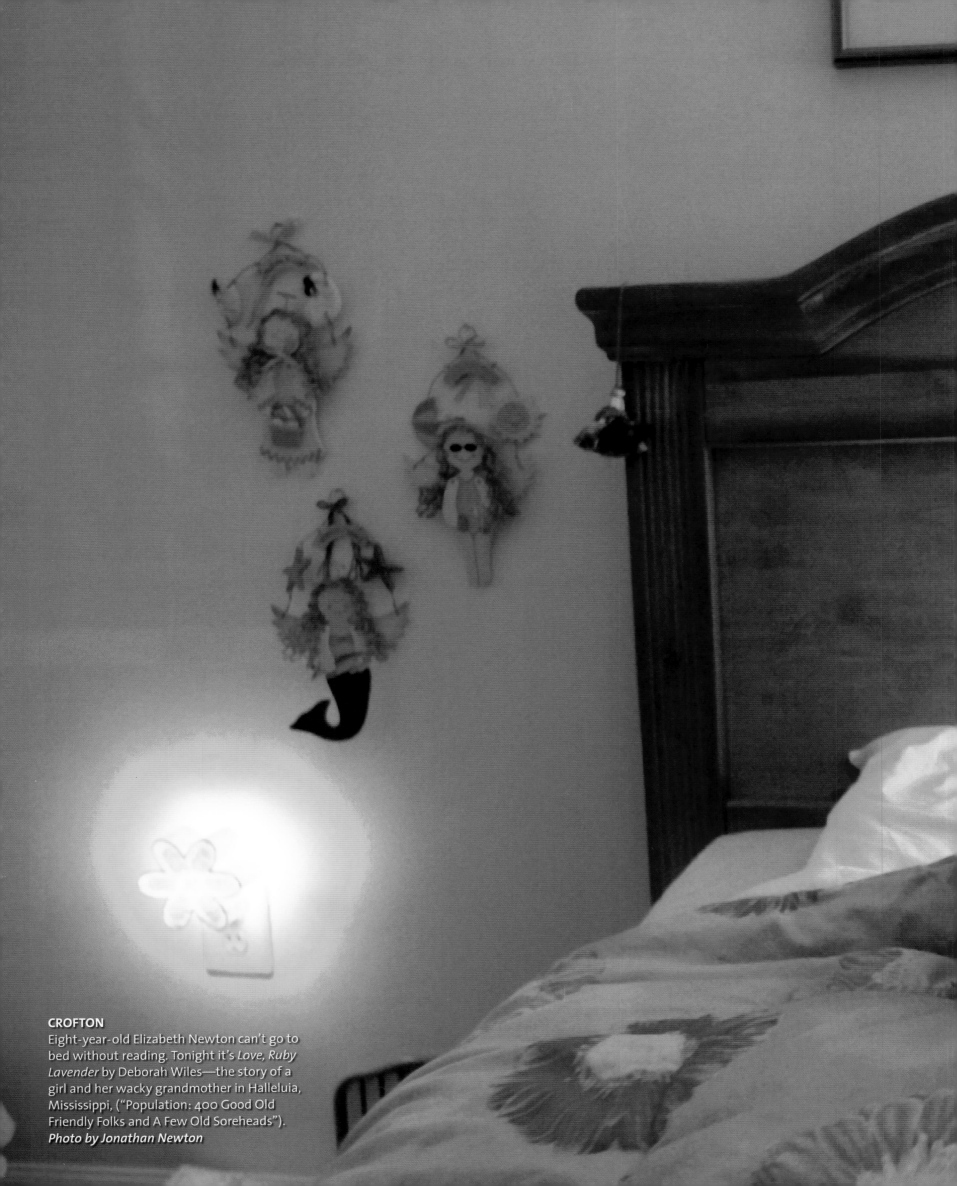

CROFTON
Eight-year-old Elizabeth Newton can't go to bed without reading. Tonight it's *Love, Ruby Lavender* by Deborah Wiles—the story of a girl and her wacky grandmother in Halleluia, Mississippi, ("Population: 400 Good Old Friendly Folks and A Few Old Soreheads").
Photo by Jonathan Newton

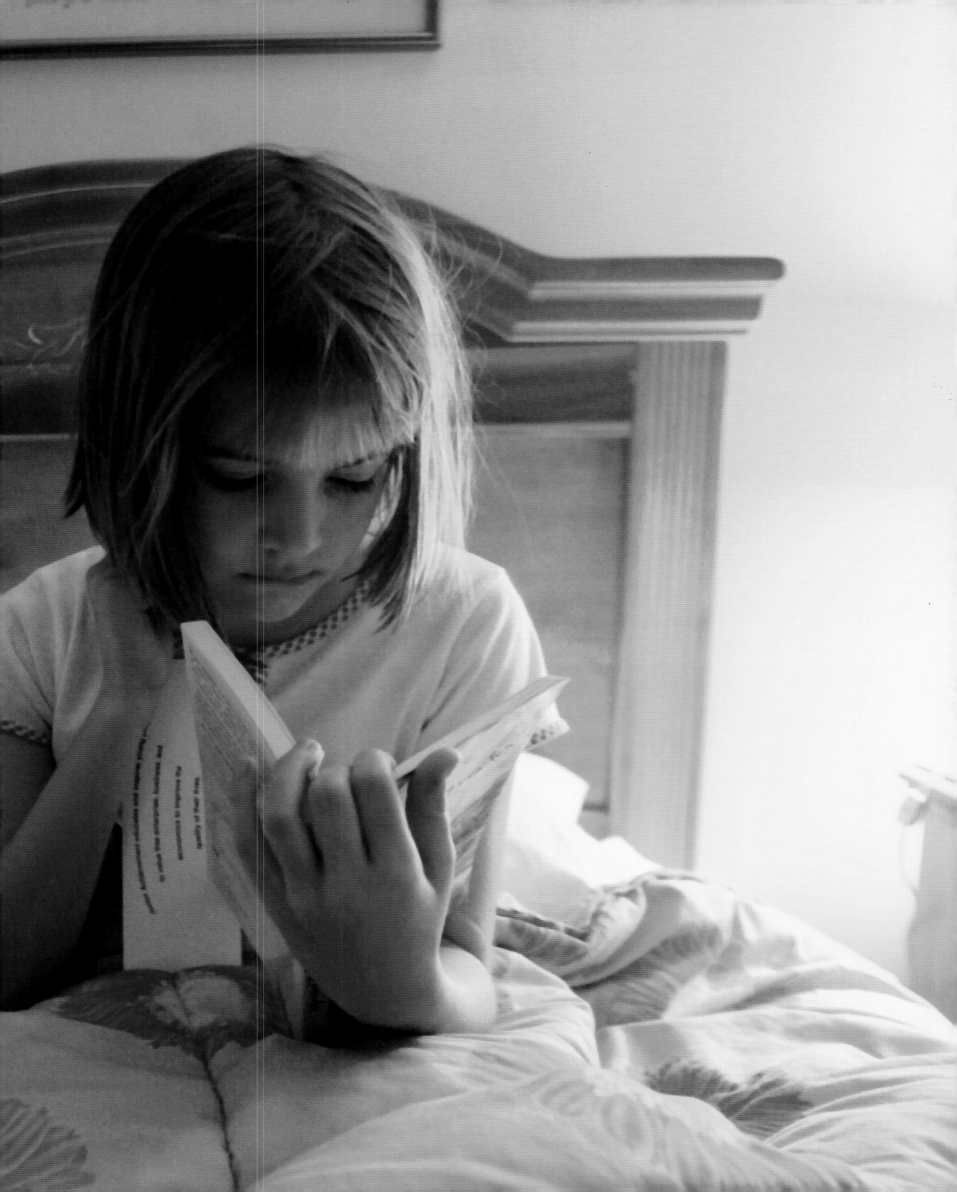

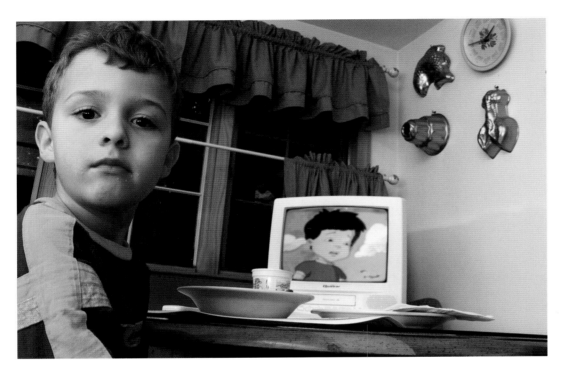

PASADENA

Luke Janiszewski watches cartoons after finishing a lunch of cream of wheat and peanut butter toast at his grandmother Linda McCloskey's house. His brother Jake will soon wake from a nap and grandma will bring out the Play-Doh.

Photo by Herrmann + Starke

SILVER SPRING

Preteenage wasteland: Jamie Barkin, 12, finds comfort in her unmade bed. "She doesn't have to make it and probably wouldn't even if she had to," says her dad. Instead, Jamie saves her energy for classes (drama and English are her favorites), sports (soccer, baseball, and swimming), and tending her many pets, including a leopard gecko and firebellied toad.

Photo by Susan Biddle

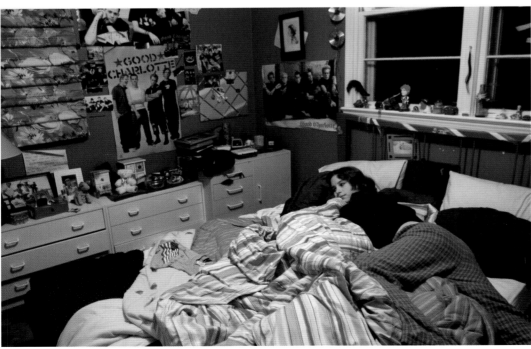

COLUMBIA

Will Charlie Fox grow up to be a firefighter or an airplane pilot? At this point, the son of photographer Nanine Hartzenbusch isn't giving it much thought. He's just doing what all 3-year-olds are hardwired to do—run around from one brightly colored thing to another until they get hungry, get hurt, or fall asleep.

Photo by Nanine Hartzenbusch,
The Baltimore Sun

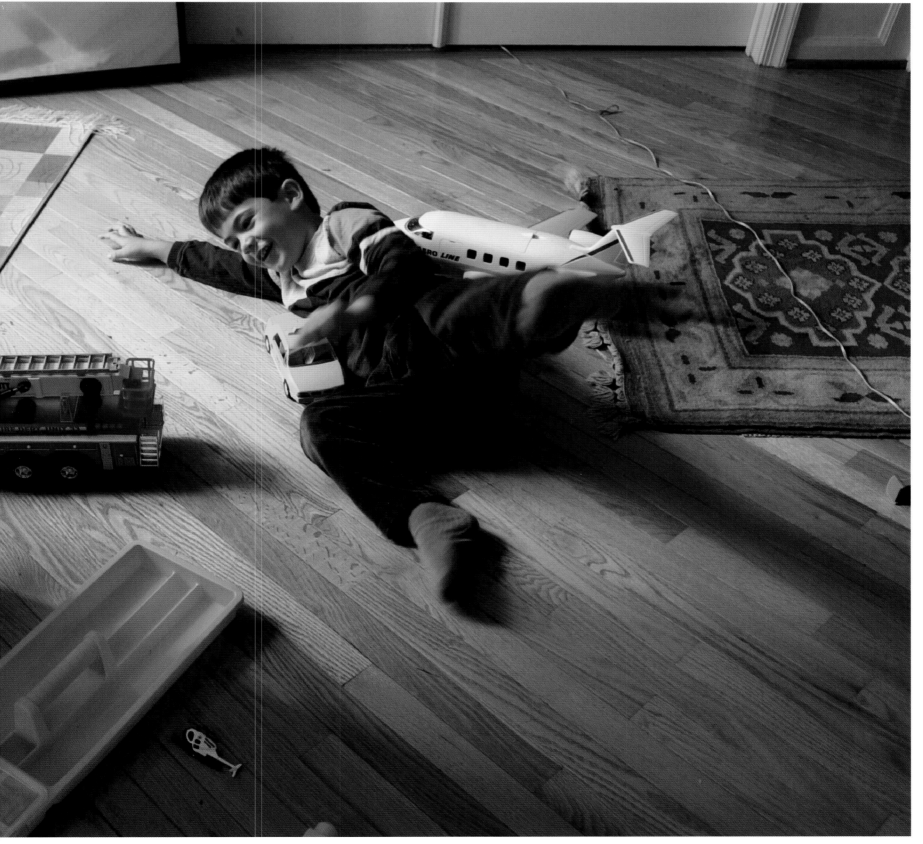

CHEVY CHASE
Hannah Robinson's mom, Sheryl Stolberg, covers the U.S. Congress for *The New York Times*, but that is not what matters about Sunday afternoons with the paper. Hannah doesn't care whether Stolberg is reading her own story or the business section, as long as she can be in that comfort zone, tucked under mom's arm.
Photo by Scott Robinson

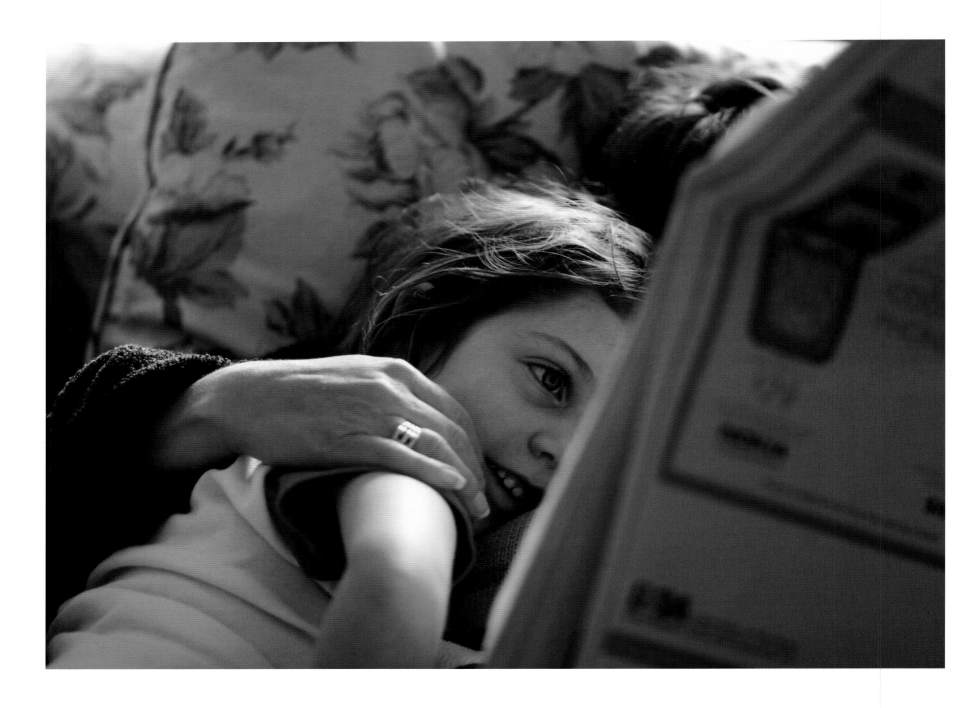

POOLESVILLE

Fourth-grader Lindsay Poss says she prefers reading—biographies, mysteries, and histories—to playing recess games at Poolesville Elementary School.

Photo by Hugh Allan Flick

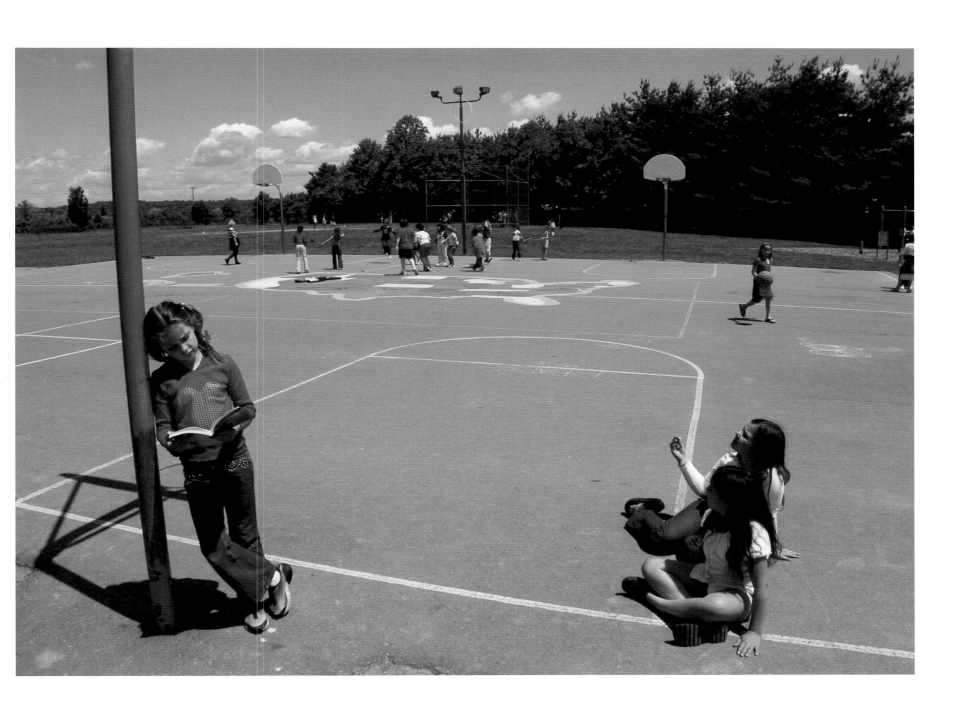

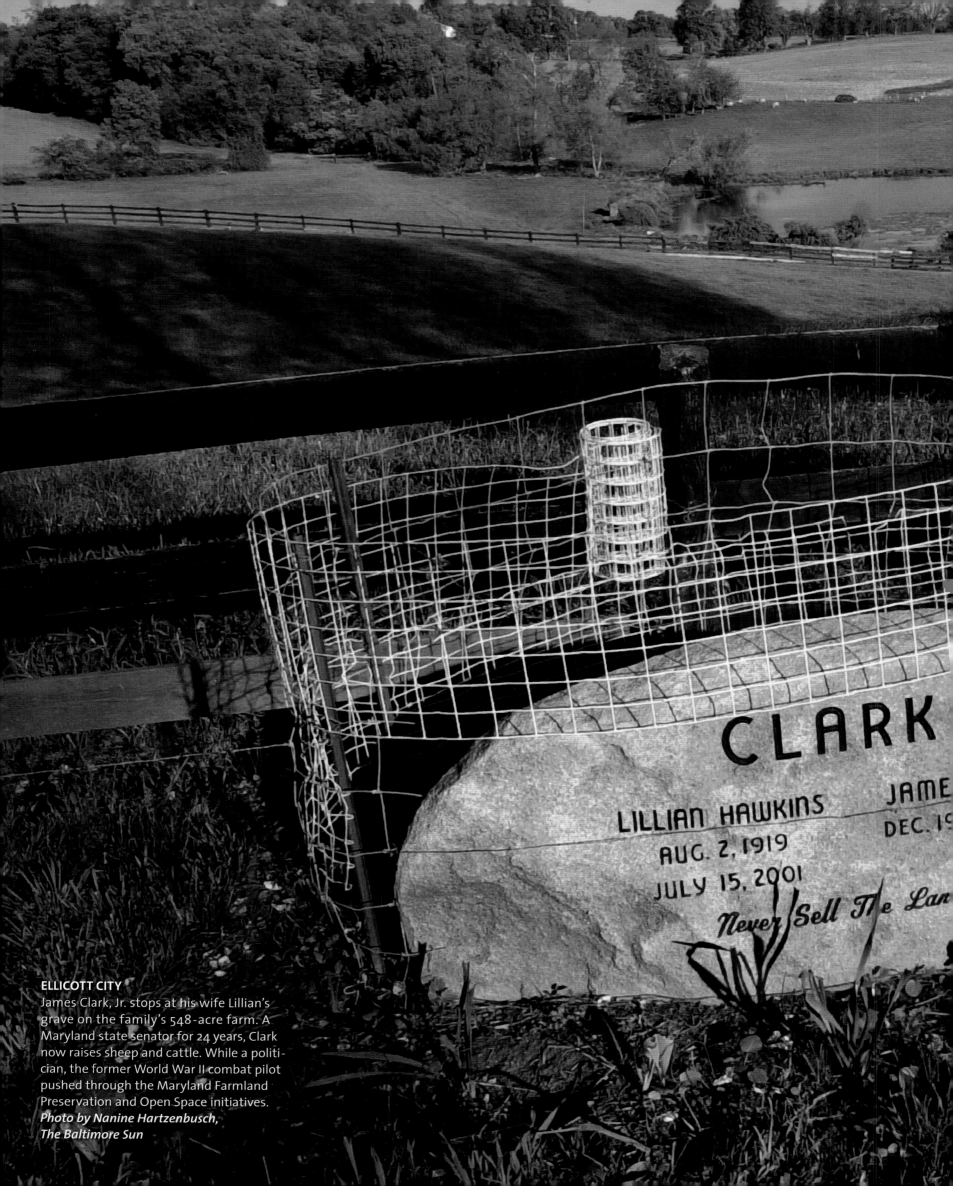

ELLICOTT CITY
James Clark, Jr. stops at his wife Lillian's grave on the family's 548-acre farm. A Maryland state senator for 24 years, Clark now raises sheep and cattle. While a politician, the former World War II combat pilot pushed through the Maryland Farmland Preservation and Open Space initiatives.
Photo by Nanine Hartzenbusch,
The Baltimore Sun

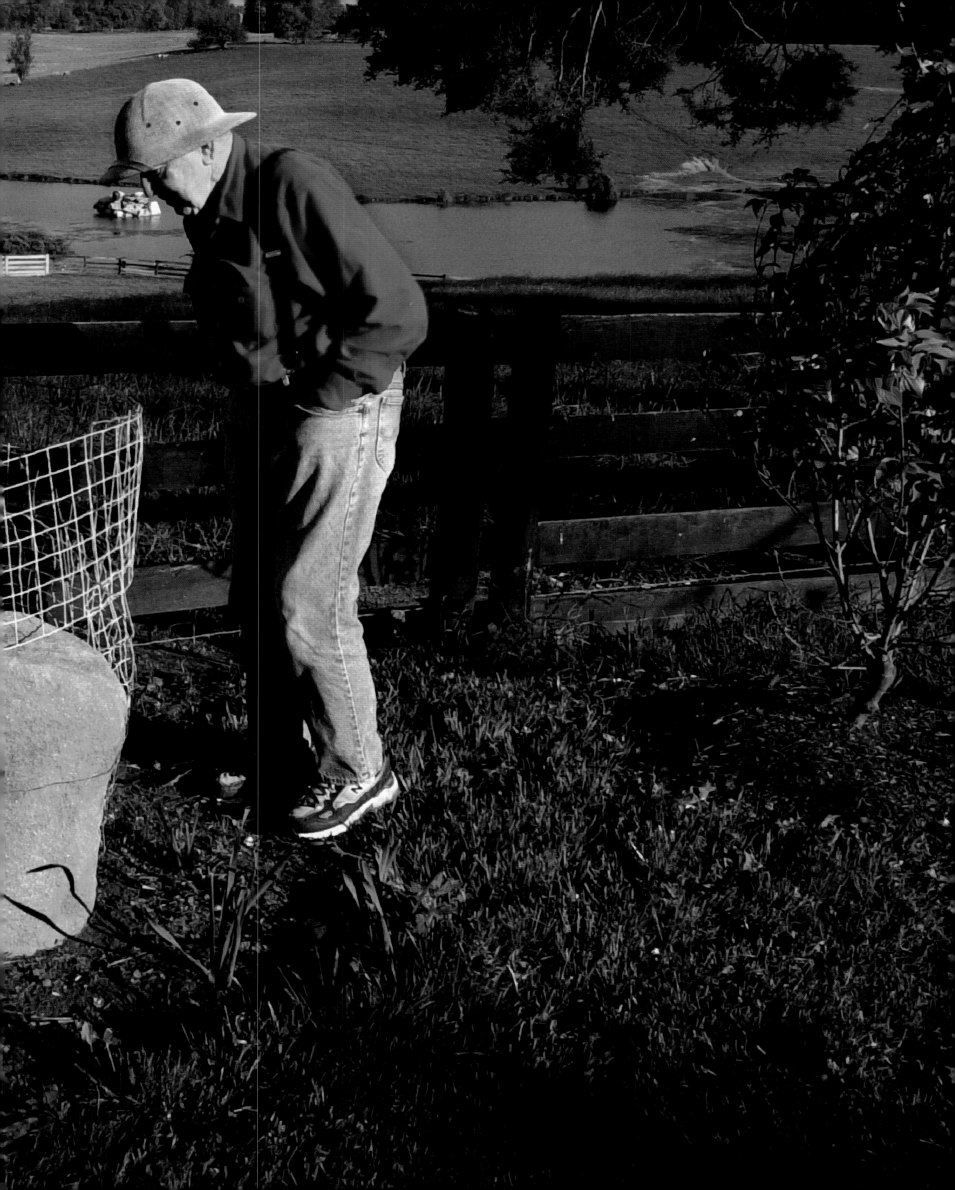

HUNTINGTOWN

Life *is* a beach. Sue Coffey left her high-octane Department of Energy job in Germantown two years ago and retired to a cottage on Chesapeake Bay with her Yorkies. She says she spends hours watching activity on the bay—the oyster and crab boats, the *Pride of Baltimore*, and training ships out of Annapolis.
Photo by Amy Deputy

CROFTON

The only time Jennifer Newton and her family see Sam, a hunter/gatherer cat, is at breakfast. His favorite spot is on top of the newspaper—the section someone is reading, of course.
Photo by Jonathan Newton

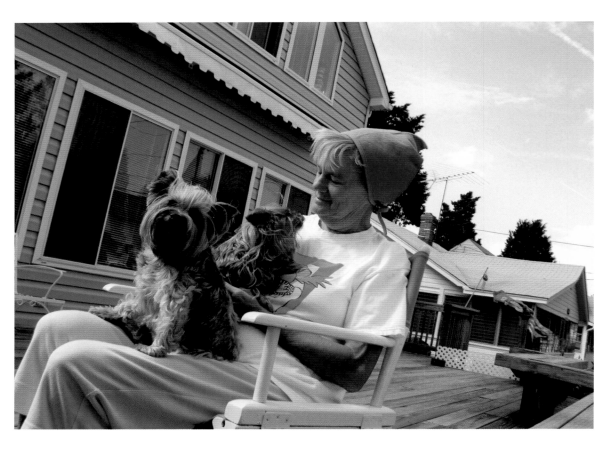

FALLSTON

The upcoming Harford County 4-H Fair is Bennett Remsberg's first competition and he wants to make sure he's prepared to parade William the pig properly in front of the judges. Sister Becky tags along on the family's small farm, 30 miles northeast of Baltimore.
Photo by Edwin Remsberg

WESTMINSTER

Colleen Feld almost lost her life 17 years ago while helping neglected animals: On her way to rescue two dogs, a tree blew over, crushing her car and leaving her paralyzed. Now, she volunteers at Animal Rescue and has adopted three dogs and 41 cats. "If we took care of each other—the two-legged and the four-legged—it would be a better world," she says.
Photo by Laurie DeWitt

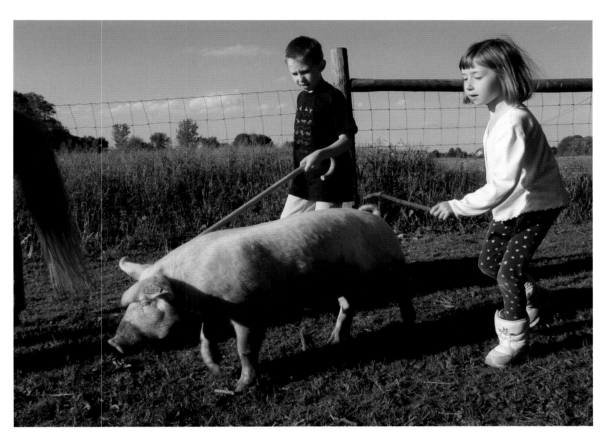

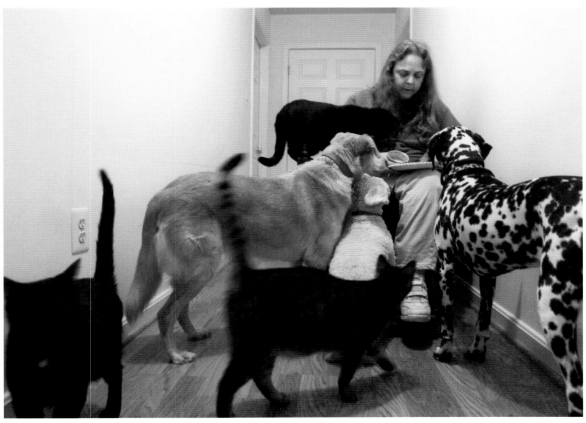

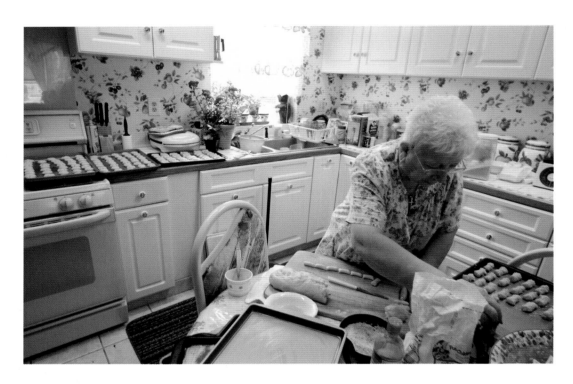

BALTIMORE

Rosa Aquia, who moved to Baltimore's Little Italy from Sicily 50 years ago, begins a baking process that will produce 100 pounds of cookies for the upcoming Feast of St. Anthony. The annual June event has been celebrated since 1904 and will be attended by just about everybody in the neighborhood, including three generations of Aquia's family.

Photo by James W. Prichard

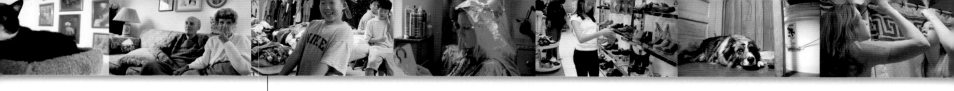

SILVER SPRING
Alex Kim models a pair of size 52 shorts at the Korean Baptist Church's annual bazaar. Monies raised at the bazaar fund missionary trips sponsored by the church, which moved to Silver Spring from D.C. about 20 years ago.
Photo by Joel Jang

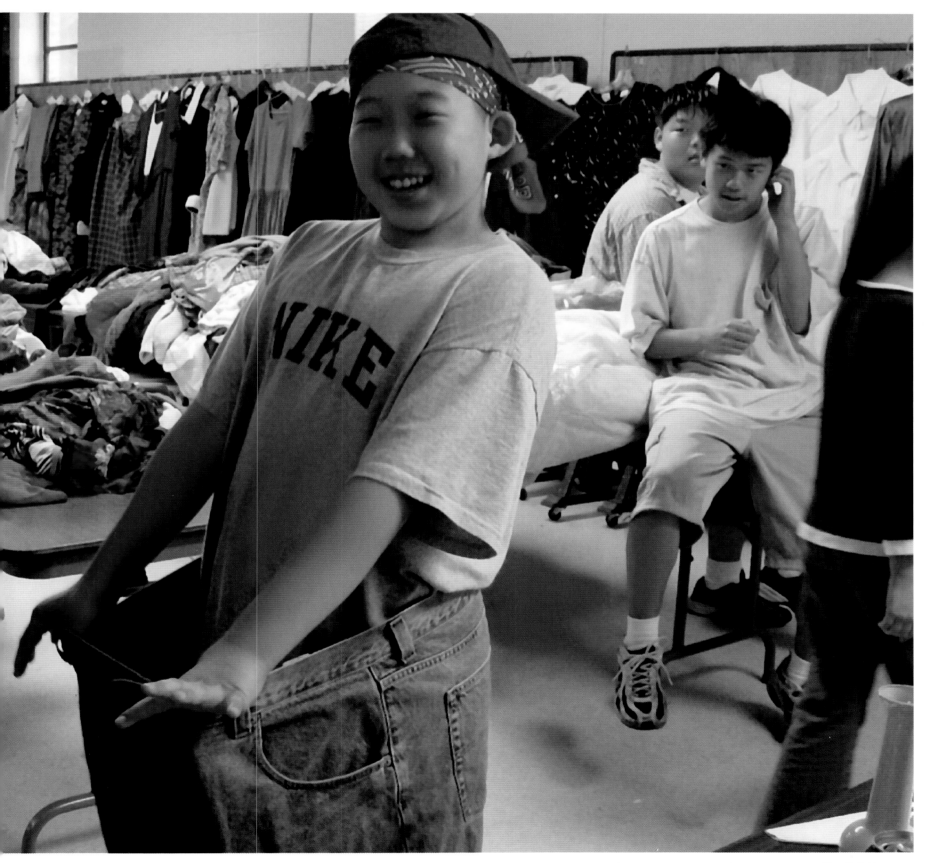

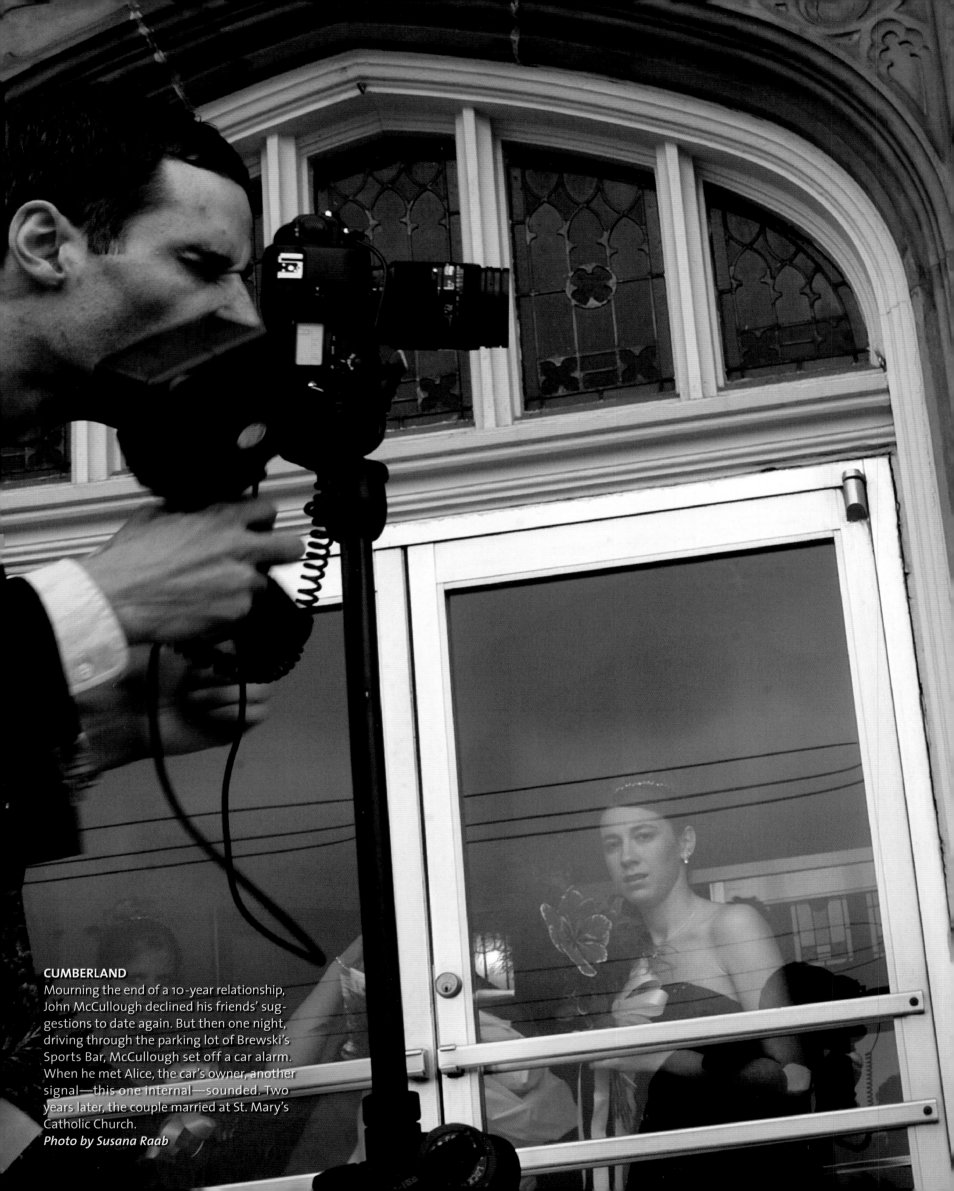

CUMBERLAND
Mourning the end of a 10-year relationship, John McCullough declined his friends' suggestions to date again. But then one night, driving through the parking lot of Brewski's Sports Bar, McCullough set off a car alarm. When he met Alice, the car's owner, another signal—this one internal—sounded. Two years later, the couple married at St. Mary's Catholic Church.
Photo by Susana Raab

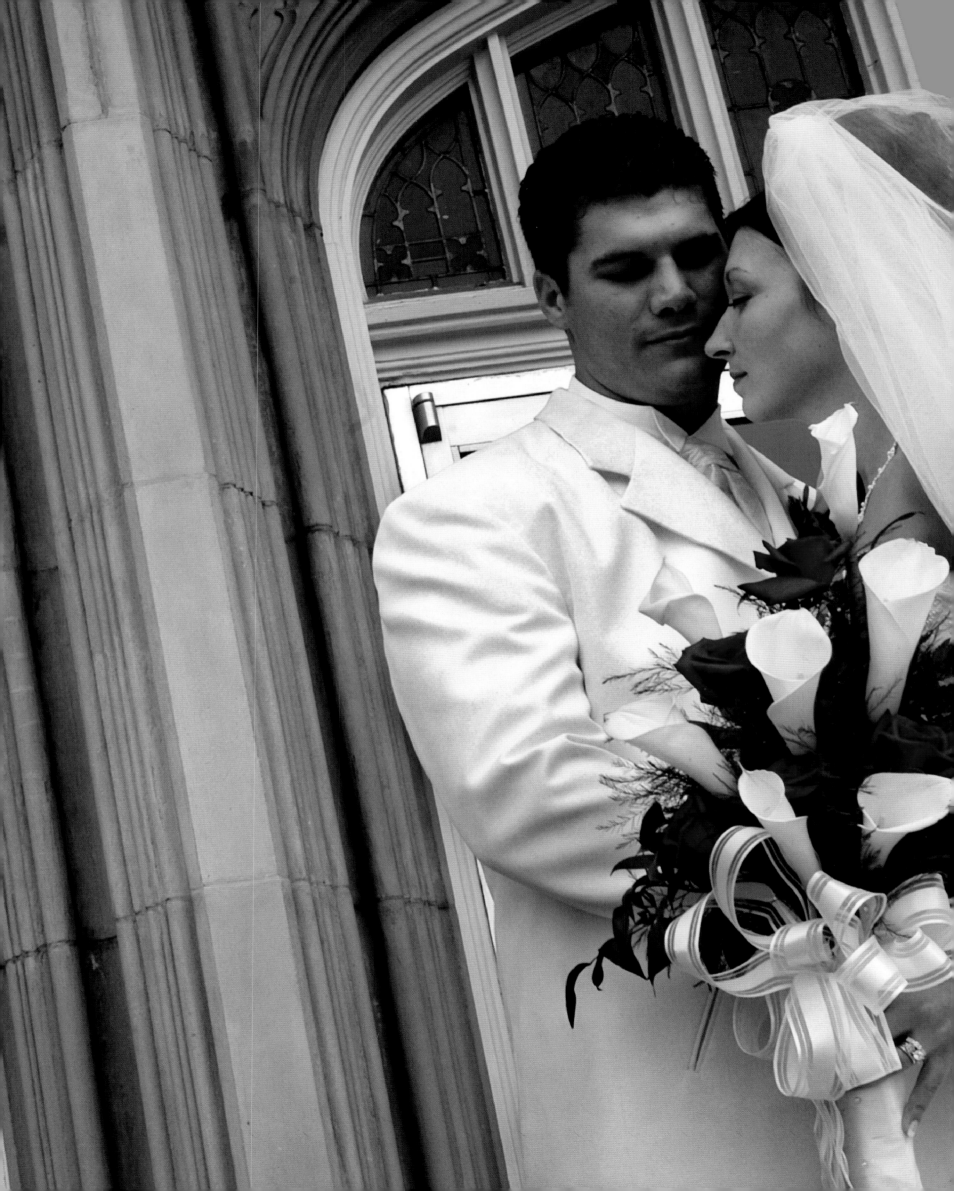

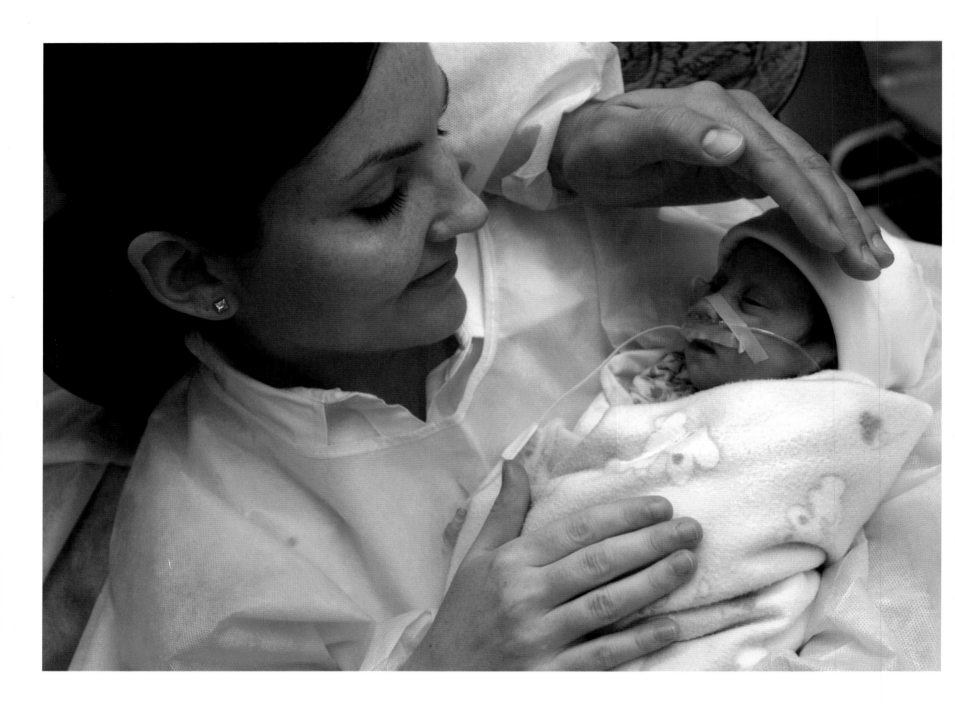

BALTIMORE

On her daily visit to the Johns Hopkins Hospital's Neonatal Intensive Care Unit, Jean Lucas-Gerber holds her newborn daughter McKenzie Gerber. Born two months premature, McKenzie lives in the 36-bed NICU, where nurses will continue to monitor her heartbeat and feed her intravenously until she is stable enough to go home.
Photos by Chiaki Kawajiri

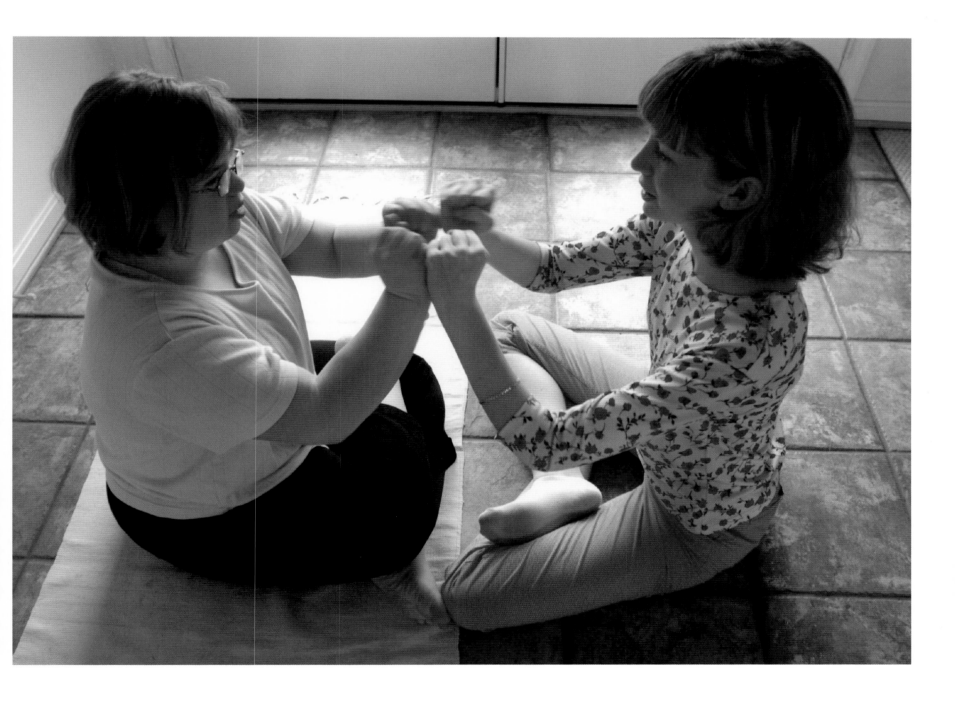

ELLICOTT CITY

Alexis Conover, 13, who has Down's syndrome, and her sister Christine, 15, play "Miss Mary Mack" in their living room. "Alexis couldn't have a better big sister," says their mother. Christine plays basketball and board games with Alexis and helps her to prepare for the Special Olympics. Alexis competes in bowling and swimming.

The year 2003 marked a turning point in the history of photography: It was the first year that digital cameras outsold film cameras. To celebrate this unprecedented sea change, the *America 24/7* project invited amateur photographers—along with students and professionals—to shoot and, via the Internet, submit digital images. Think of it as audience participation. Their visions of community are interspersed with the professional frames throughout this book. On the following four pages, however, we present a gallery produced exclusively by amateur photographers.

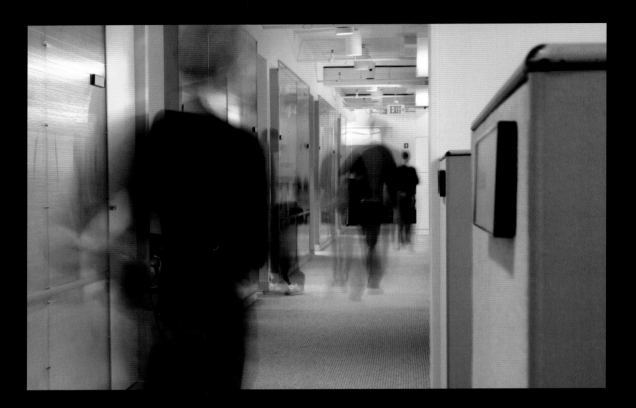

BETHESDA An employee at the CoStar Group, a corporate real estate research company, stares down the hall at the onset of another long day. *Photo by Richard Baillieul*

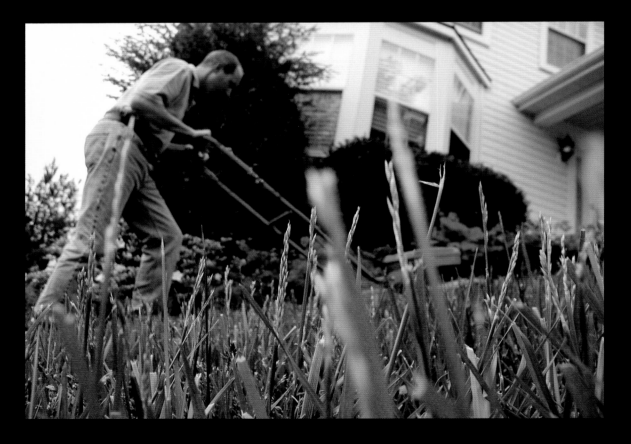

BALTIMORE A self-portrait of weekend lawn-warrior Neil Rothman in the yard of his home northwest of downtown Baltimore. *Photo by Neil Rothman*

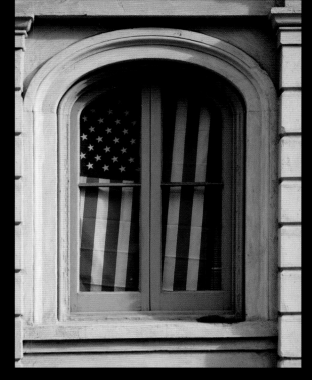

BALTIMORE Two hundred and twenty-seven years after Betsy Ross sewed the original American flag with 13 stars arranged in a circle, the newest version shades a residential window. *Photo by Kenn Macintosh*

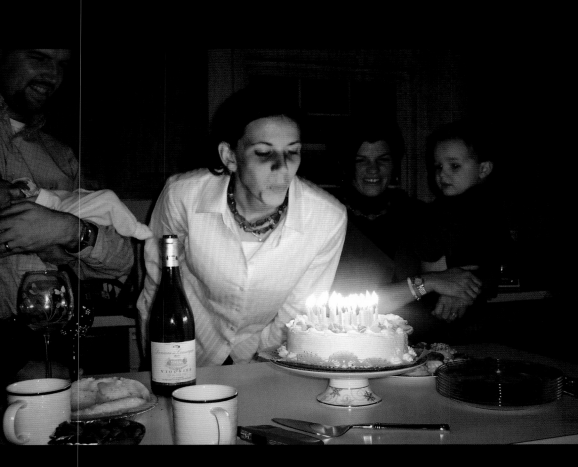

ABINGDON One birthday closer to 30. Jill Fisher blows out 28 candles. The supporting cast: husband Joel holding his niece Holland and sister-in-law Kristin holding her son John. *Photo by Lois Fisher*

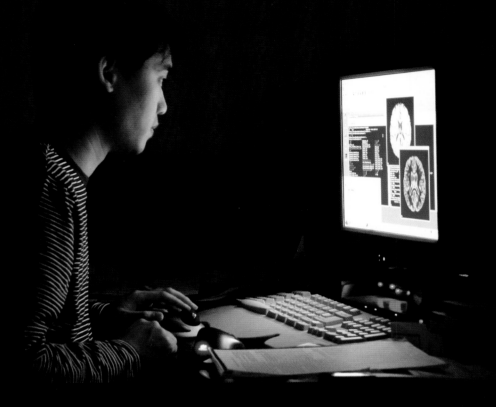

GAITHERSBURG Professor by day, researcher by night: Johns Hopkins University radiology assistant professor Dzung Pham works on a research paper about medical image processing. *Photo by Dzung Pham*

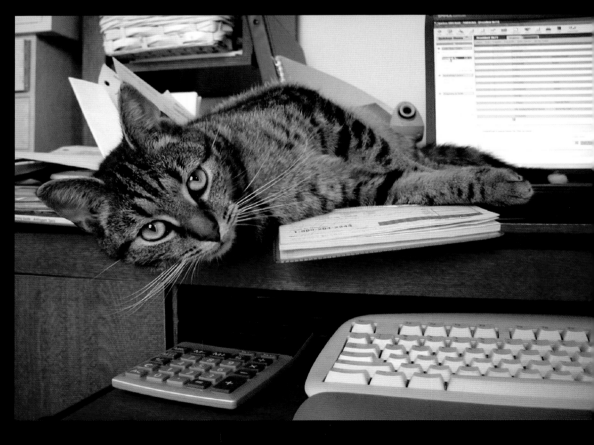

WESTMINSTER Stan the Man does his best to distract owner Mary Lou Jones from working in her home office. *Photo by Mary Lou Jones*

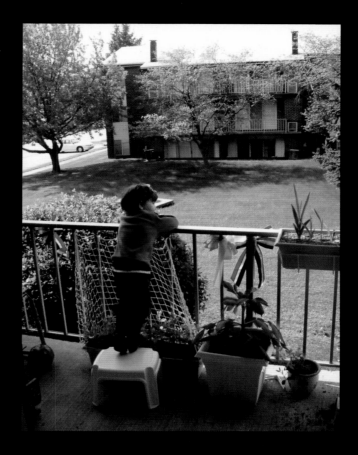

BALTIMORE He considers himself an avid gardener, but Yomi Klaff's mom says it's more of a dirt issue. After helping transplant spring bulbs, Yomi surveys Pickwick Apartments' common green, looking for new dirt-moving possibilities. *Photo by Sari Klaff*

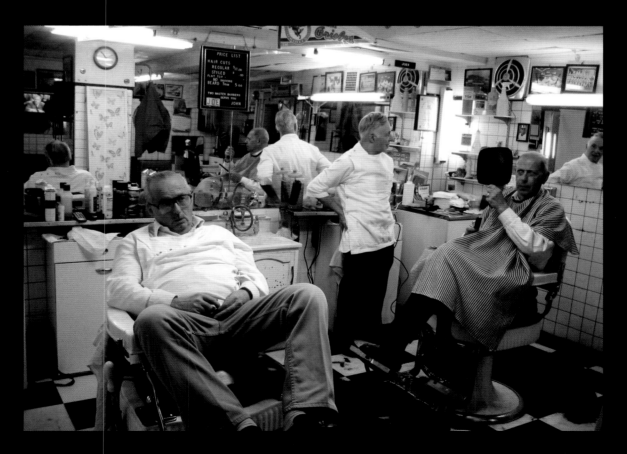

BALTIMORE Barber Joseph Quigley (left) takes a load off between customers at the Marylander Apartments basement barbershop. Partner John Carignano waits for a customer's verdict. *Photo by Harvey Mateo*

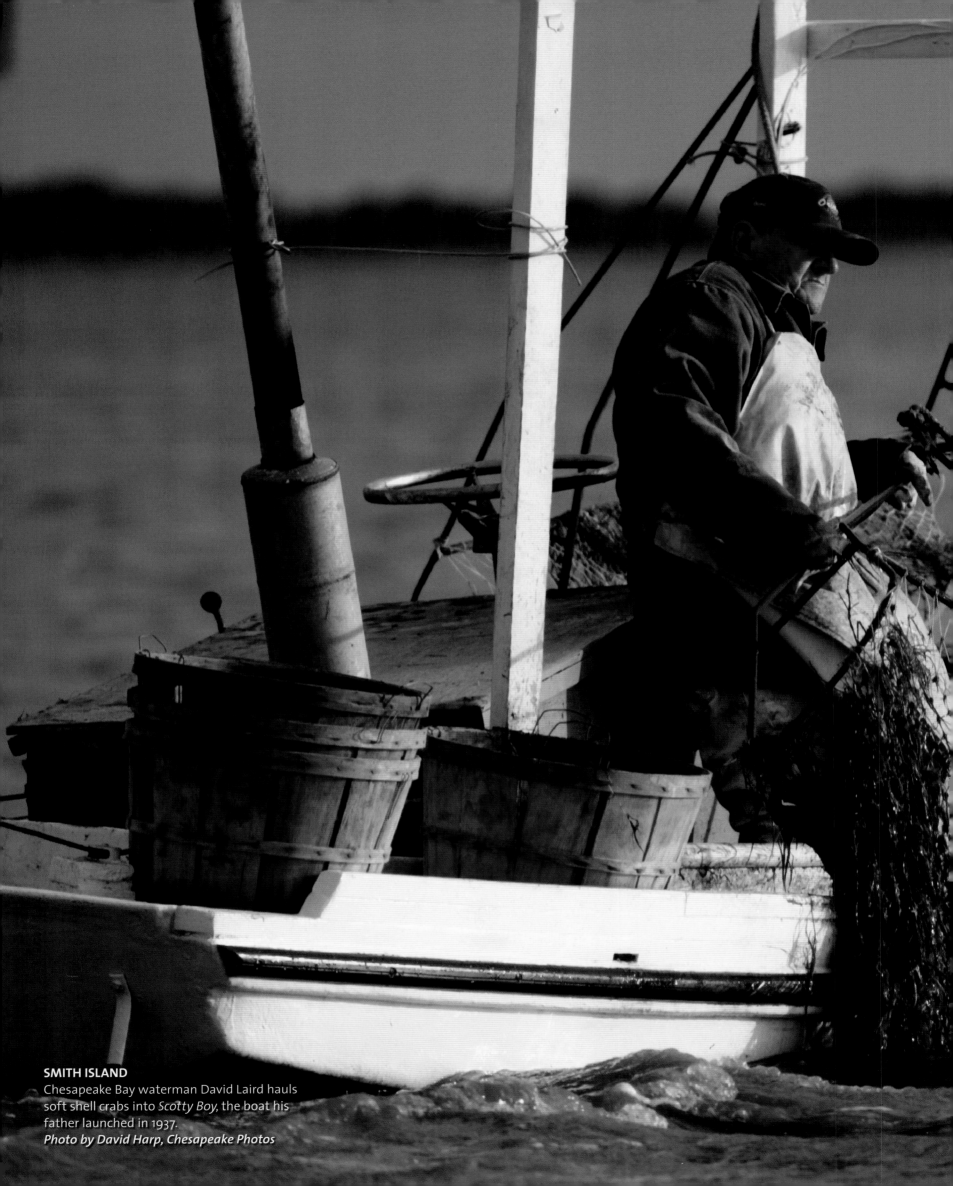

SMITH ISLAND
Chesapeake Bay waterman David Laird hauls
soft shell crabs into *Scotty Boy*, the boat his
father launched in 1937.
Photo by David Harp, Chesapeake Photos

Hard At Work

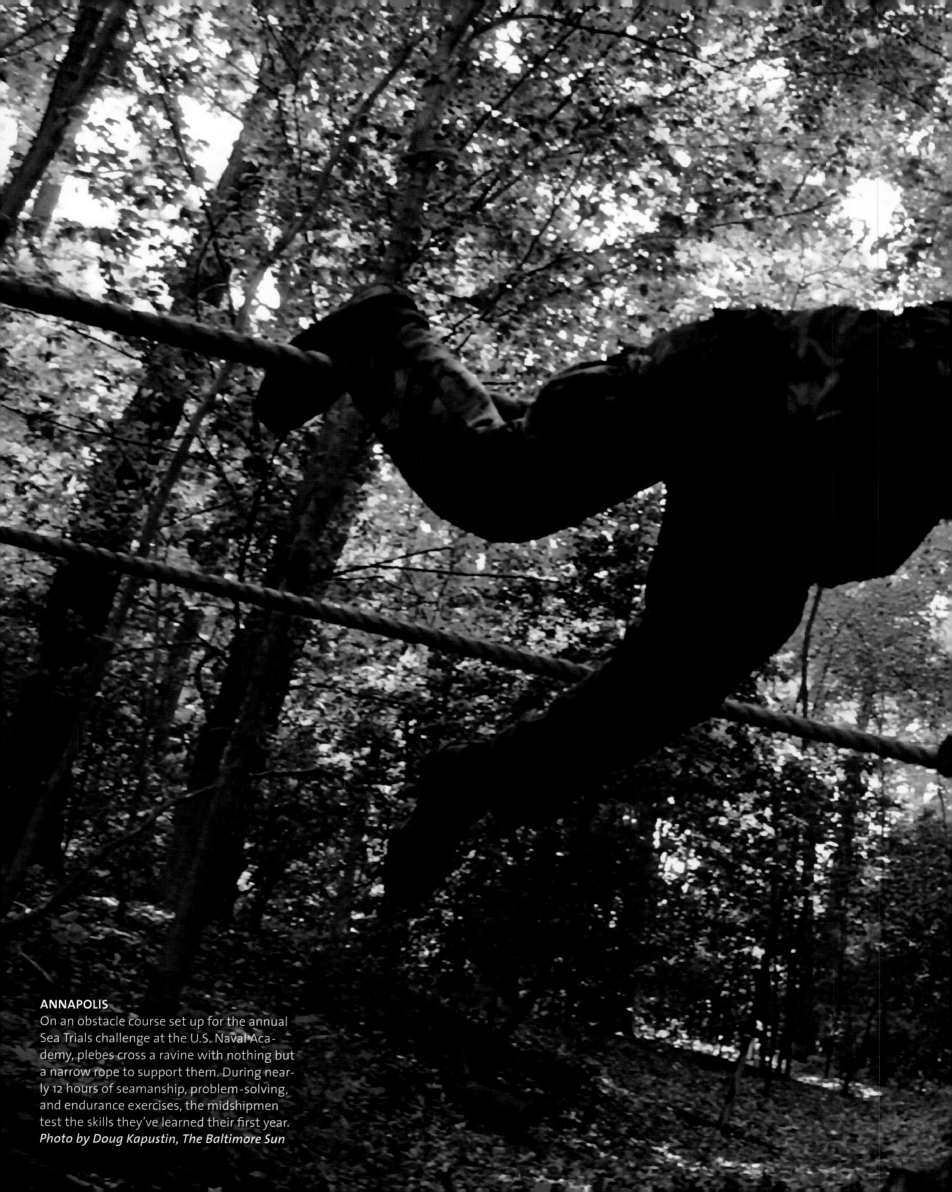

ANNAPOLIS
On an obstacle course set up for the annual Sea Trials challenge at the U.S. Naval Academy, plebes cross a ravine with nothing but a narrow rope to support them. During nearly 12 hours of seamanship, problem-solving, and endurance exercises, the midshipmen test the skills they've learned their first year.
Photo by Doug Kapustin, The Baltimore Sun

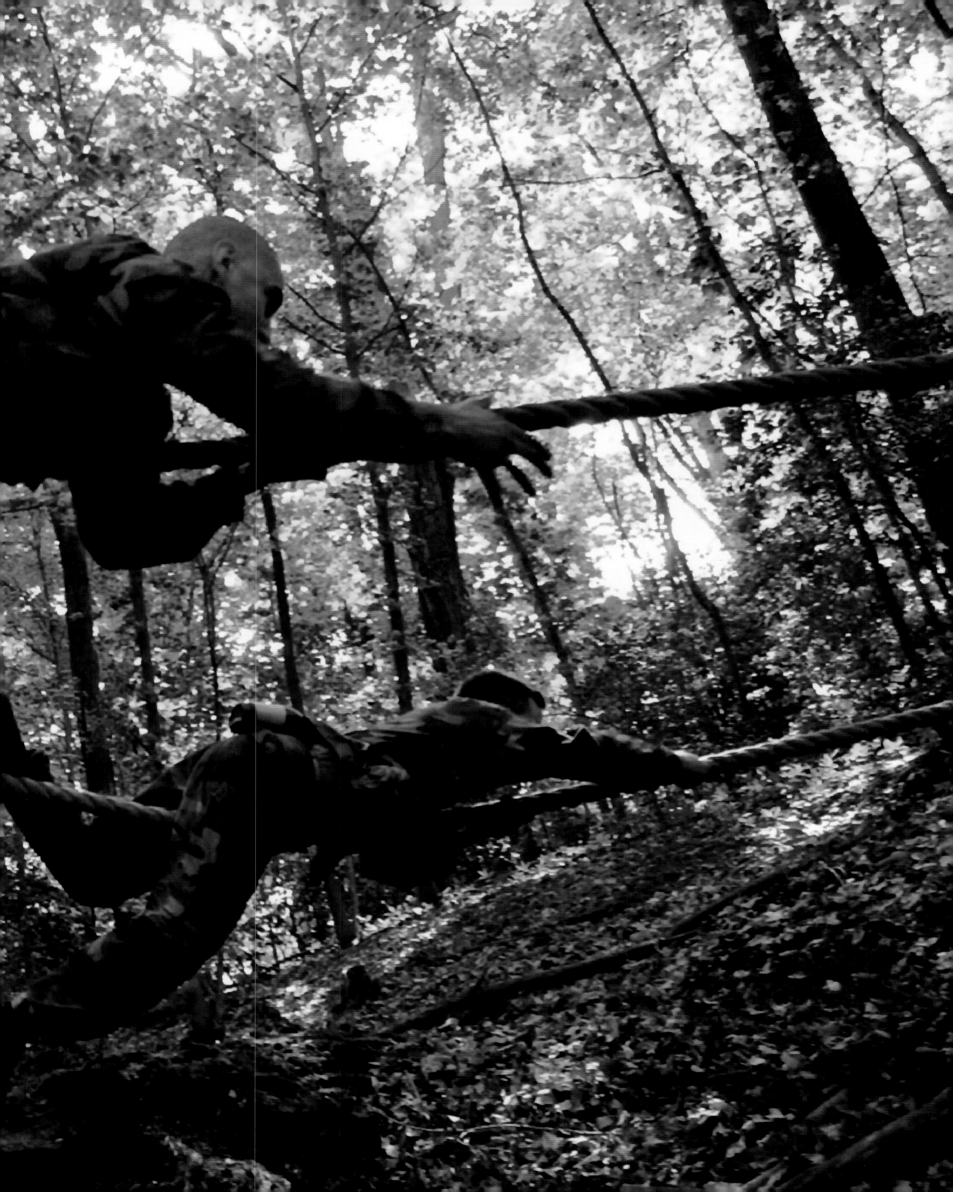

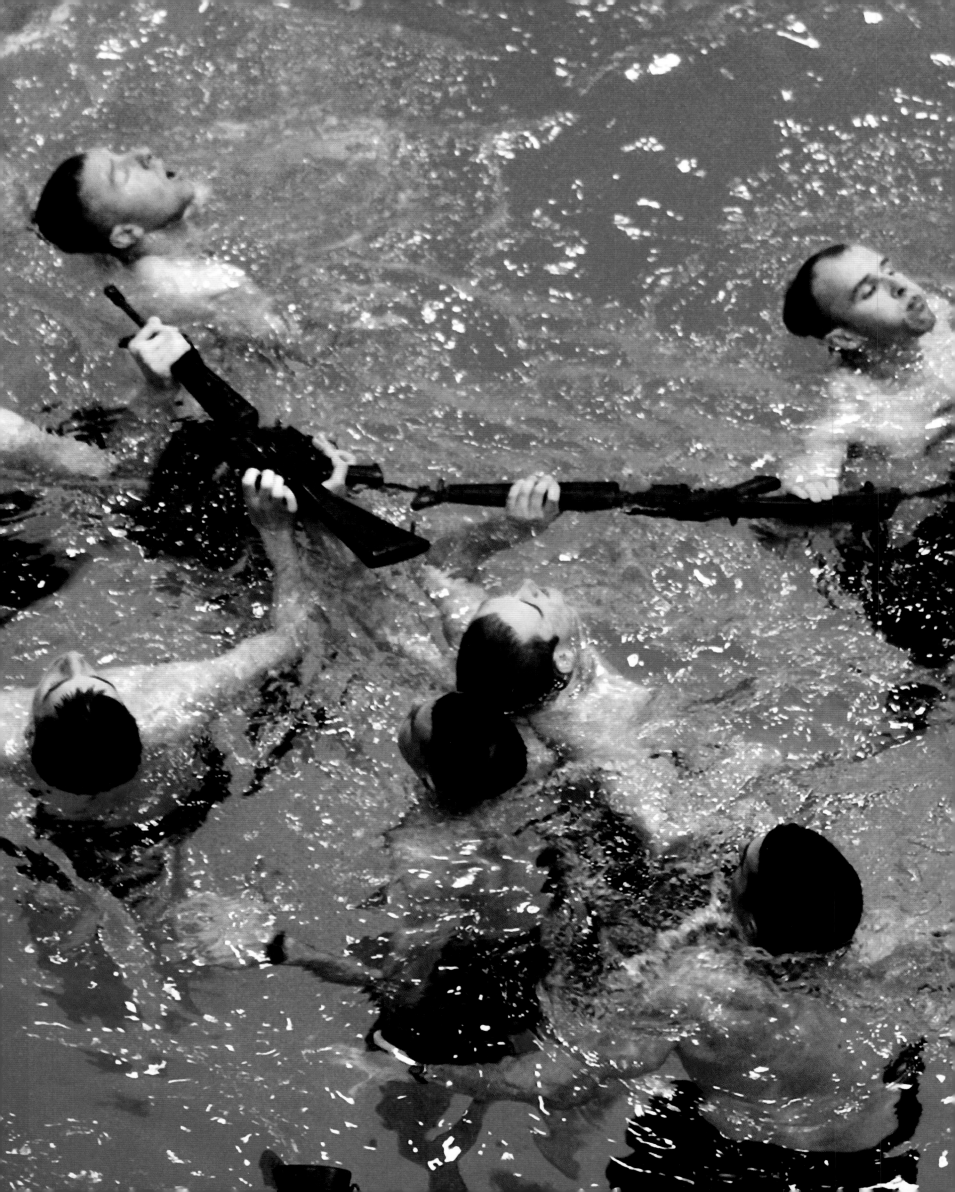

ANNAPOLIS

For the aquatic phase of the U.S. Naval Academy's Sea Trials, plebes have to keep their heads—and their rifles—above water.
Photos by Doug Kapustin, The Baltimore Sun

ANNAPOLIS

Mud bath: A cadet who had successfully swung across the muck pit gets pulled into it by a classmate who didn't.

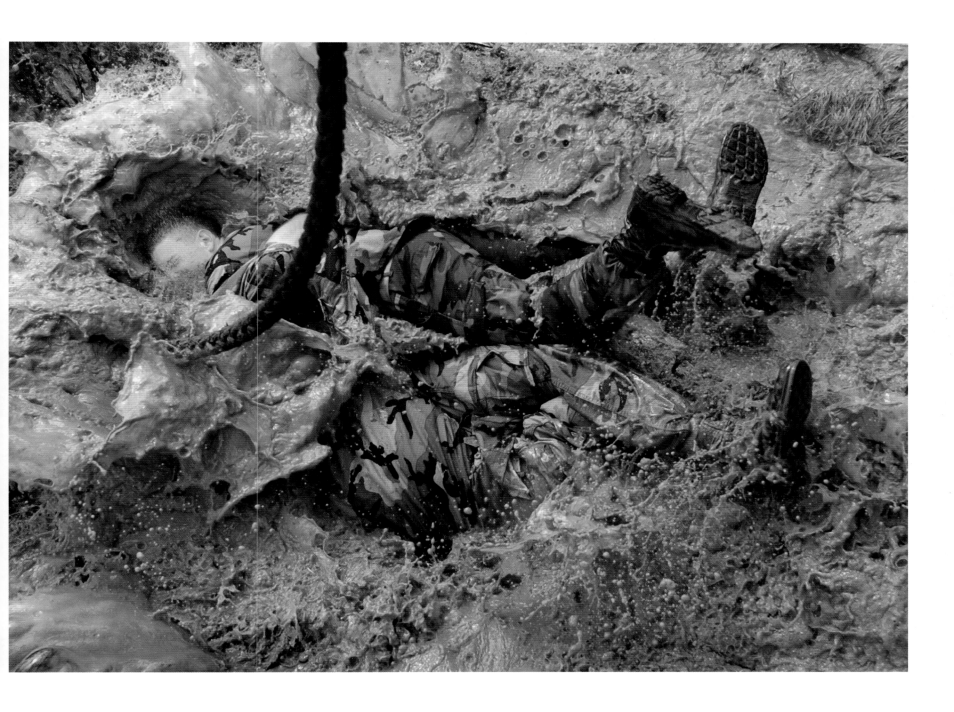

GORTNER

In the far western corner of Maryland, a buggy trundles across Pleasant Valley, settled by a clan of German Amish in the 1850s to avoid military conscription. There are more than 90 distinguishable types of Amish buggies. They can be white and yellow, or black and grey. Their speed is more limited, with the average buggy ride rarely exceeding 8 mph.

Photos by Jerry Jackson

GORTNER

Samuel Yoder installs a solar-powered electrical fence to discourage his cattle if they ever try to bust out of their pasture. While many Amish in the Pleasant Valley have hooked up to the power grid, Yoder maintains his people's traditional ways and lives without relying on Allegheny Power for electricity.

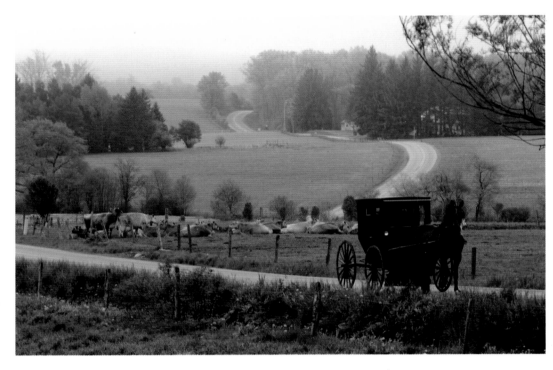

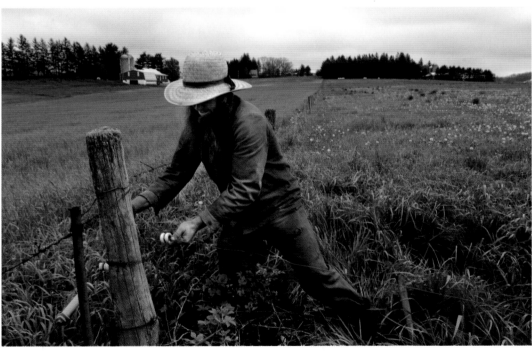

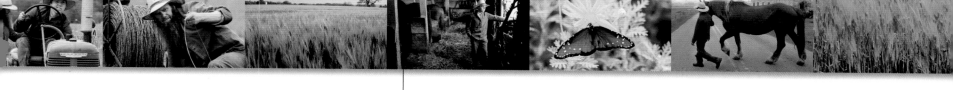

GORTNER

Young Sam Yoder, in mid-chore, gazes out the stable window. The horses are so well trained that all Sam has to do to get them watered is to let them out of the stalls, one at a time, and wait for each to come back from the barn's trough.

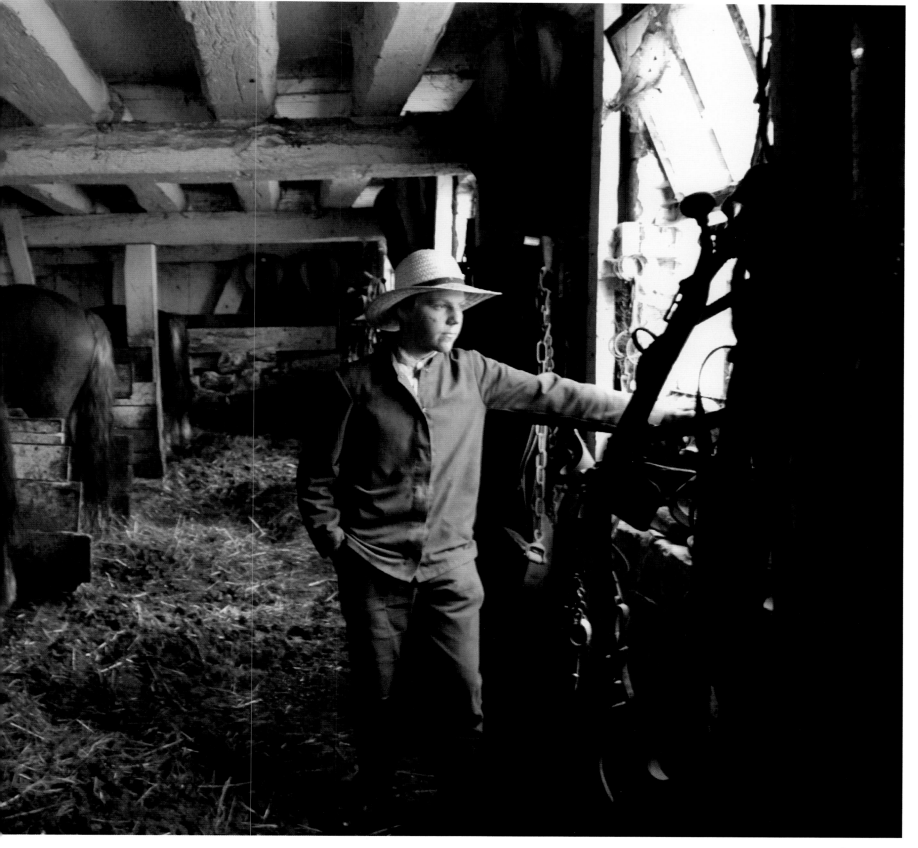

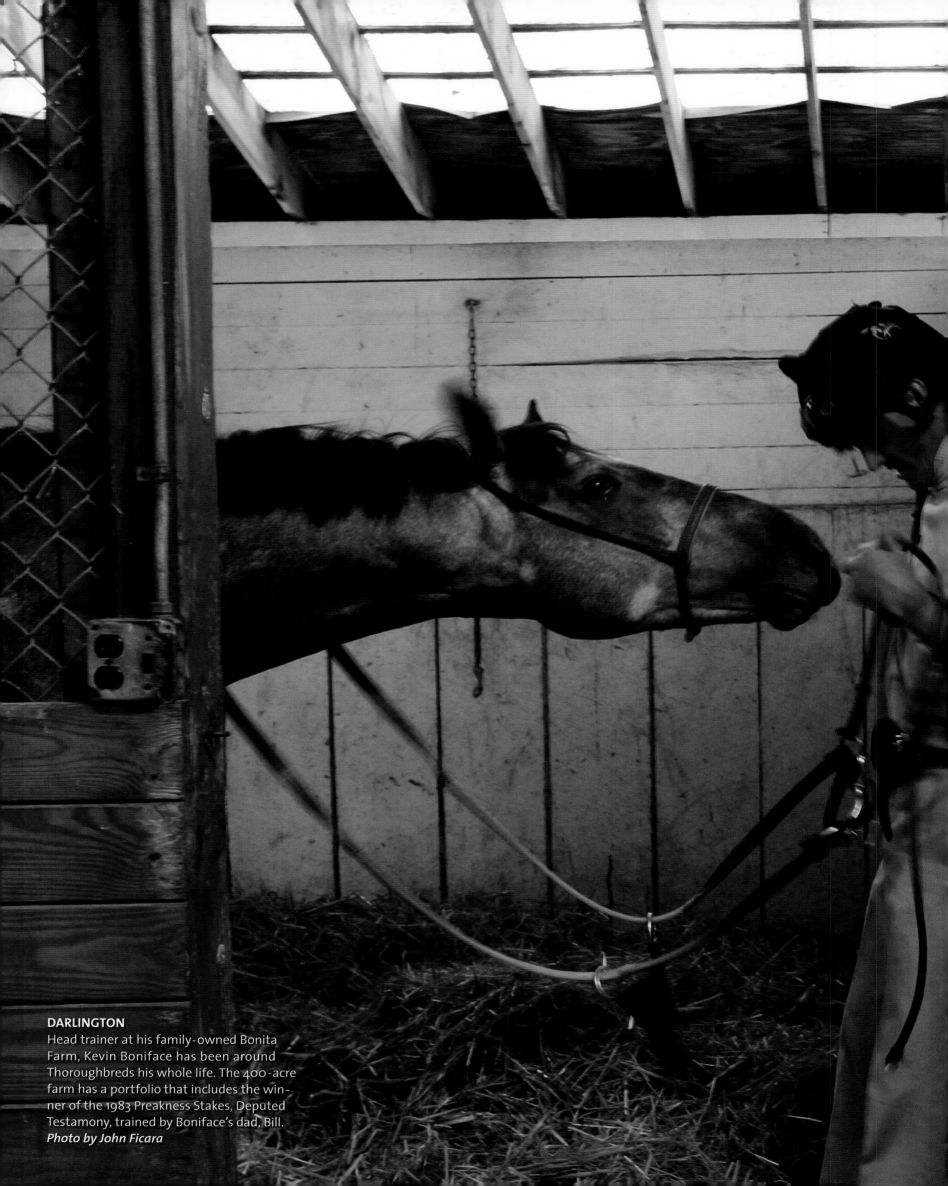

DARLINGTON
Head trainer at his family-owned Bonita Farm, Kevin Boniface has been around Thoroughbreds his whole life. The 400-acre farm has a portfolio that includes the winner of the 1983 Preakness Stakes, Deputed Testamony, trained by Boniface's dad, Bill.
Photo by John Ficara

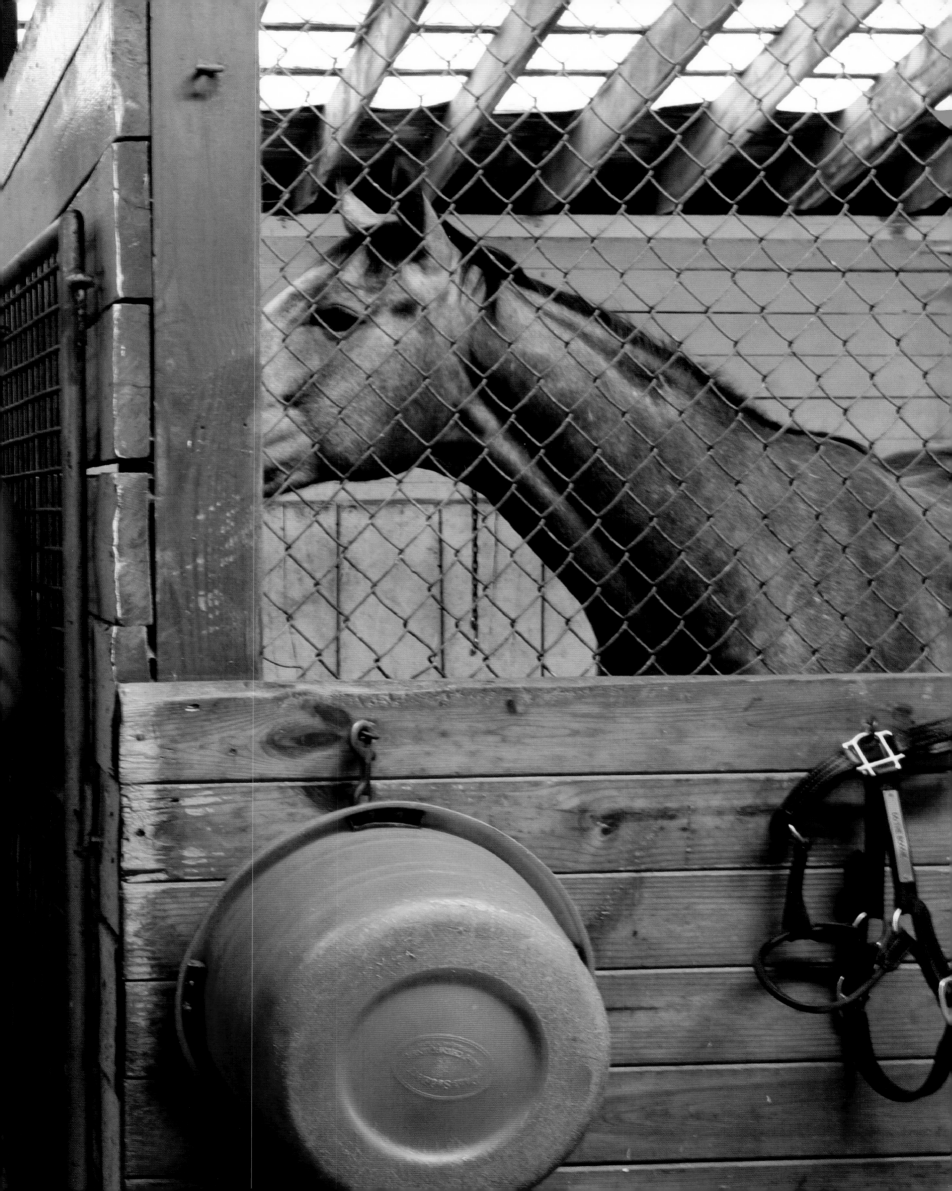

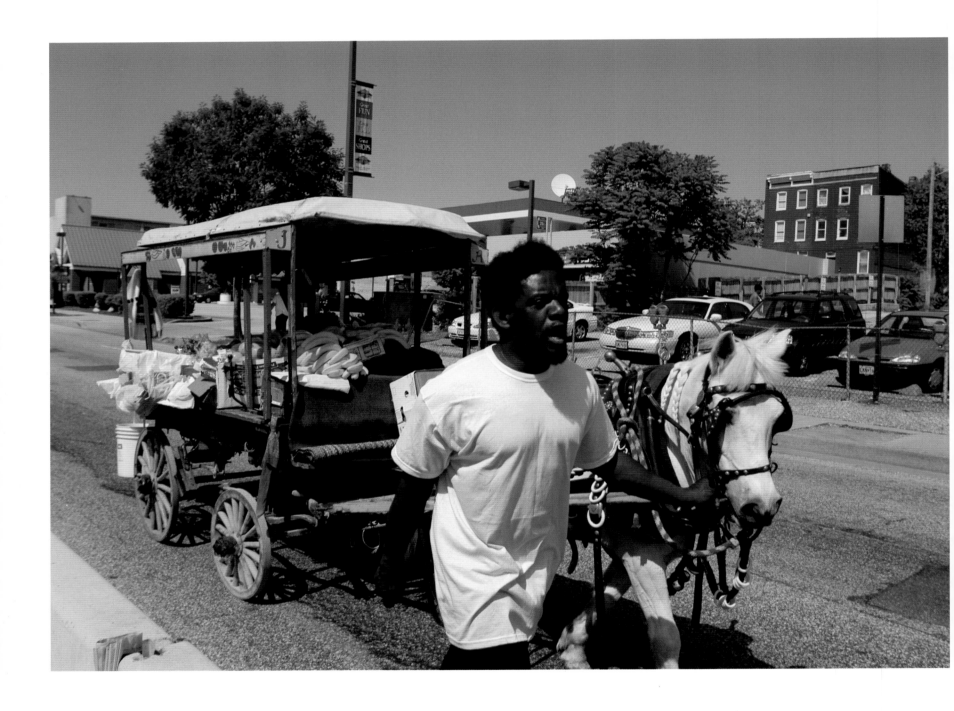

BALTIMORE

They're called "Arabbers," Baltimore's traditional street vendors (like Ricky) who sell fresh produce and other goods from horse-drawn carts. The door-to-door style of doing business is dying out, subject to the forces of urban renewal and increasing regulation and restrictions.
Photos by Gunes Kocatepe

BALTIMORE
The Pitcher Street Stable in West Baltimore is one of the three left that support Arabbers. Hundreds of stables once fielded the entrepreneurs.

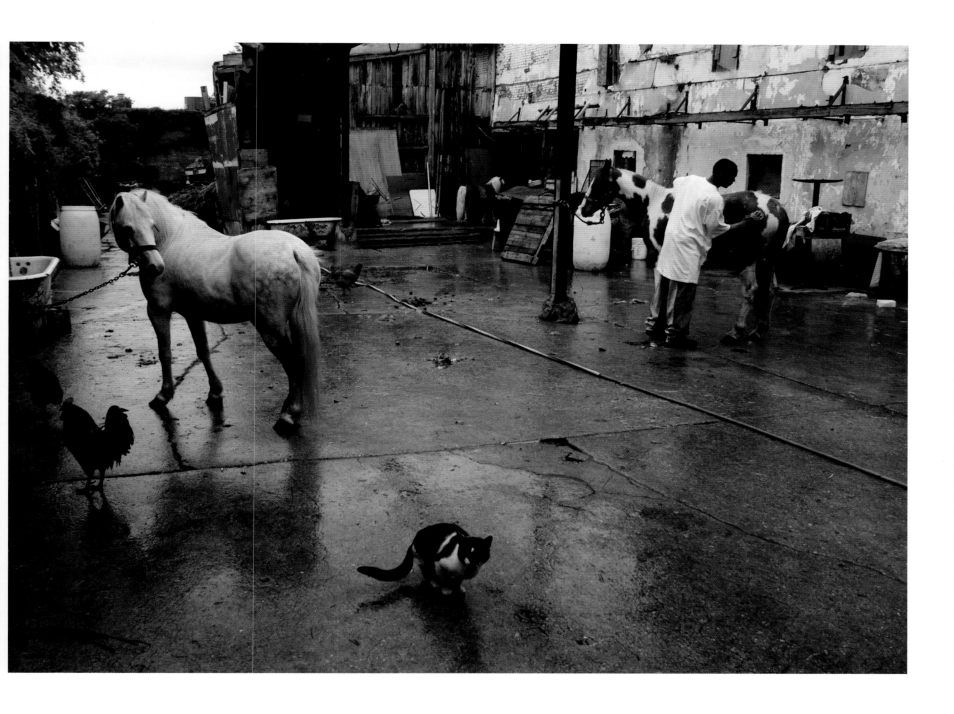

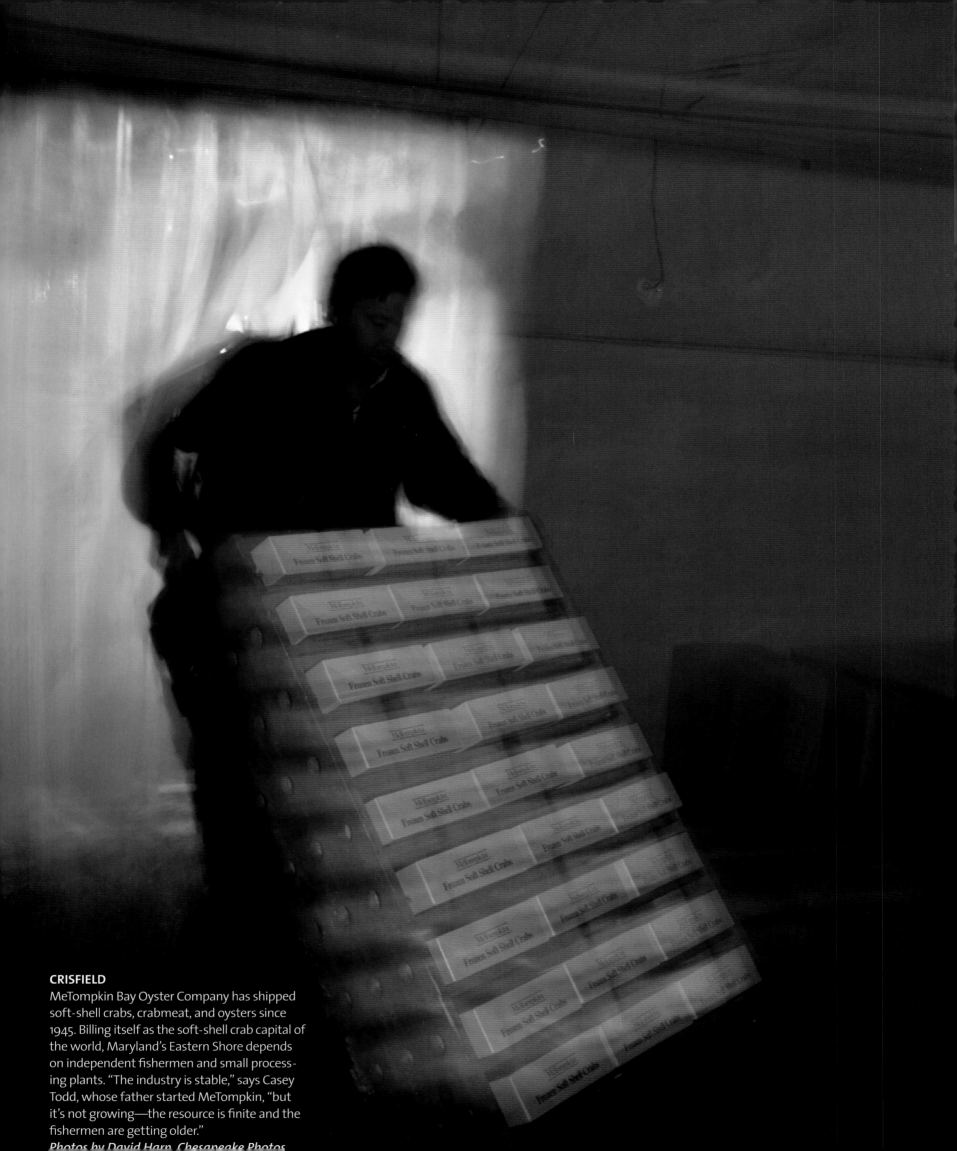

CRISFIELD
MeTompkin Bay Oyster Company has shipped soft-shell crabs, crabmeat, and oysters since 1945. Billing itself as the soft-shell crab capital of the world, Maryland's Eastern Shore depends on independent fishermen and small processing plants. "The industry is stable," says Casey Todd, whose father started MeTompkin, "but it's not growing—the resource is finite and the fishermen are getting older."

Photos by David Harp, Chesapeake Photos

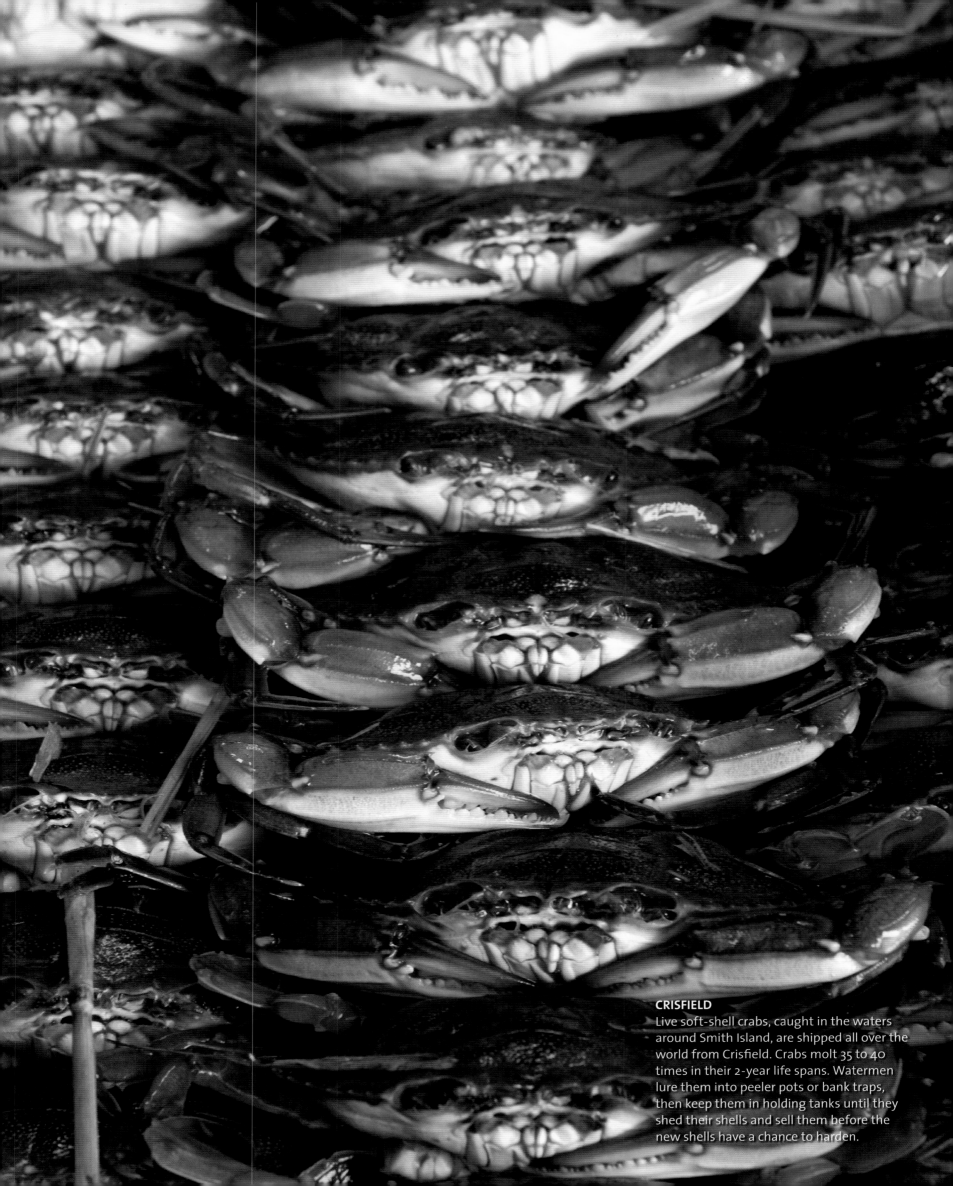

CRISFIELD

Live soft-shell crabs, caught in the waters around Smith Island, are shipped all over the world from Crisfield. Crabs molt 35 to 40 times in their 2-year life spans. Watermen lure them into peeler pots or bank traps, then keep them in holding tanks until they shed their shells and sell them before the new shells have a chance to harden.

BALTIMORE
Submarine dream team: Chef John Mandato of the Pikesville Hilton, Jason McNamara, a cook at Turf Valley Country Club, and John Wooley, a chef instructor at Baltimore International College, collaborate on a 5-foot soft-shell crab sub at Pimlico Race Course on the day of the Preakness Stakes.
Photo by Jim Preston, The Baltimore Sun

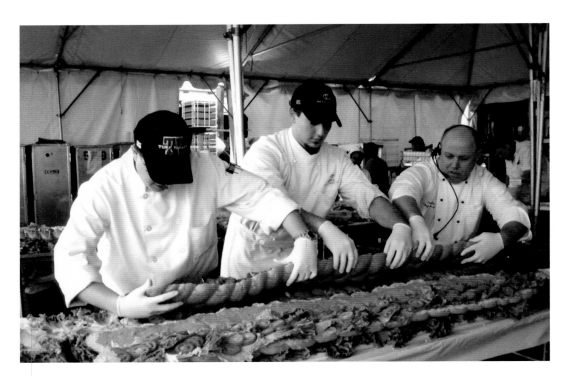

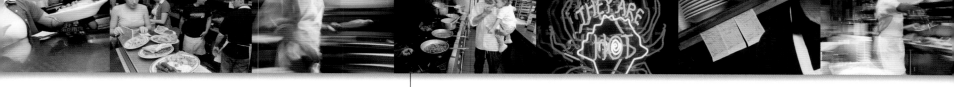

BALTIMORE
Who needs baby food when your dad's the chef at Café di Roma? Not Valentina Iazzetti, that's for sure. Papa Antonio is also the pastry chef. His specialty? "Name it and I will love to make it," says the Milan native.
Photo by James W. Prichard

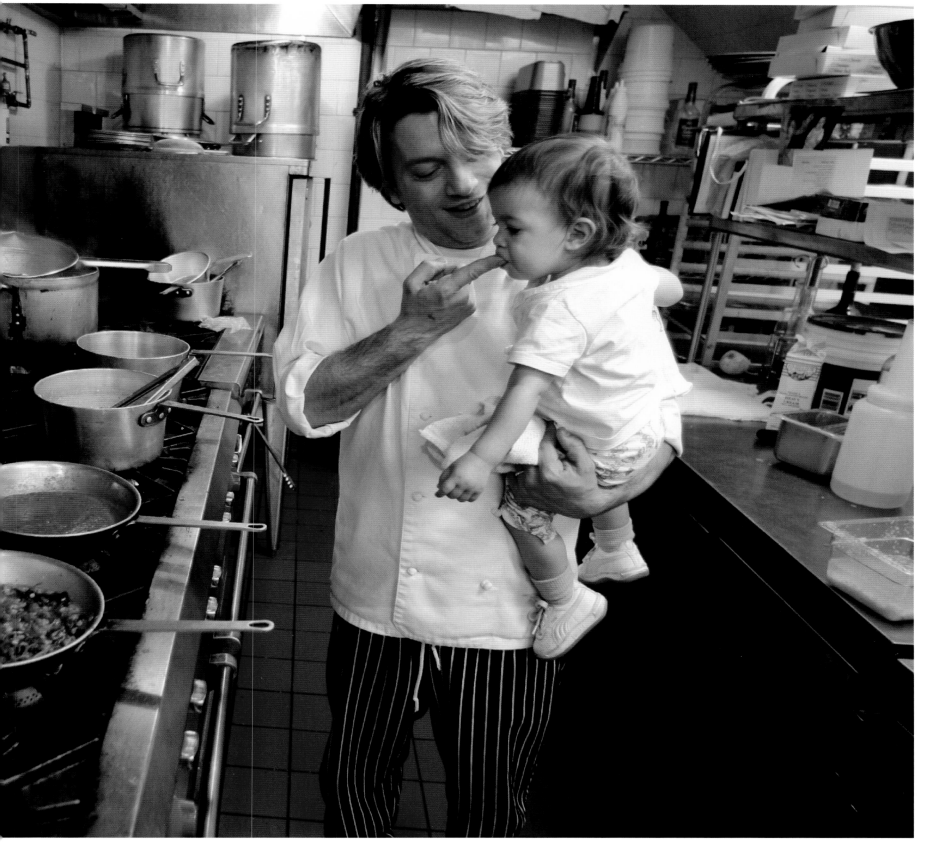

FREELAND

In 2002, Lori and Lester Hess (left) bought the Wright general store building (circa 1877) on White Hall Road. Since then, the couple, a nurse and a contractor, have gutted and renovated the old landmark and moved in, but there's still a lot of work to do.

Photo by Jim Preston, The Baltimore Sun

BALTIMORE
At Gennuso's unisex barbershop, kids like Daniel Jackson get a lollipop for sitting still. In business in the Anneslie neighborhood since 1975, barber Charles Gennuso keeps customers for a lifetime.
Photo by Karen Jackson

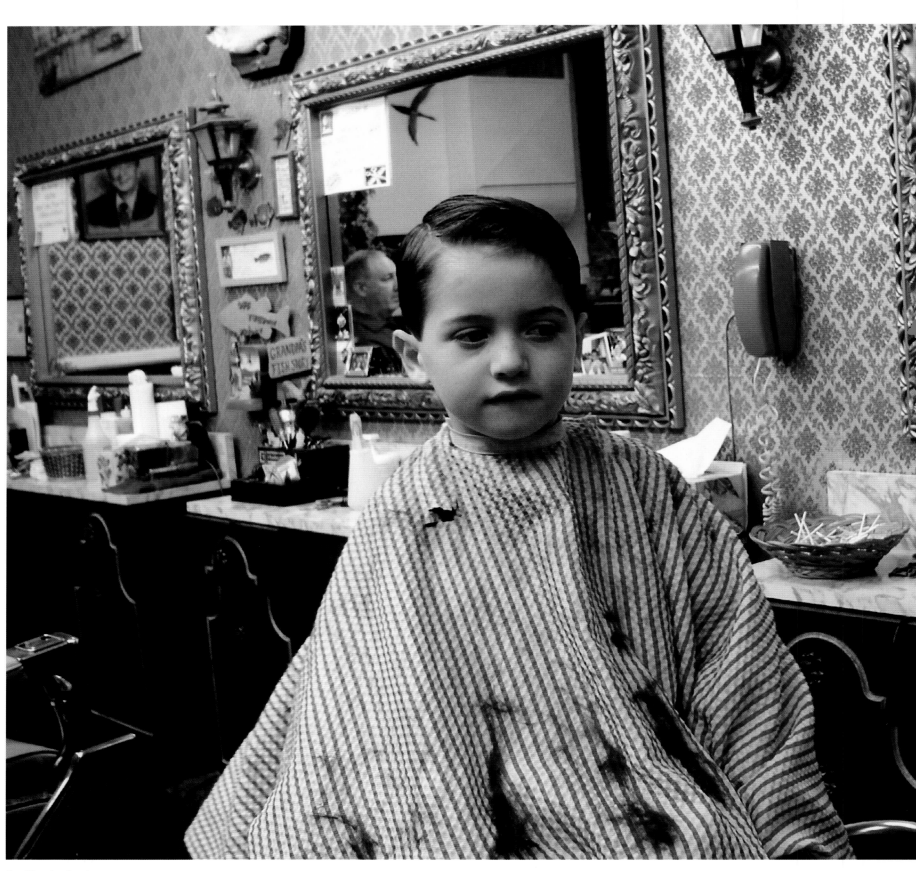

BALTIMORE

Pure confection: Sharon Lynn Martin's coiffure might have been spun from sugar. "I don't have the time or patience to fool with it," says Martin, who sees Darlene at Phyllis' Hair Design on Conklin Street every two weeks. "I do my own eyes, though."

Photo by Jim Burger

BALTIMORE

Women will do almost anything to look good, including dyeing, teasing, and spraying their hair into submission. Evelyn Bartkowiak goes to Nina Rund at Phyllis' for "the masterpiece," as she calls it, and she isn't alone. The salon is packed from 6 a.m. to 6 p.m. six days a week.

Photo by Jim Burger

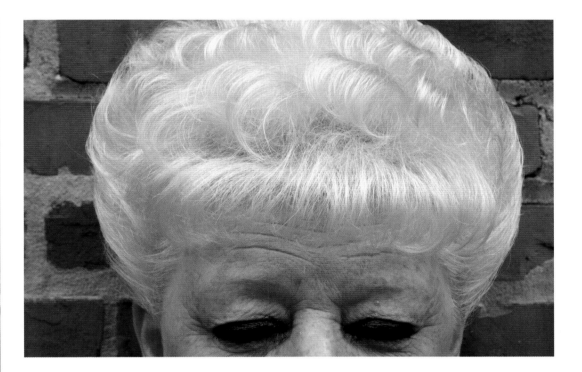

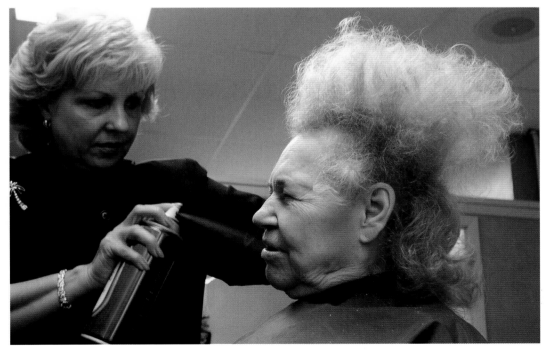

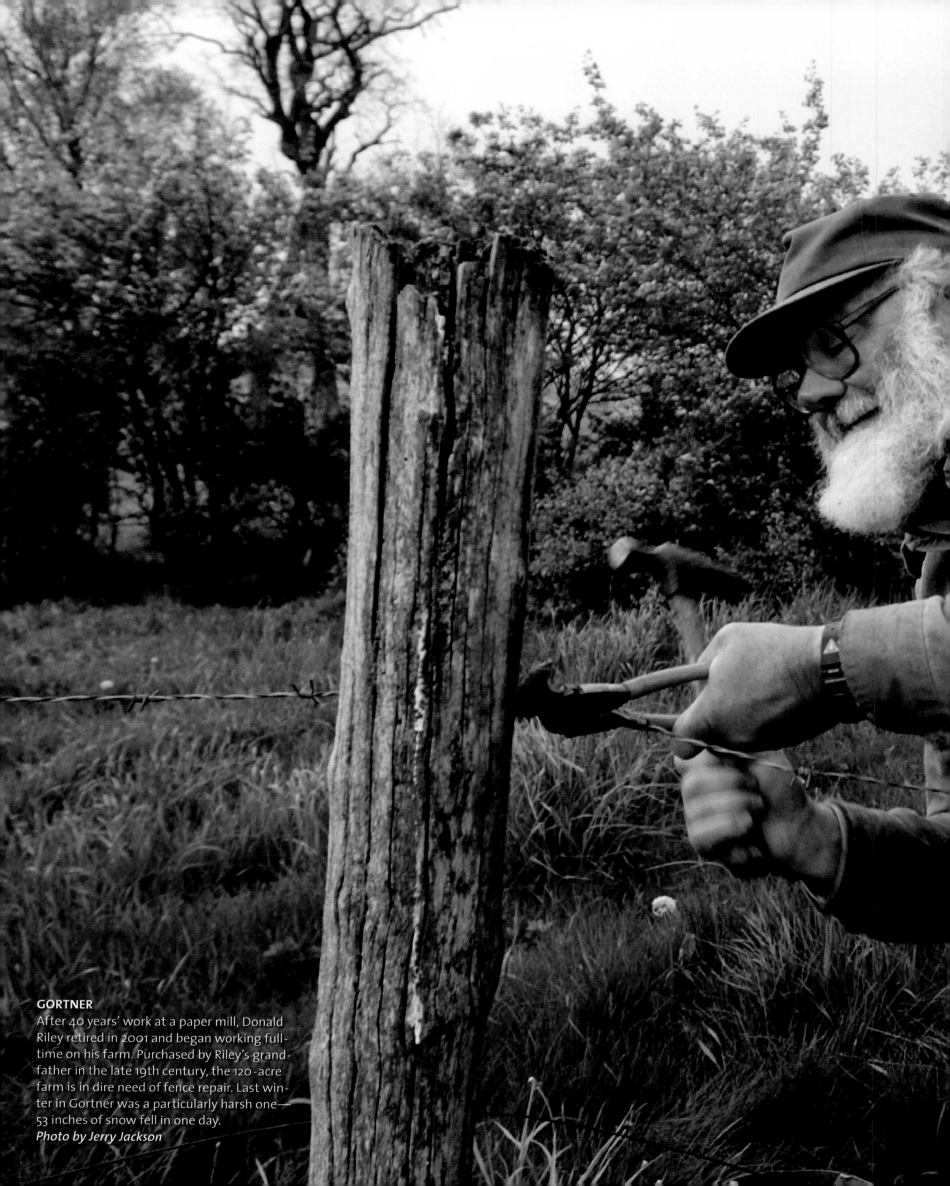

GORTNER
After 40 years' work at a paper mill, Donald Riley retired in 2001 and began working full-time on his farm. Purchased by Riley's grandfather in the late 19th century, the 120-acre farm is in dire need of fence repair. Last winter in Gortner was a particularly harsh one—53 inches of snow fell in one day.
Photo by Jerry Jackson

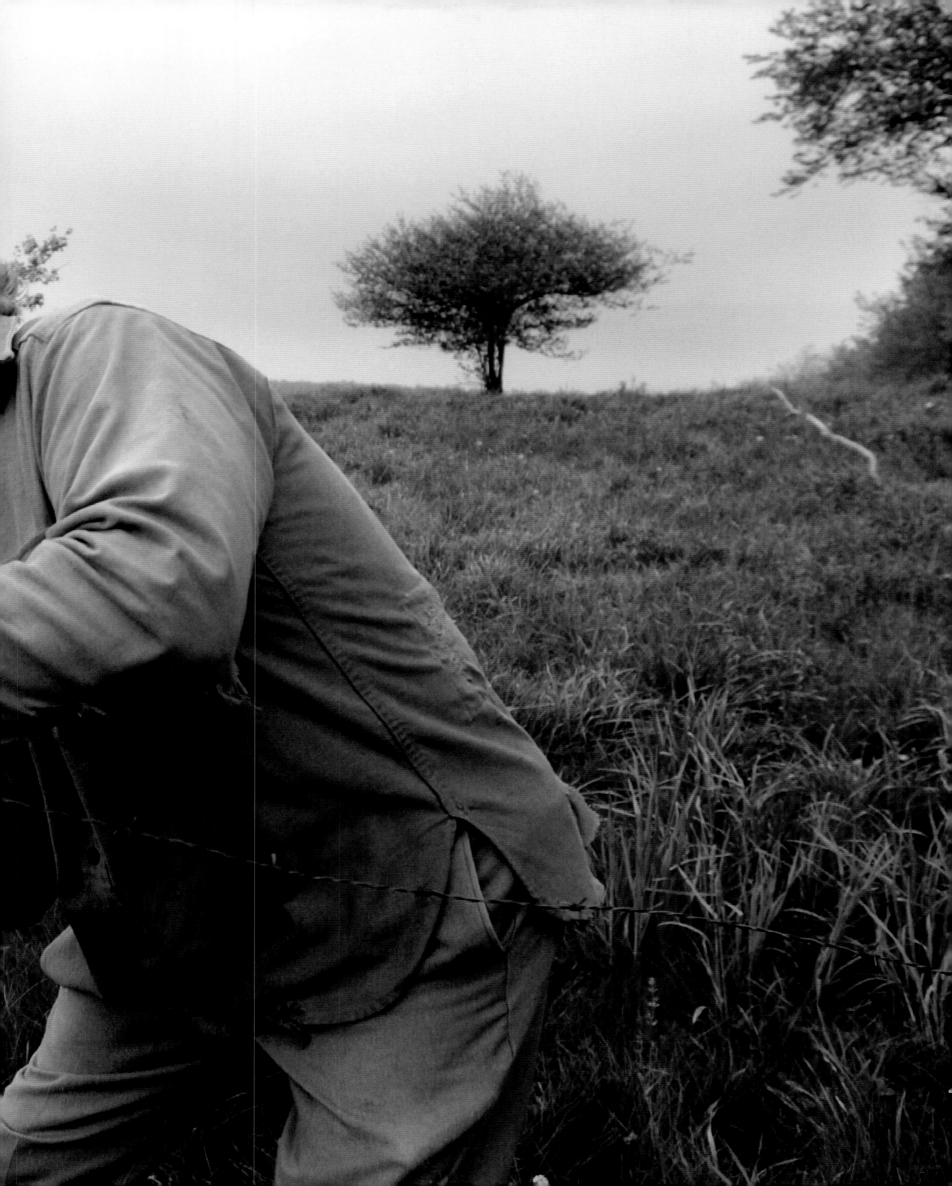

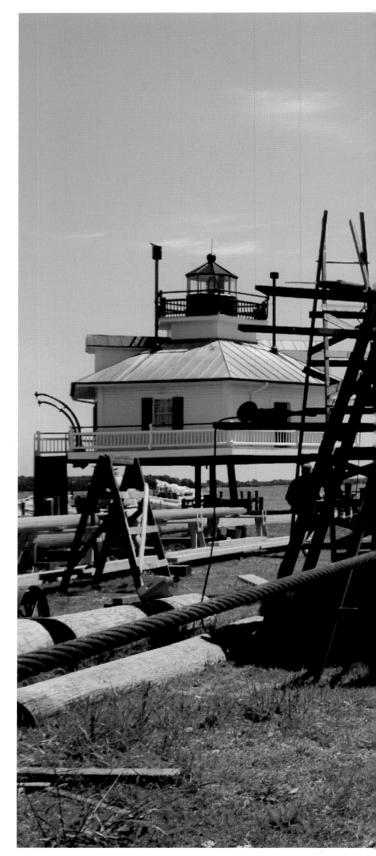

ANNAPOLIS

Montana native Marion Warren, 83, bought his first 4x5 Speed Graphic camera in St. Louis in 1939. Over the years, he's made pictures for the U.S. Navy, served as Maryland's official photographer, and done groundbreaking work in architectural photography. His black-and-white coverage of Chesapeake Bay, which documents its critical condition, began in 1984.

Photo by Rick Kozak, kofoto

SMITH ISLAND

The lure of island life on Chesapeake Bay brought artist Reuben Becker to the fishing hamlet of Ewell on Smith Island 30 years ago. Having given up his career as a dental technician, Becker lives frugally in order to make art full-time. He often paints on scrounged doors—canvas is scarce on the Island, where everything is brought in on the twice-a-day mailboat.

Photo by David Harp, Chesapeake Photos

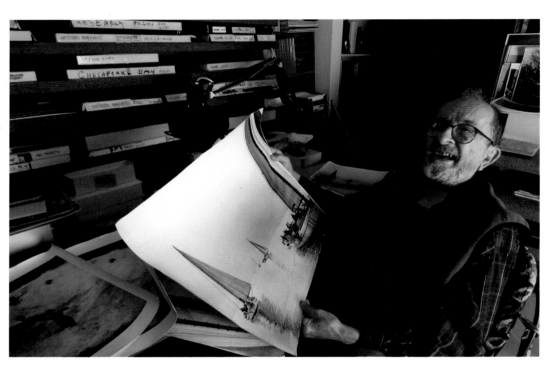

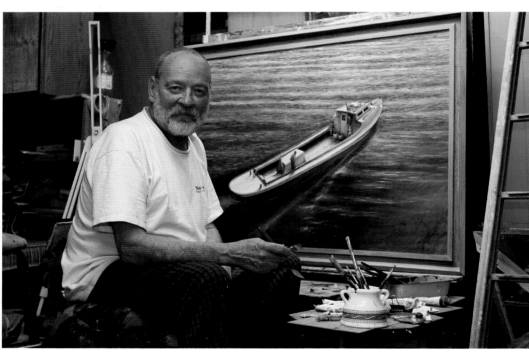

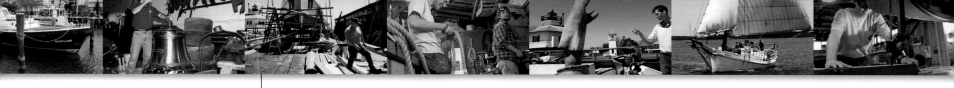

ST. MICHAELS

At the shipyard of the Chesapeake Bay Maritime Museum, boat builders Jerry Pruitt, Lonnie Moore, and Charles Bradshaw (front) work on Pruitt's 1949 buyboat, the *Delvin K*. Buyboats meet oyster-dredging skipjacks on the water and shuttle the catch to market, allowing the sail-powered boats to continue their scouring.

Photo by Shannon Bishop

OCEAN CITY

A 13-foot tiger shark replica on display outside the Life-Saving Station Museum turns heads on the boardwalk. The actual 1,210-pound shark was landed 27 miles off Ocean City beach in 1983 by Grace Czerniak of Buffalo, New York.

Photo by Gunes Kocatepe

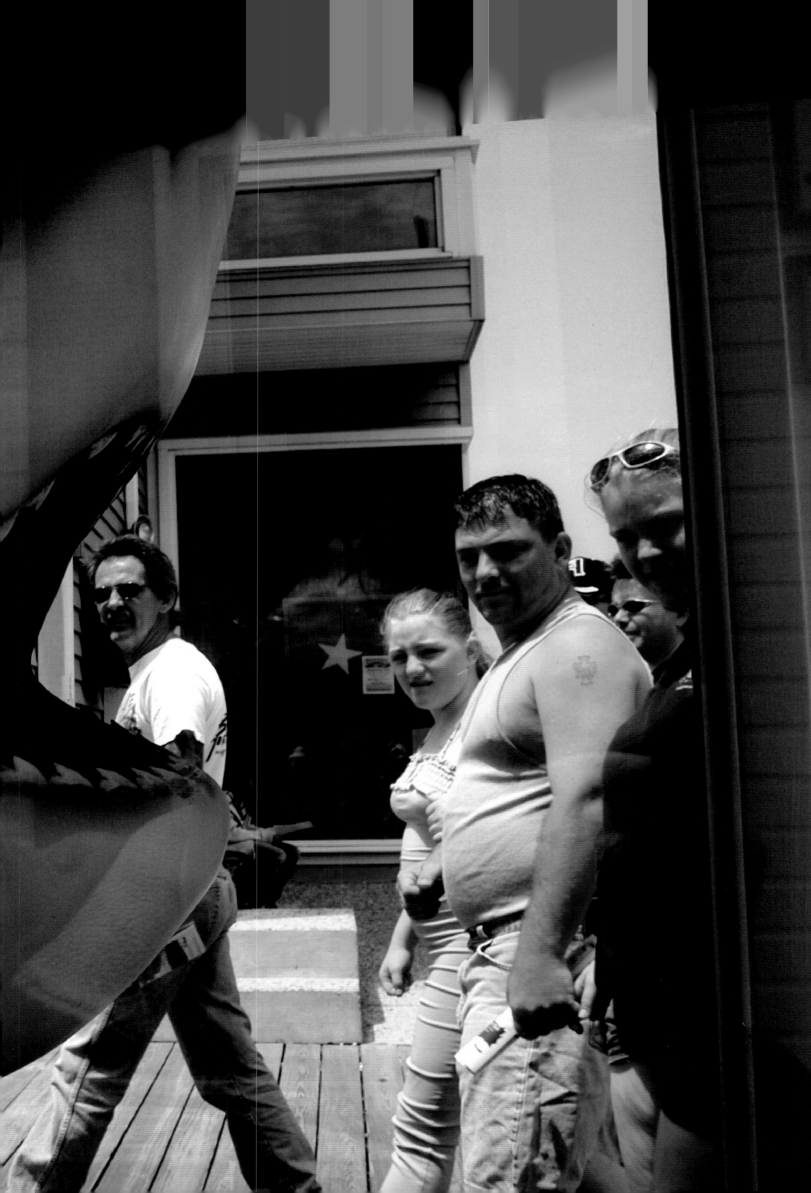

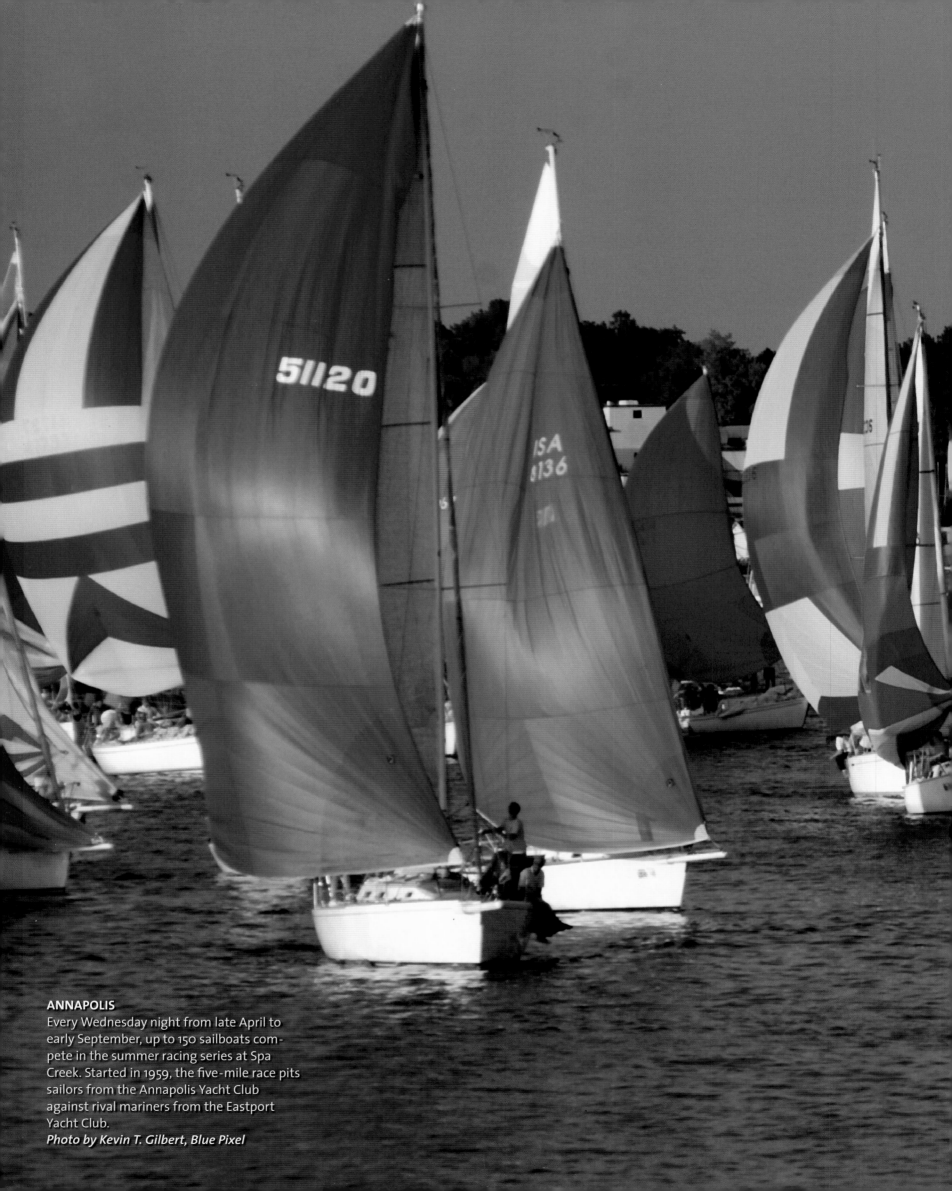

ANNAPOLIS
Every Wednesday night from late April to early September, up to 150 sailboats compete in the summer racing series at Spa Creek. Started in 1959, the five-mile race pits sailors from the Annapolis Yacht Club against rival mariners from the Eastport Yacht Club.
Photo by Kevin T. Gilbert, Blue Pixel

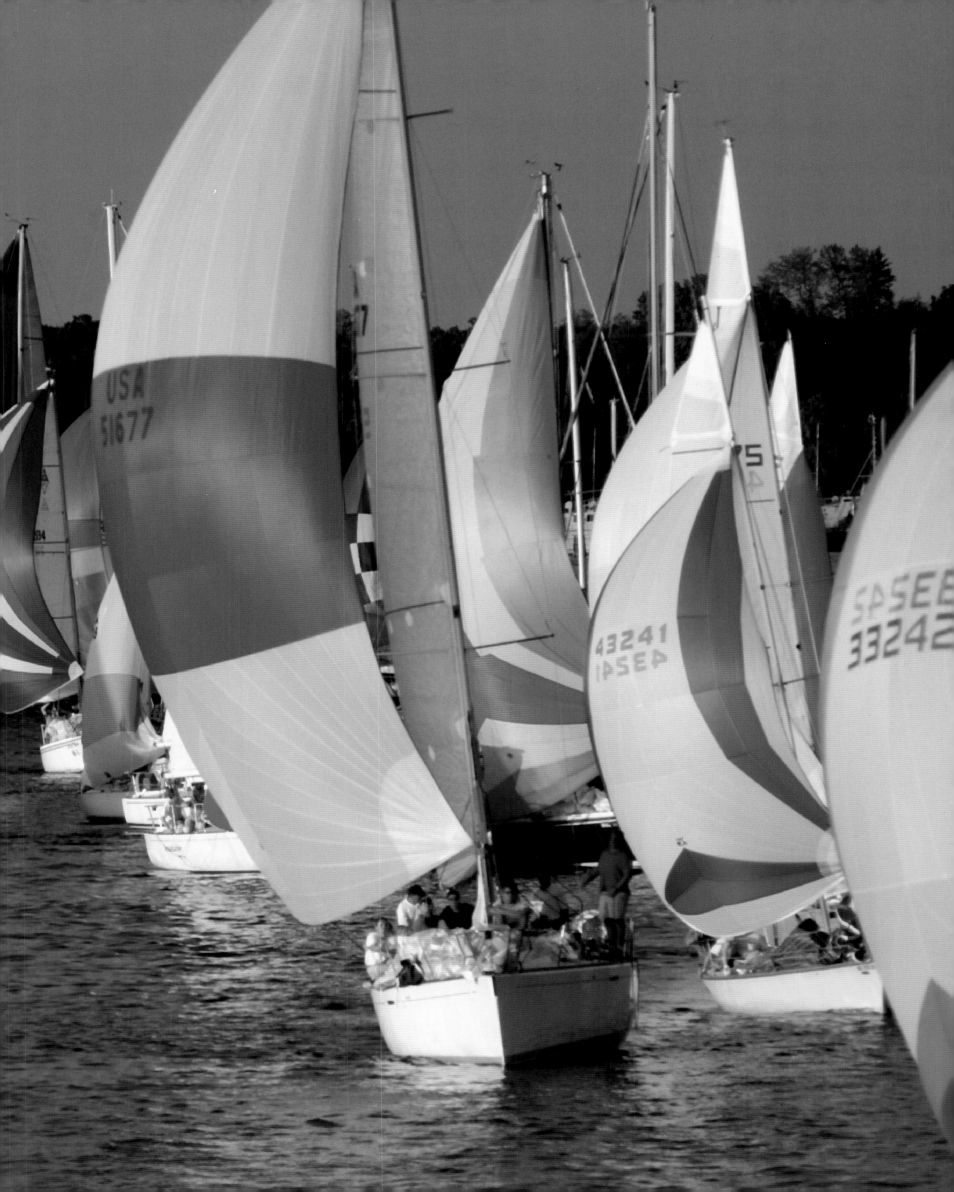

BALTIMORE

More than 100,000 fans at Pimlico watched the running of the 128th Preakness Stakes. But the second leg of the Triple Crown wasn't the only game in town. There were seven other stakes races that day, and Tara Catalano-Smith of North East and Melanie Heffner-Bass of Rising Sun caught them all.

Photos by James W. Prichard

BALTIMORE

Win, place, or no-show: According to several revelers, this fan passed out from one too many brewskies during the pre-Preakness infield party.

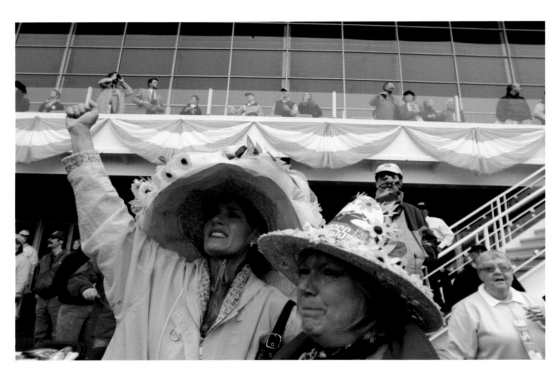

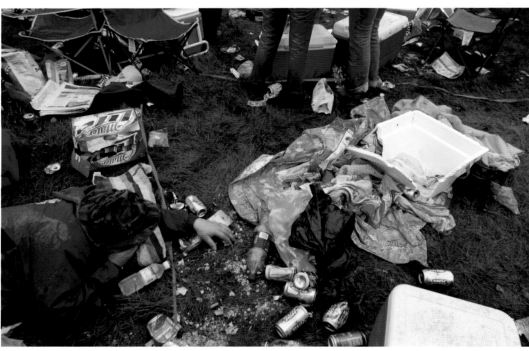

BALTIMORE

Racing Hall of Fame jockey Pat Day drives During, a 3-year-old, across the finish line in the Sir Barton Stakes—three lengths behind the winner, Best Minister. Later in the afternoon, the 30-year veteran made a bid for his sixth Preakness Stakes victory but didn't finish in the money. First place went to Funny Cide, the Kentucky Derby winner.

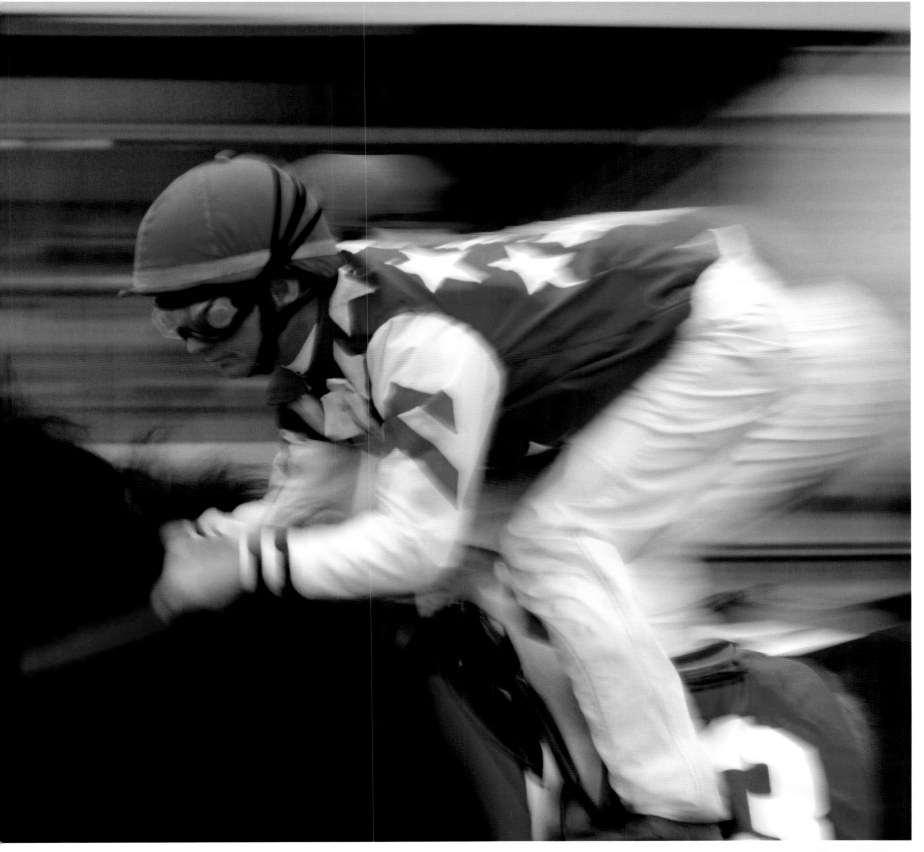

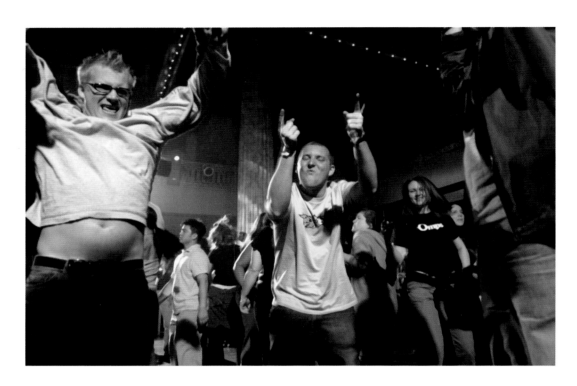

BALTIMORE

Clubbers rock out on the circular dance floor at Redwood Trust nightclub, with its $200,000 Phazon sound system pounding techno, hip-hop, and trance. The club's name comes from the Mercantile Safe-Deposit and Trust Co. that formerly occupied the old brick building downtown. Teller windows have given way to a well-stocked bar and the vault is the VIP lounge.
Photo by Laurie DeWitt

CUMBERLAND

Every Friday night, the Cumberland Armory—an arsenal by day—is transformed into the under-21 dance club, Phat Rabbitz. From 9 to midnight, patrons pour in from throughout western Maryland to dance to DJ Brent Goss's selection of hip-hop, rap, and reggae rhythms.
Photo by Susana Raab

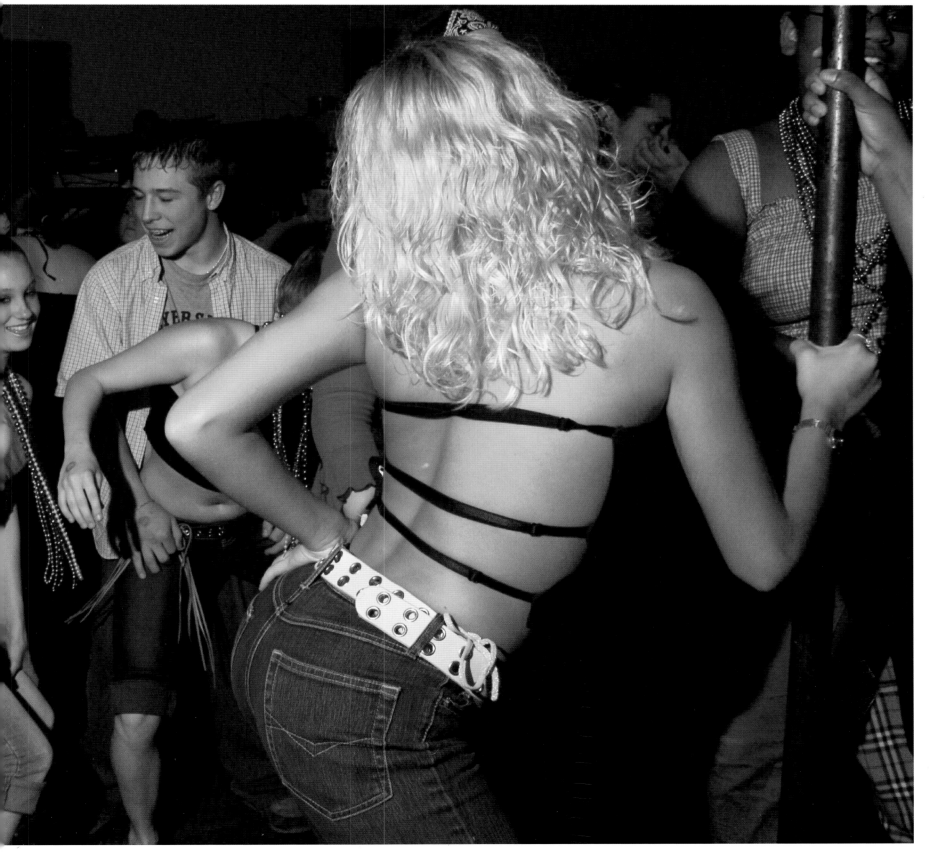

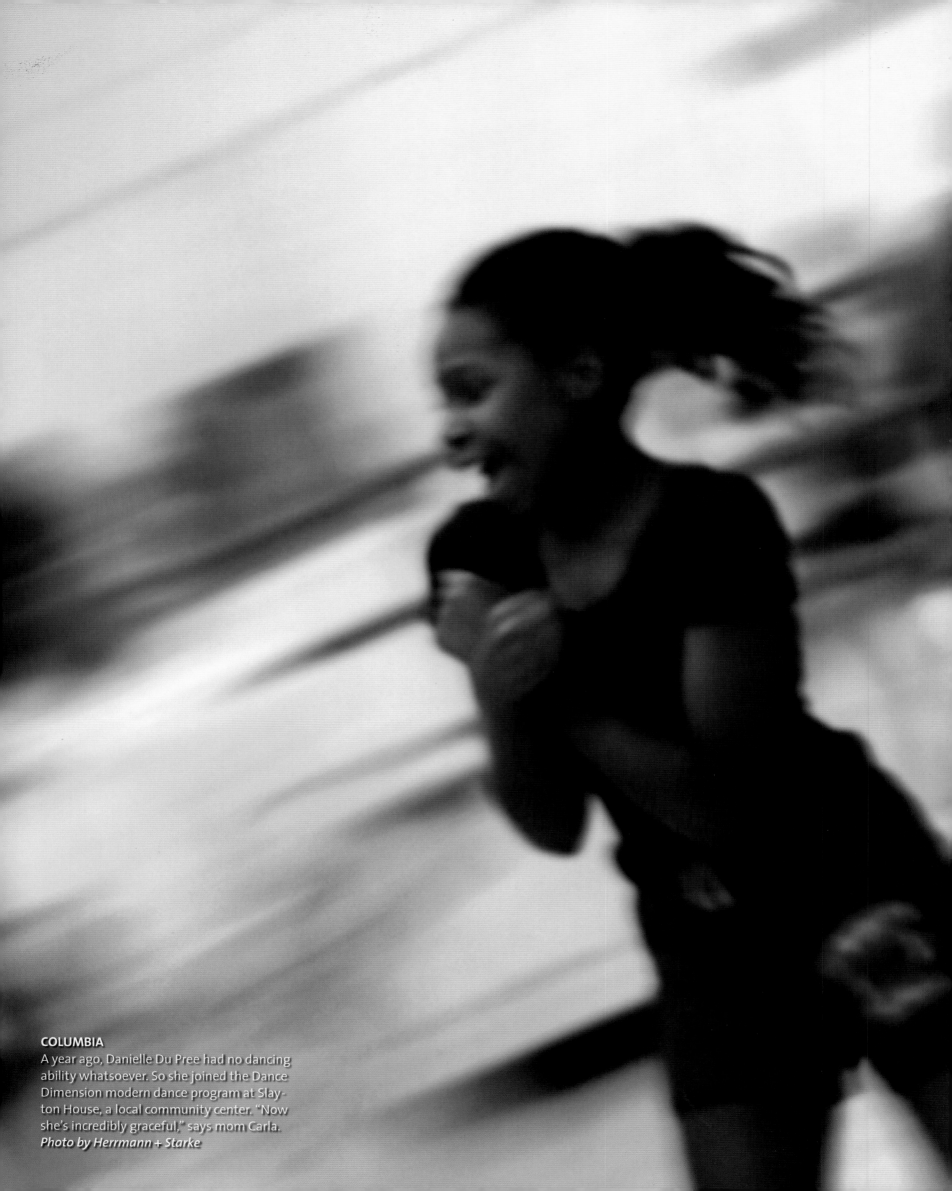

COLUMBIA
A year ago, Danielle Du Pree had no dancing ability whatsoever. So she joined the Dance Dimension modern dance program at Slayton House, a local community center. "Now she's incredibly graceful," says mom Carla.
Photo by Herrmann + Starke

TOWSON

Students at Carver Center for Arts and Technology connect during the end-of-the-year dance recital. Founded in 1993, the magnet school offers college-preparatory classes in everything from business and acting to carpentry and cosmetology.
Photo by Alexander Morozov

JESSUP

Ray and Marta West met seven years ago on the dance floor at Blob's Park Bavarian Biergarten and Polka Palace. "It's a love story," says Marta, who has danced ballet and flamenco. "It's difficult to find the right partner with the same passion for the music and dances." Saturday nights, the couple execute their polka, waltz, and tango moves in that same ballroom.

Photo by Gunes Kocatepe

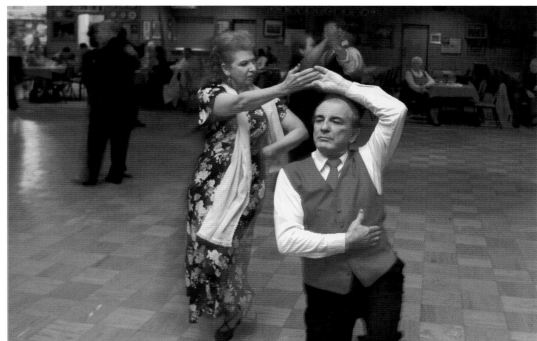

BALTIMORE

His voice isn't spot-on, but Mickey Light does have the Chairman of the Board's mannerisms and style down cold. He's been performing his Sounds of Sinatra tribute for 16 years and collecting memorabilia since he was 13. "I want to keep his name and songs alive," says Light, who does it his way at the Keswick Multi-Care Center.
Photo by Dennis Drenner

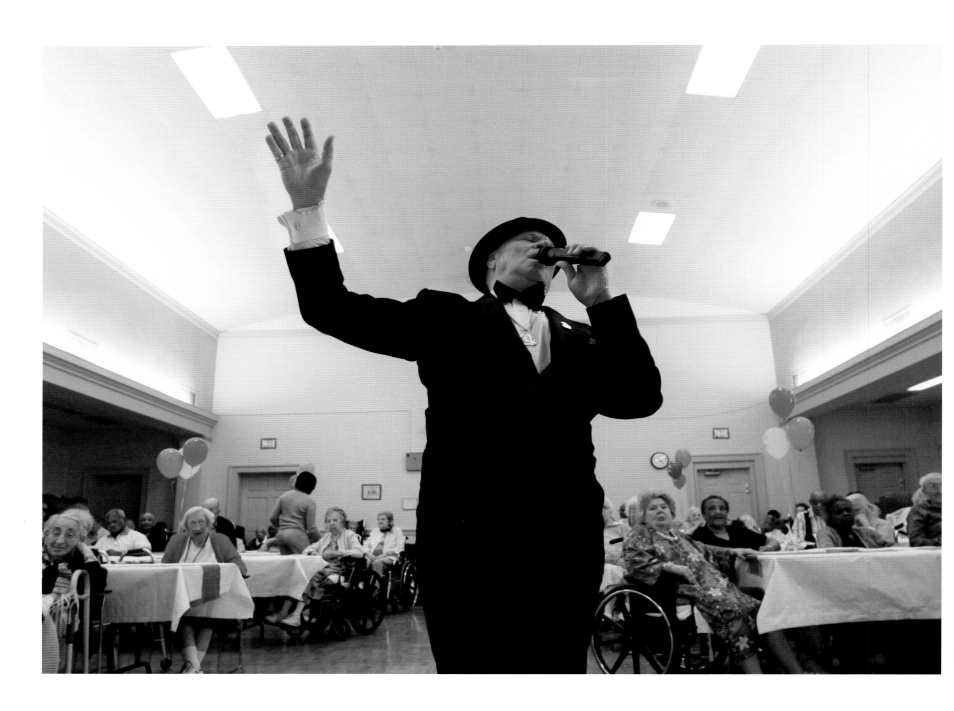

BALTIMORE
Tony Castellano's team competes in a semifinal match at an all-day bocce tournament in Little Italy's D'Alesandro Park. The grand prize is $750.
Photo by James W. Prichard

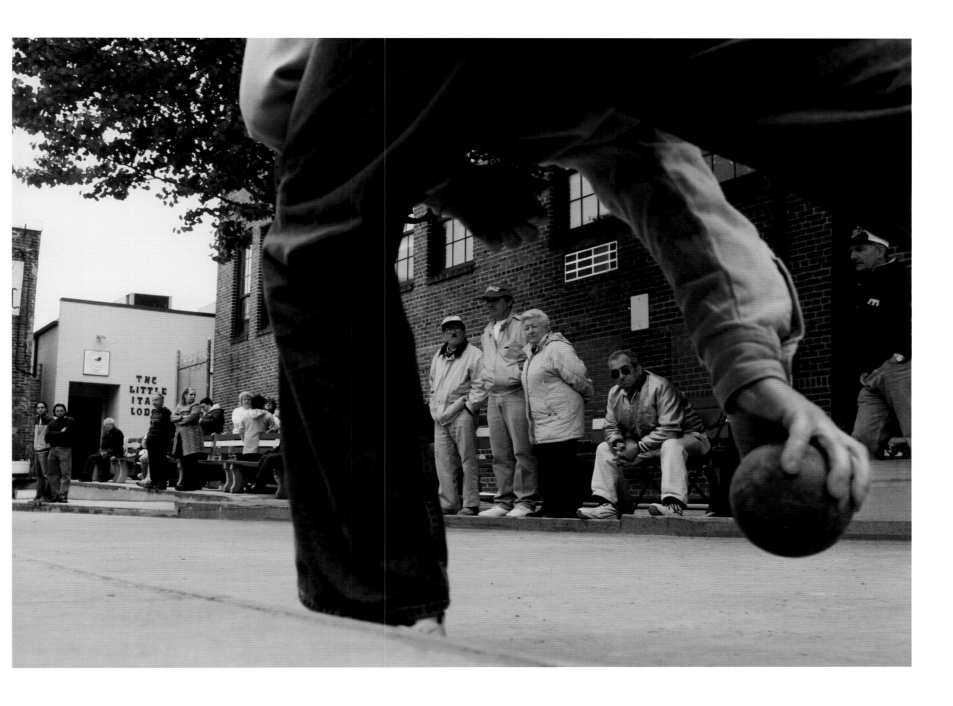

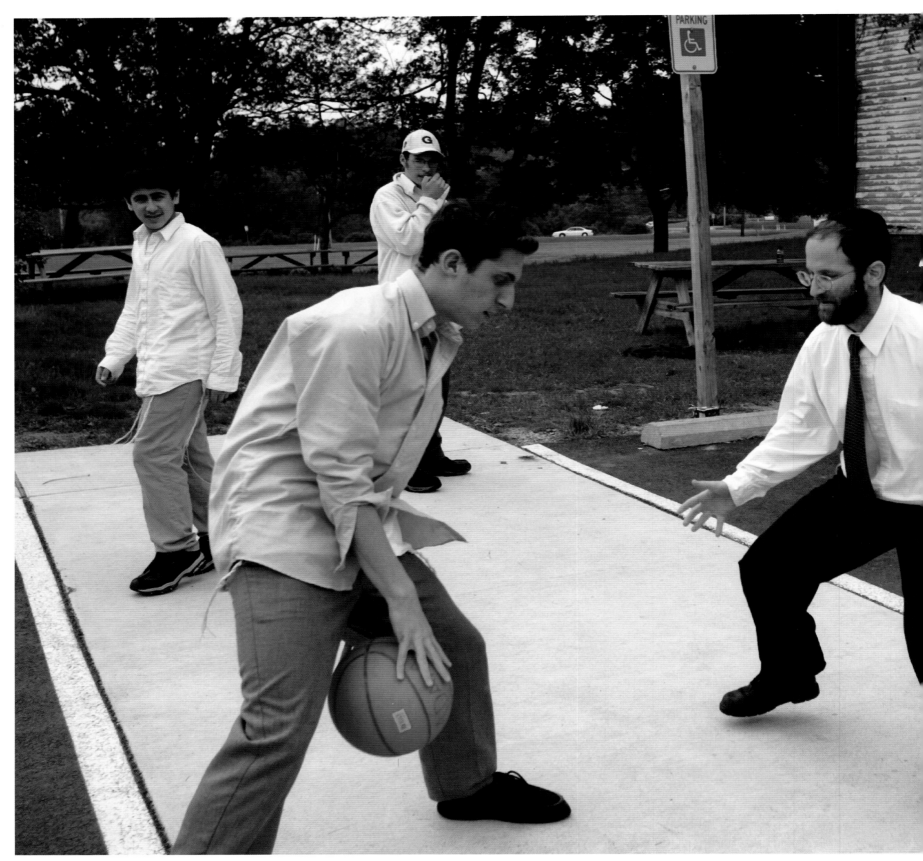

SPENCERVILLE

Jonathan Sragg plays hoops with teacher Rabbi William Tave at Eshkol Academy. The Yeshiva, which is leasing space from Cedar Ridge Community Church while its new building is being constructed, is unique. In addition to Torah learning, a more diverse education—art, music, sports—is offered. According to founder Jack Abramoff, "Students need to apply Torah knowledge to the real world."

Photo by Matt Mendelsohn

ST. MICHAELS

At the shipyard of the Chesapeake Bay Maritime Museum, boat builders Jerry Pruitt, Lonnie Moore, and Charles Bradshaw (front) work on Pruitt's 1949 buyboat, the *Delvin K*. Buyboats meet oyster-dredging skipjacks on the water and shuttle the catch to market, allowing the sail-powered boats to continue their scouring.
Photo by Shannon Bishop

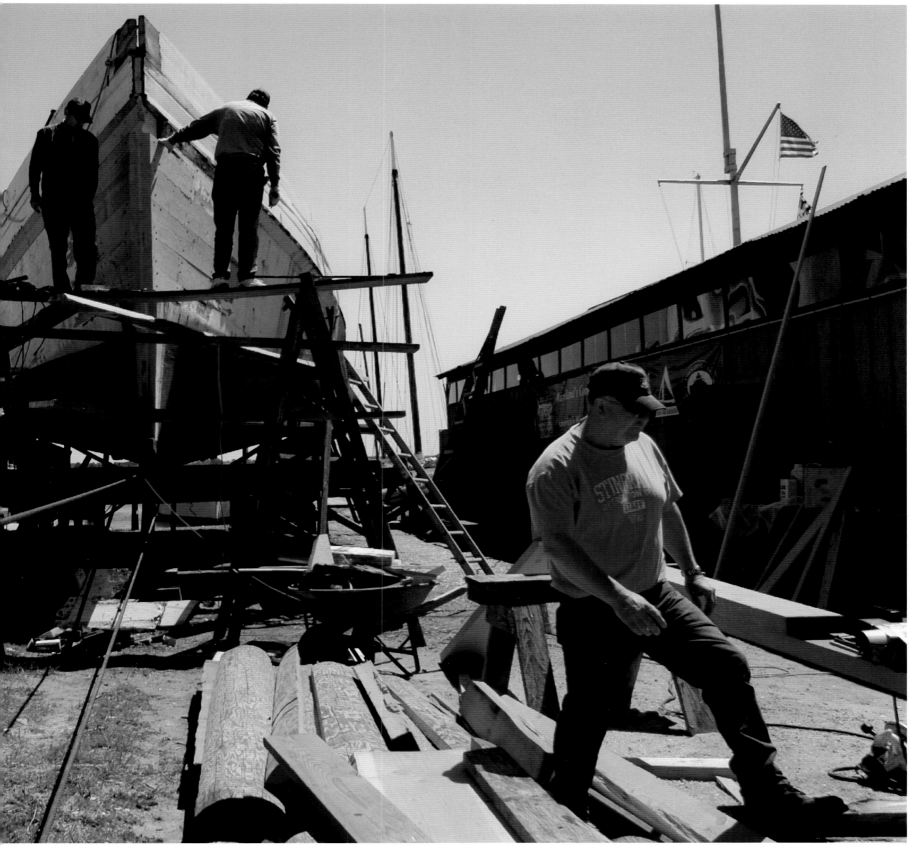

OCEAN CITY
A 13-foot tiger shark replica on display outside the Life-Saving Station Museum turns heads on the boardwalk. The actual 1,210-pound shark was landed 27 miles off Ocean City beach in 1983 by Grace Czerniak of Buffalo, New York.
Photo by Gunes Kocatepe

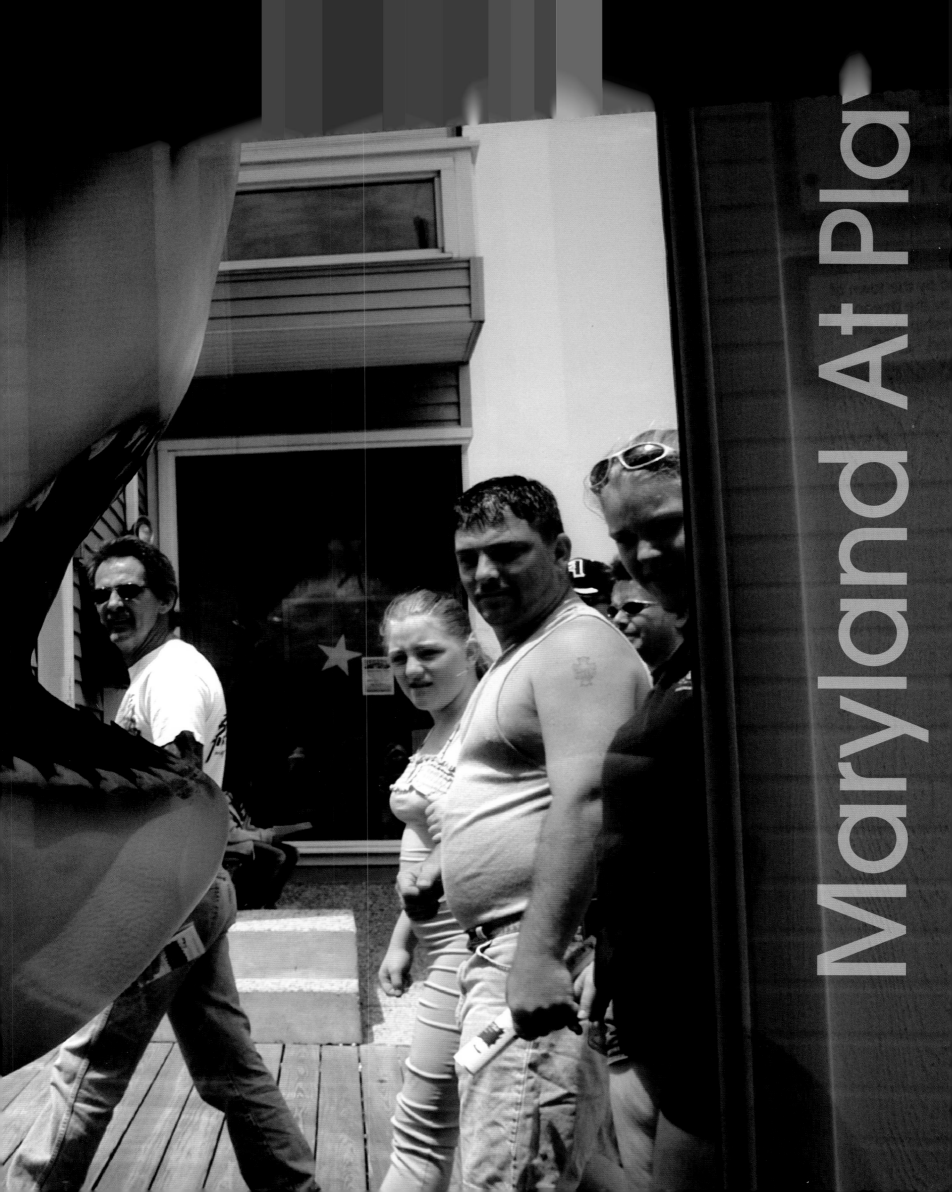

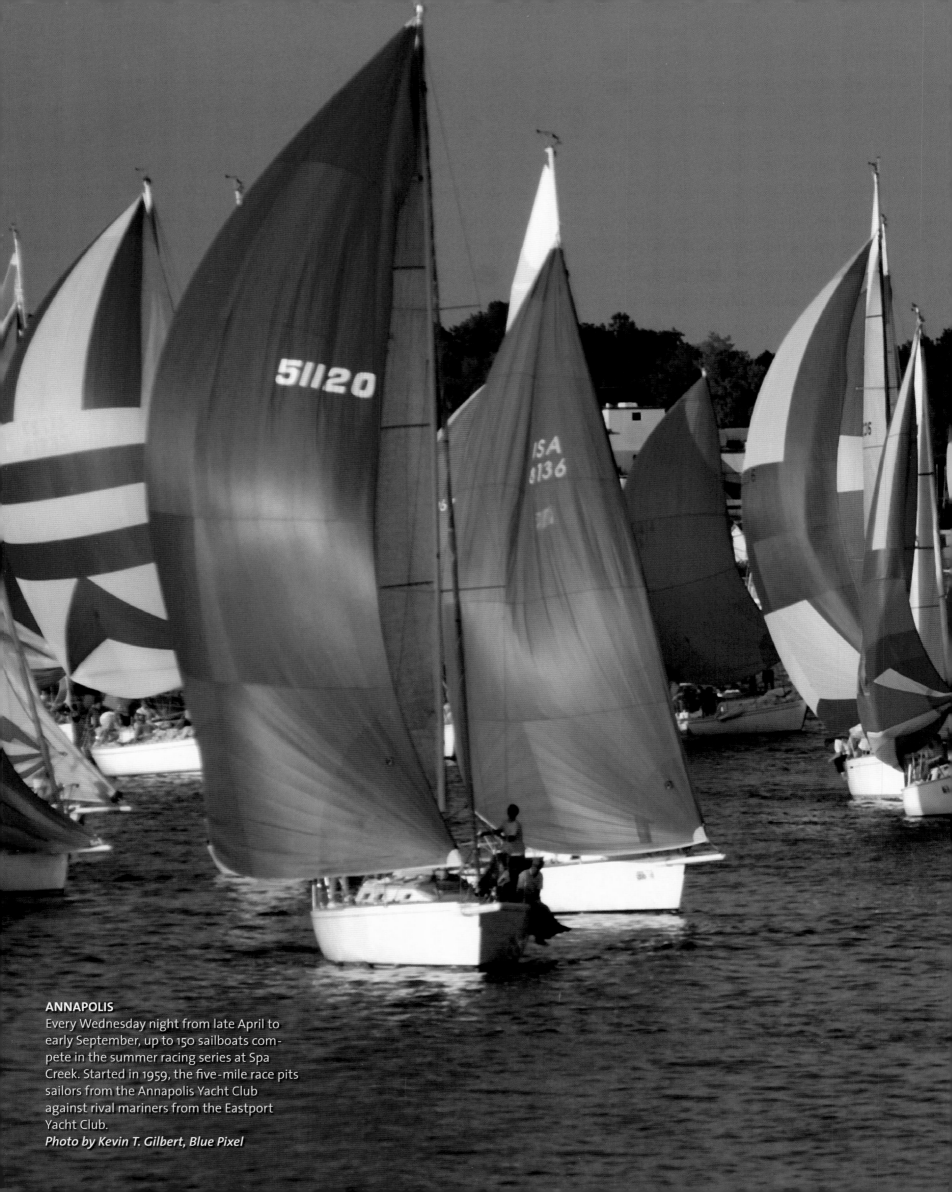

ANNAPOLIS
Every Wednesday night from late April to early September, up to 150 sailboats compete in the summer racing series at Spa Creek. Started in 1959, the five-mile race pits sailors from the Annapolis Yacht Club against rival mariners from the Eastport Yacht Club.
Photo by Kevin T. Gilbert, Blue Pixel

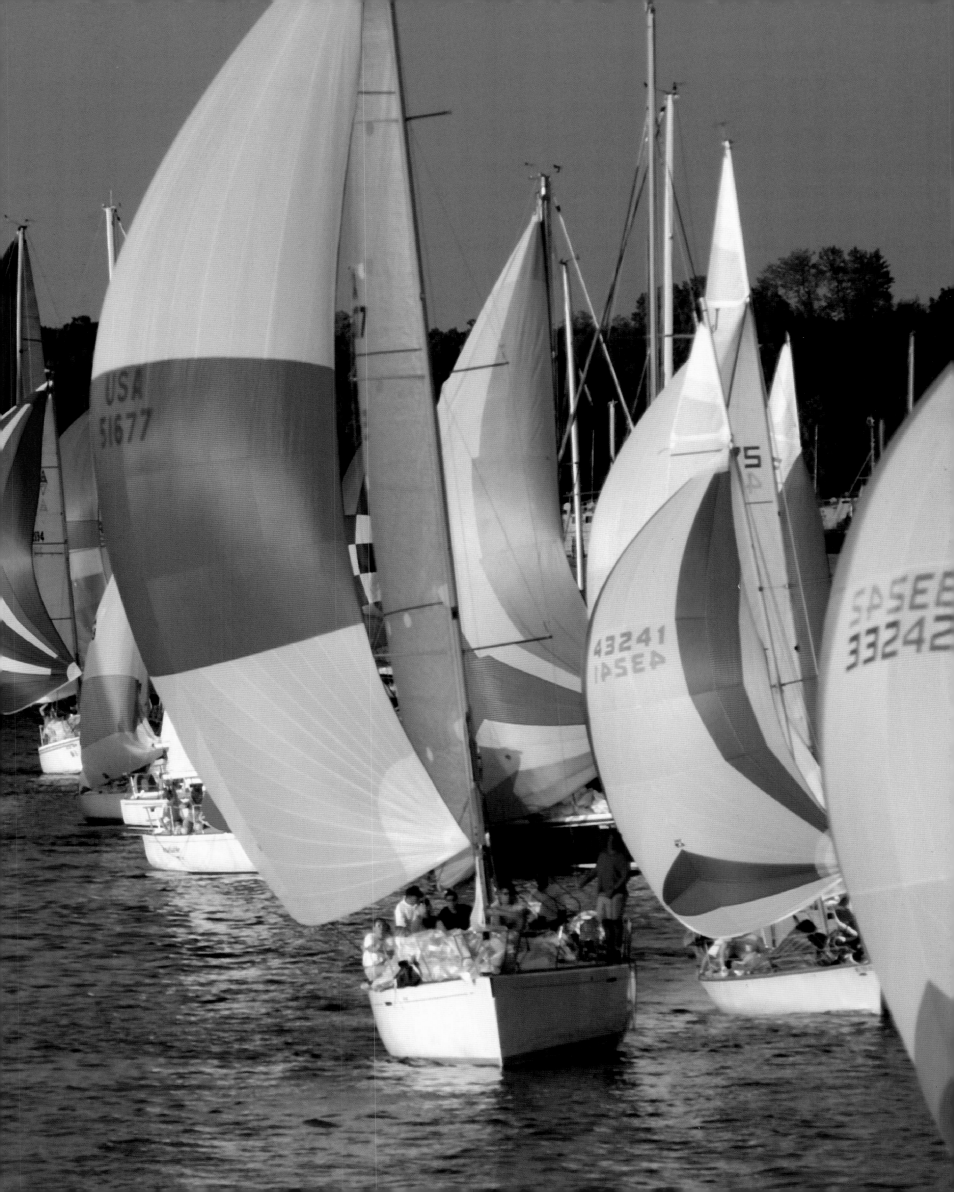

BALTIMORE

More than 100,000 fans at Pimlico watched the
running of the 128th Preakness Stakes. But the
second leg of the Triple Crown wasn't the only
game in town. There were seven other stakes
races that day, and Tara Catalano-Smith of North
East and Melanie Heffner-Bass of Rising Sun
caught them all.
Photos by James W. Prichard

BALTIMORE

Win, place, or no-show: According to several rev-
elers, this fan passed out from one too many
brewskies during the pre-Preakness infield party.

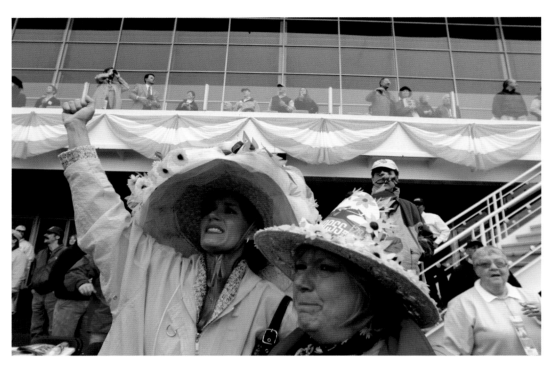

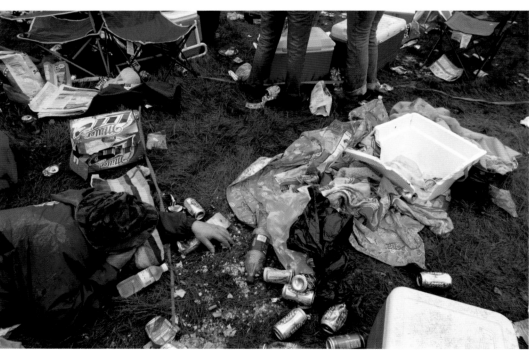

BALTIMORE

Racing Hall of Fame jockey Pat Day drives During, a 3-year-old, across the finish line in the Sir Barton Stakes—three lengths behind the winner, Best Minister. Later in the afternoon, the 30-year veteran made a bid for his sixth Preakness Stakes victory but didn't finish in the money. First place went to Funny Cide, the Kentucky Derby winner.

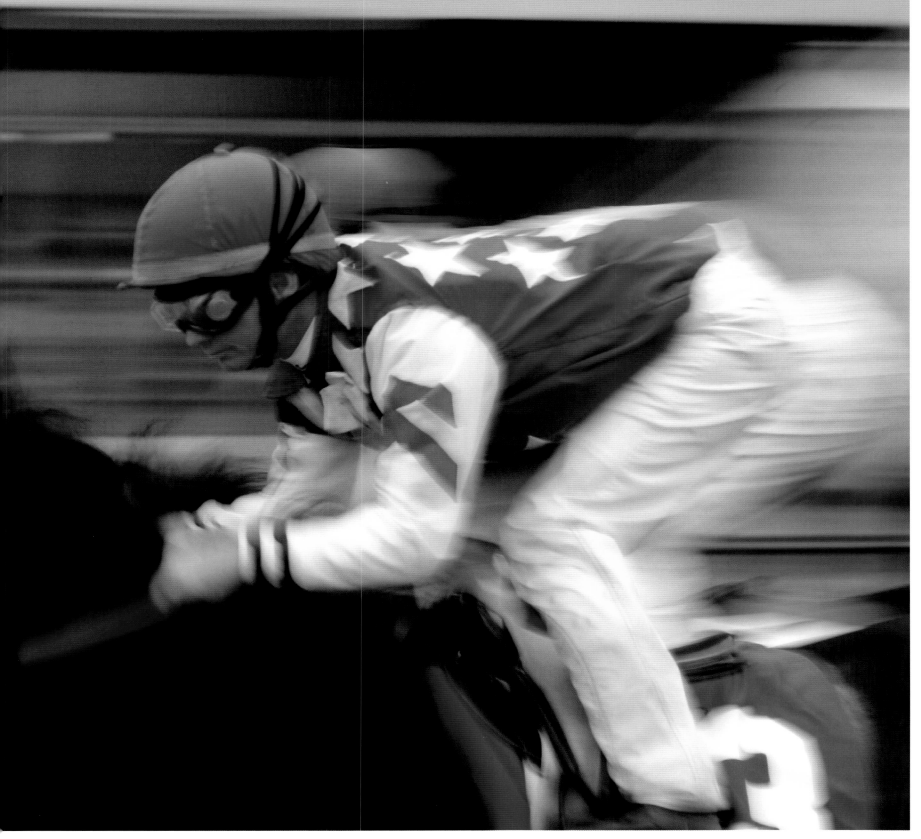

BALTIMORE

Clubbers rock out on the circular dance floor at Redwood Trust nightclub, with its $200,000 Phazon sound system pounding techno, hip-hop, and trance. The club's name comes from the Mercantile Safe-Deposit and Trust Co. that formerly occupied the old brick building downtown. Teller windows have given way to a well-stocked bar and the vault is the VIP lounge.
Photo by Laurie DeWitt

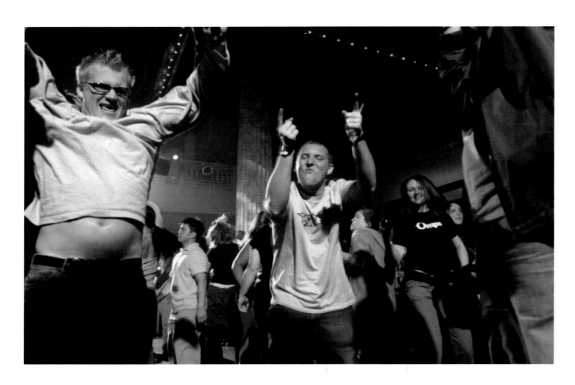

CUMBERLAND

Every Friday night, the Cumberland Armory—an arsenal by day—is transformed into the under-21 dance club, Phat Rabbitz. From 9 to midnight, patrons pour in from throughout western Maryland to dance to DJ Brent Goss's selection of hip-hop, rap, and reggae rhythms.
Photo by Susana Raab

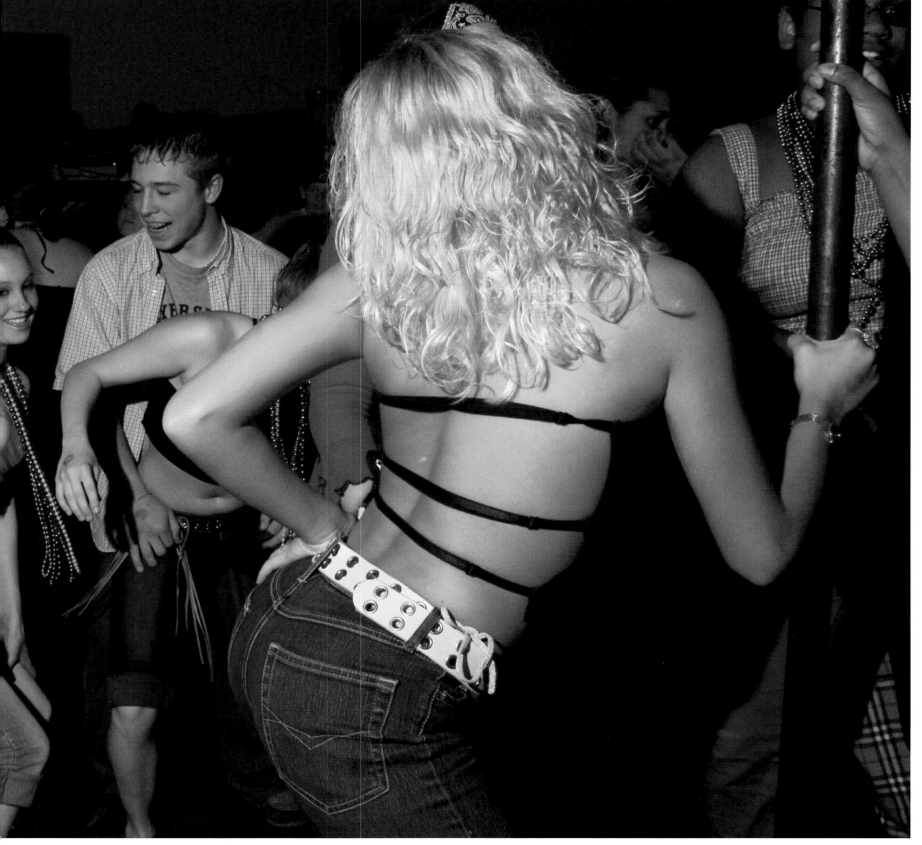

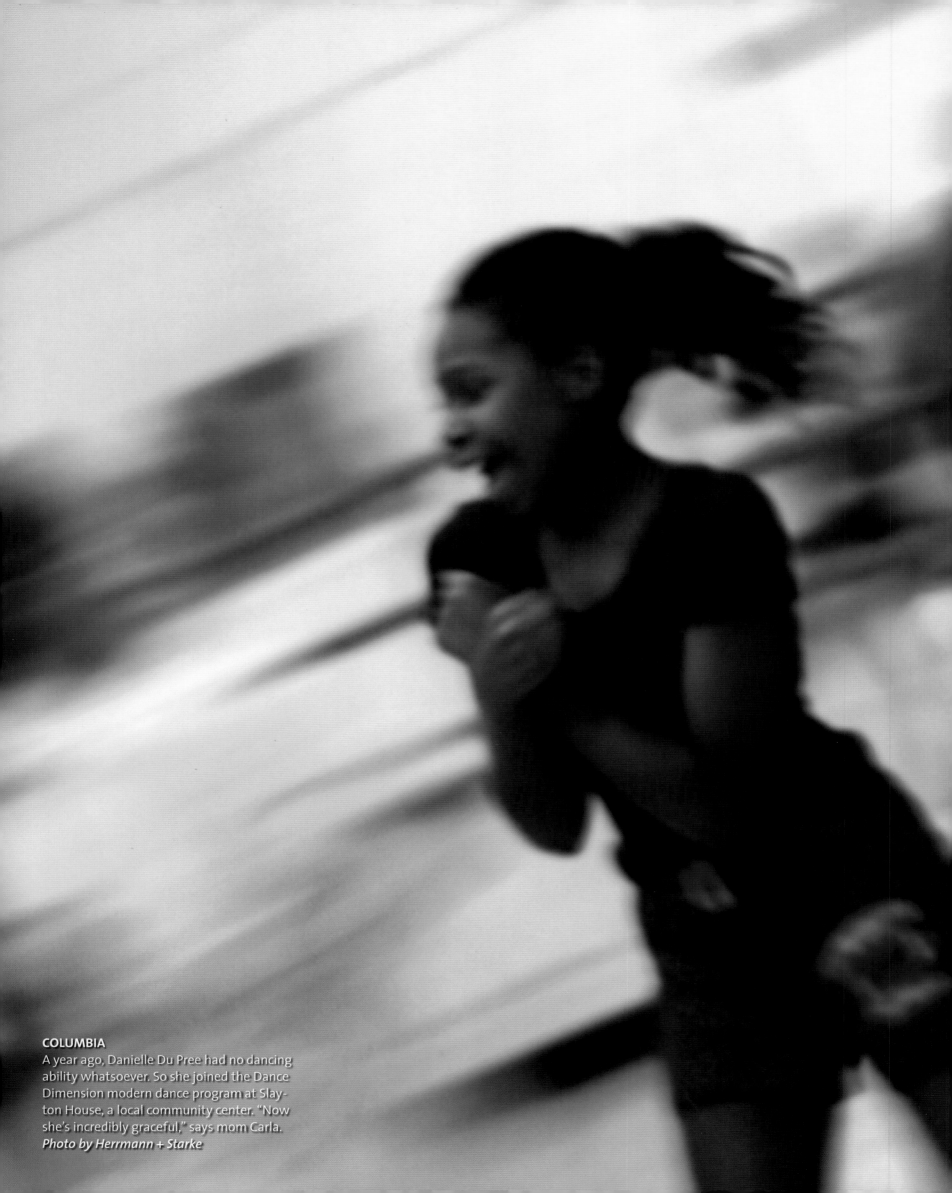

COLUMBIA
A year ago, Danielle Du Pree had no dancing ability whatsoever. So she joined the Dance Dimension modern dance program at Slayton House, a local community center. "Now she's incredibly graceful," says mom Carla.
Photo by Herrmann + Starke

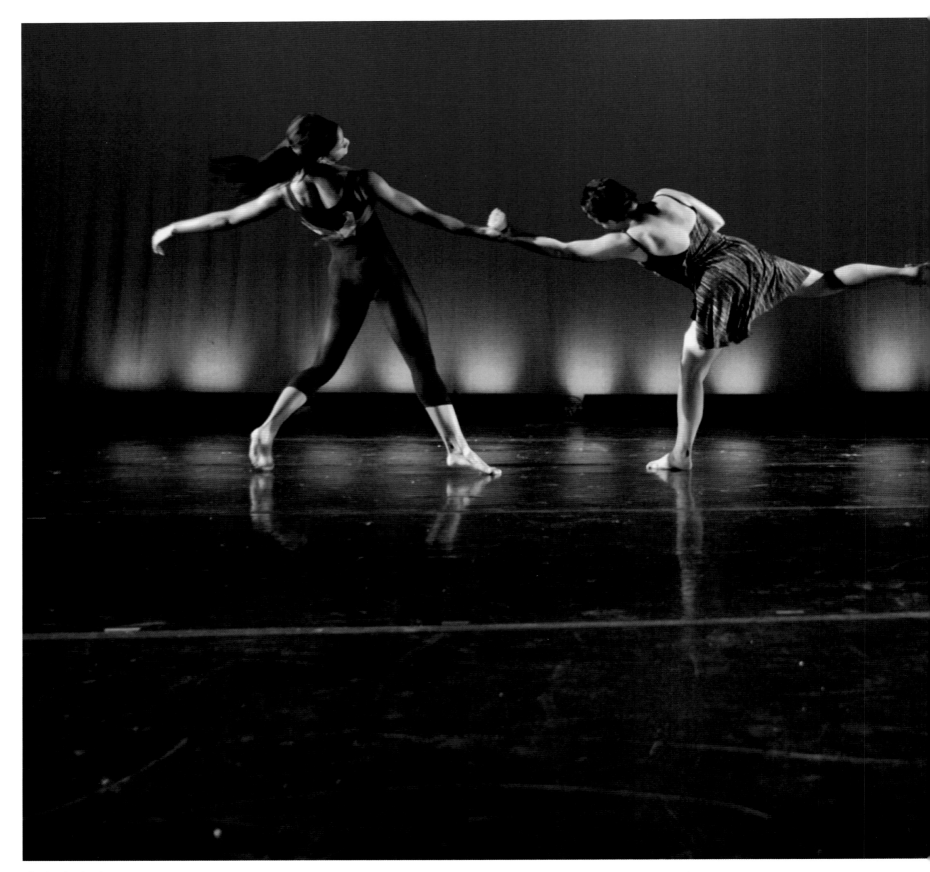

TOWSON

Students at Carver Center for Arts and Technology connect during the end-of-the-year dance recital. Founded in 1993, the magnet school offers college-preparatory classes in everything from business and acting to carpentry and cosmetology.
Photo by Alexander Morozov

JESSUP

Ray and Marta West met seven years ago on the dance floor at Blob's Park Bavarian Biergarten and Polka Palace. "It's a love story," says Marta, who has danced ballet and flamenco. "It's difficult to find the right partner with the same passion for the music and dances." Saturday nights, the couple execute their polka, waltz, and tango moves in that same ballroom.
Photo by Gunes Kocatepe

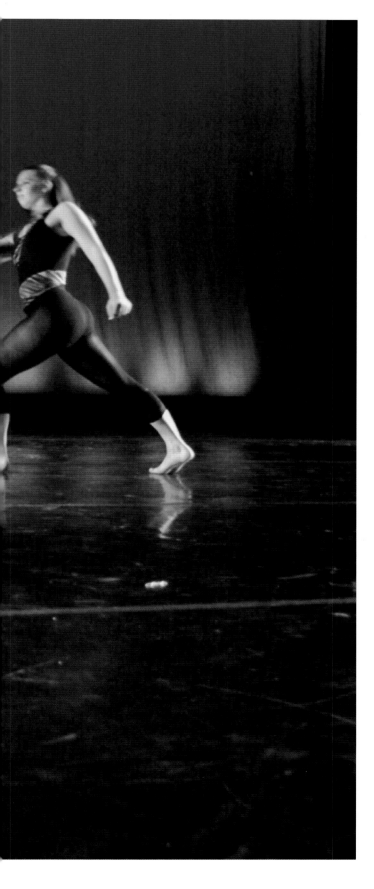

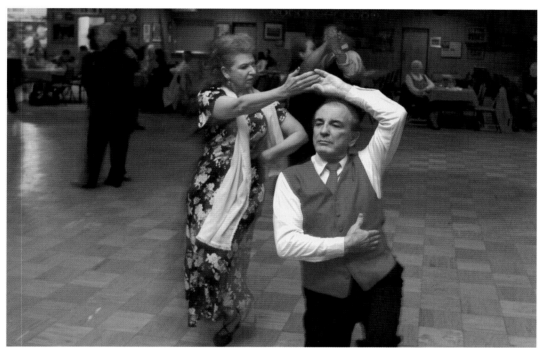

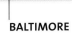

BALTIMORE

His voice isn't spot-on, but Mickey Light does have the Chairman of the Board's mannerisms and style down cold. He's been performing his Sounds of Sinatra tribute for 16 years and collecting memorabilia since he was 13. "I want to keep his name and songs alive," says Light, who does it his way at the Keswick Multi-Care Center.
Photo by Dennis Drenner

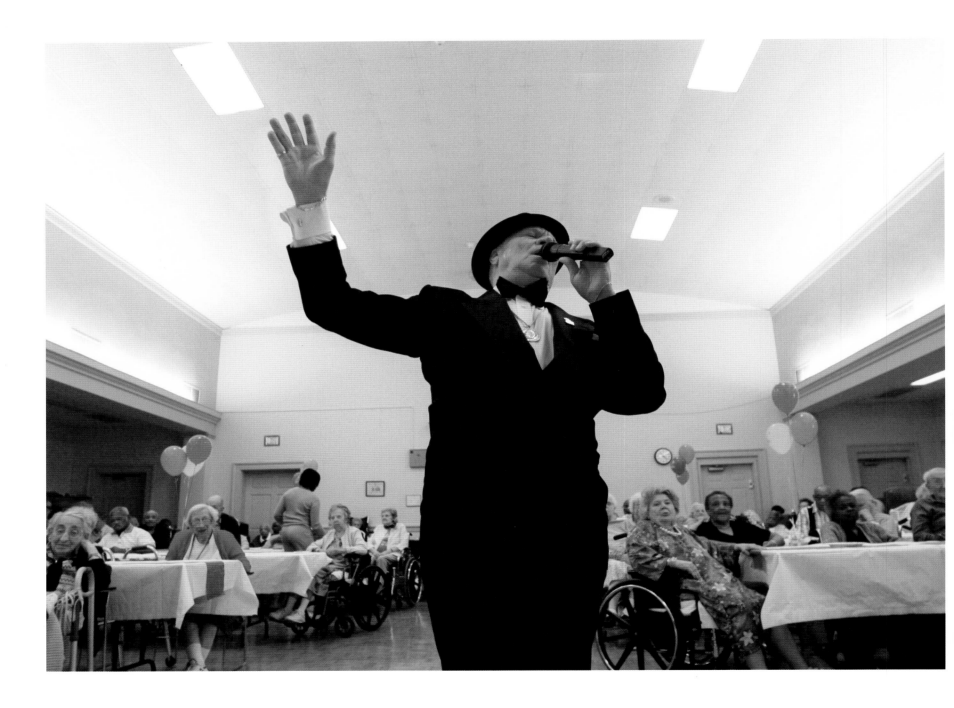

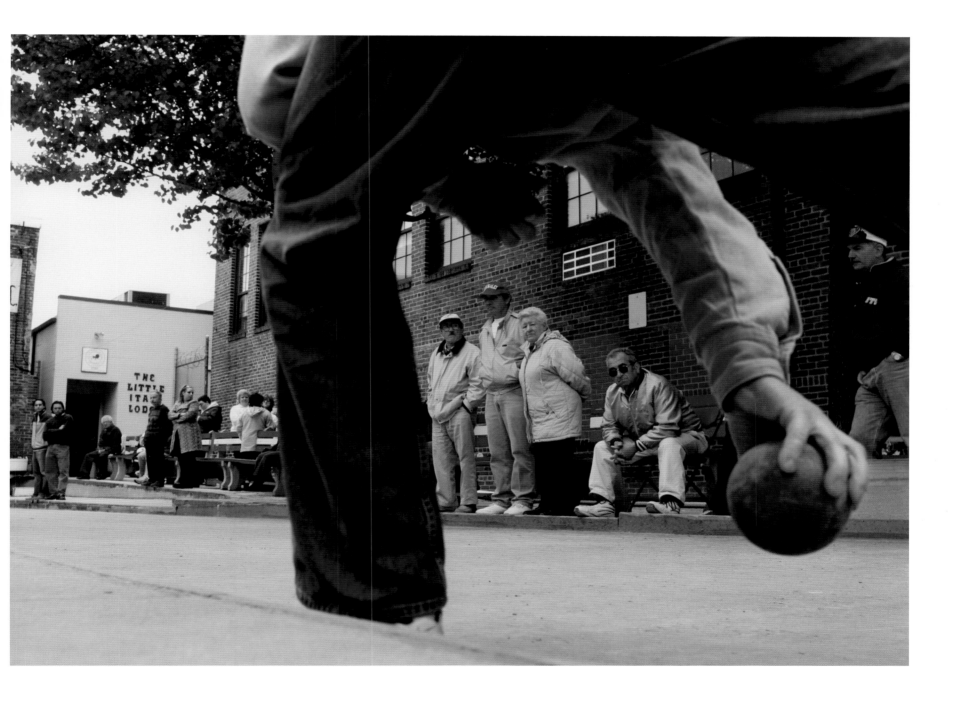

BALTIMORE

Tony Castellano's team competes in a semifinal match at an all-day bocce tournament in Little Italy's D'Alesandro Park. The grand prize is $750.
Photo by James W. Prichard

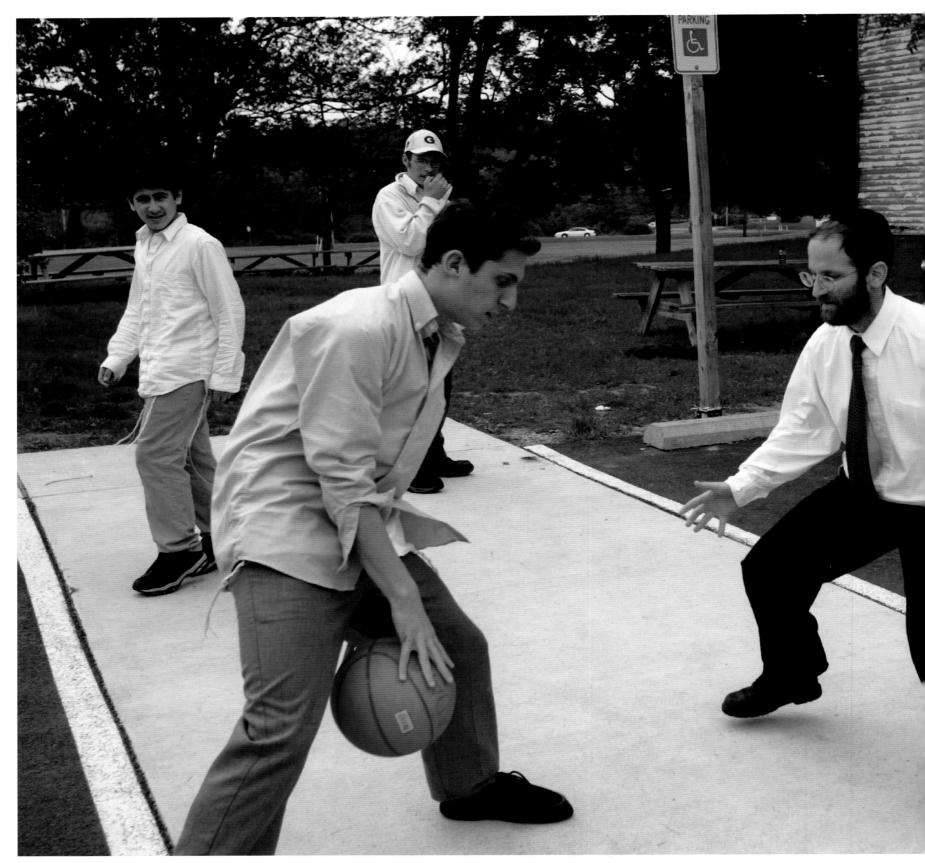

SPENCERVILLE

Jonathan Sragg plays hoops with teacher Rabbi William Tave at Eshkol Academy. The Yeshiva, which is leasing space from Cedar Ridge Community Church while its new building is being constructed, is unique. In addition to Torah learning, a more diverse education—art, music, sports—is offered. According to founder Jack Abramoff, "Students need to apply Torah knowledge to the real world."

Photo by Matt Mendelsohn

BALTIMORE
Hand clapping turns to dancing turns to testimony at the raucous reunion service. Elder Carlos Reyes (blue suit) and others stand to praise God.

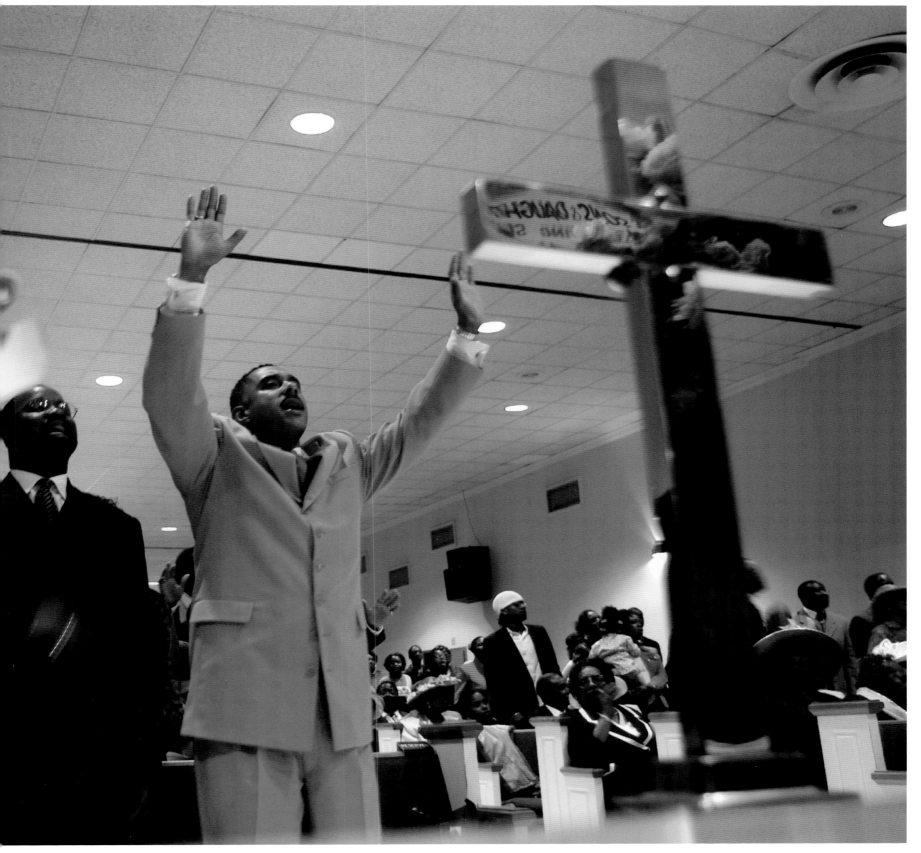

Squaring the knot: At the Maryland State Boychoir Festival at Goucher College, a member of the Cleveland BoyChoir fine-tunes Marcus White's outfit. The choir's program includes "Sanctus" by Leonard Bernstein and Native American travel songs.
Photos by Kevin T. Gilbert, Blue Pixel

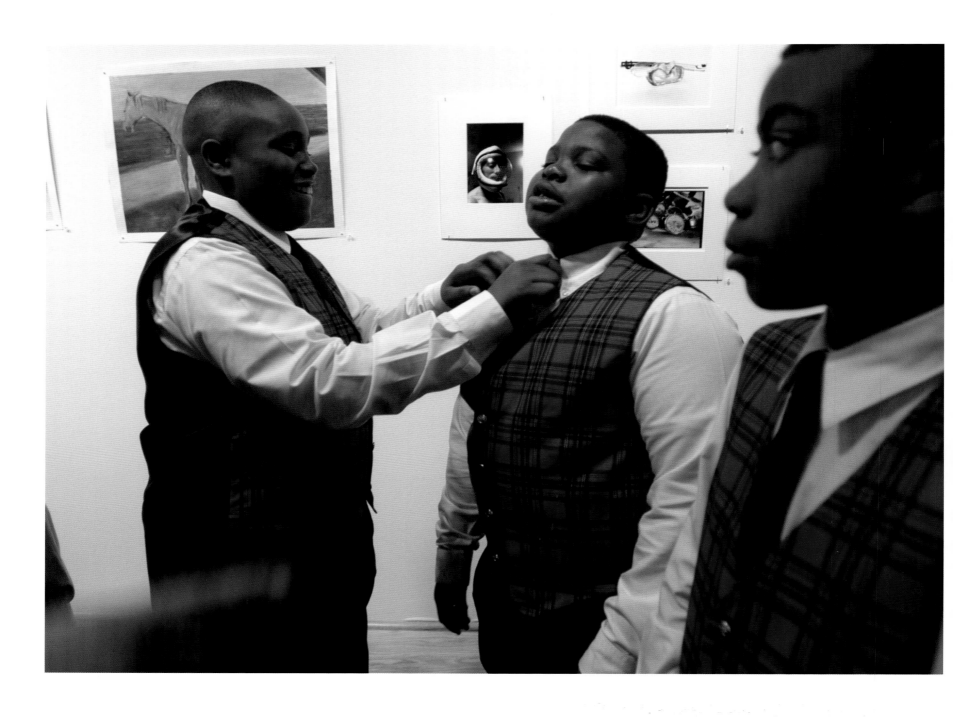

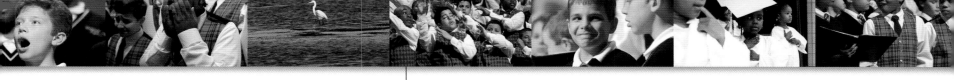

TOWSON
Members of the Newark Boys Chorus sing a
South African song at the festival. More than 250
boys from five states participate in the annual
celebration of song.

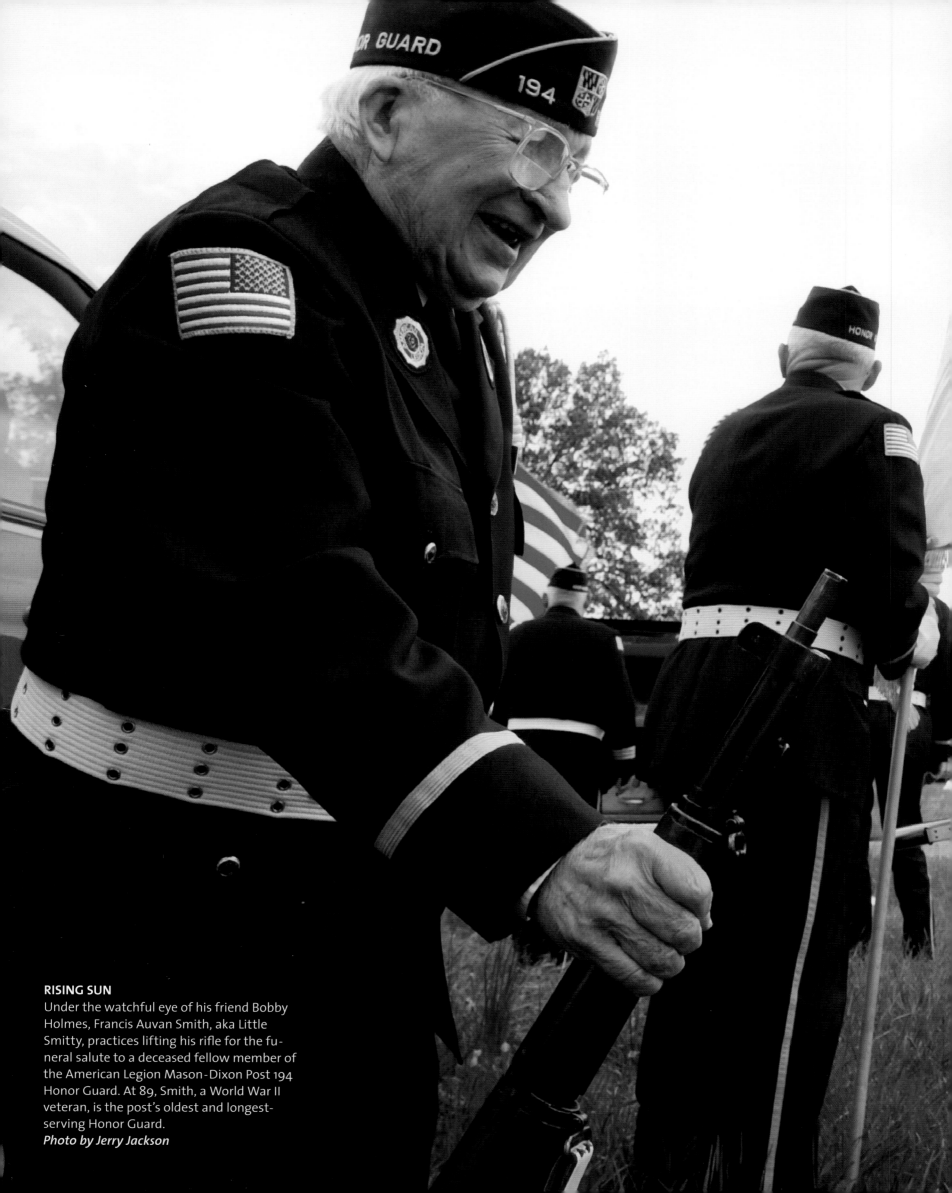

RISING SUN

Under the watchful eye of his friend Bobby Holmes, Francis Auvan Smith, aka Little Smitty, practices lifting his rifle for the funeral salute to a deceased fellow member of the American Legion Mason-Dixon Post 194 Honor Guard. At 89, Smith, a World War II veteran, is the post's oldest and longest-serving Honor Guard.

Photo by Jerry Jackson

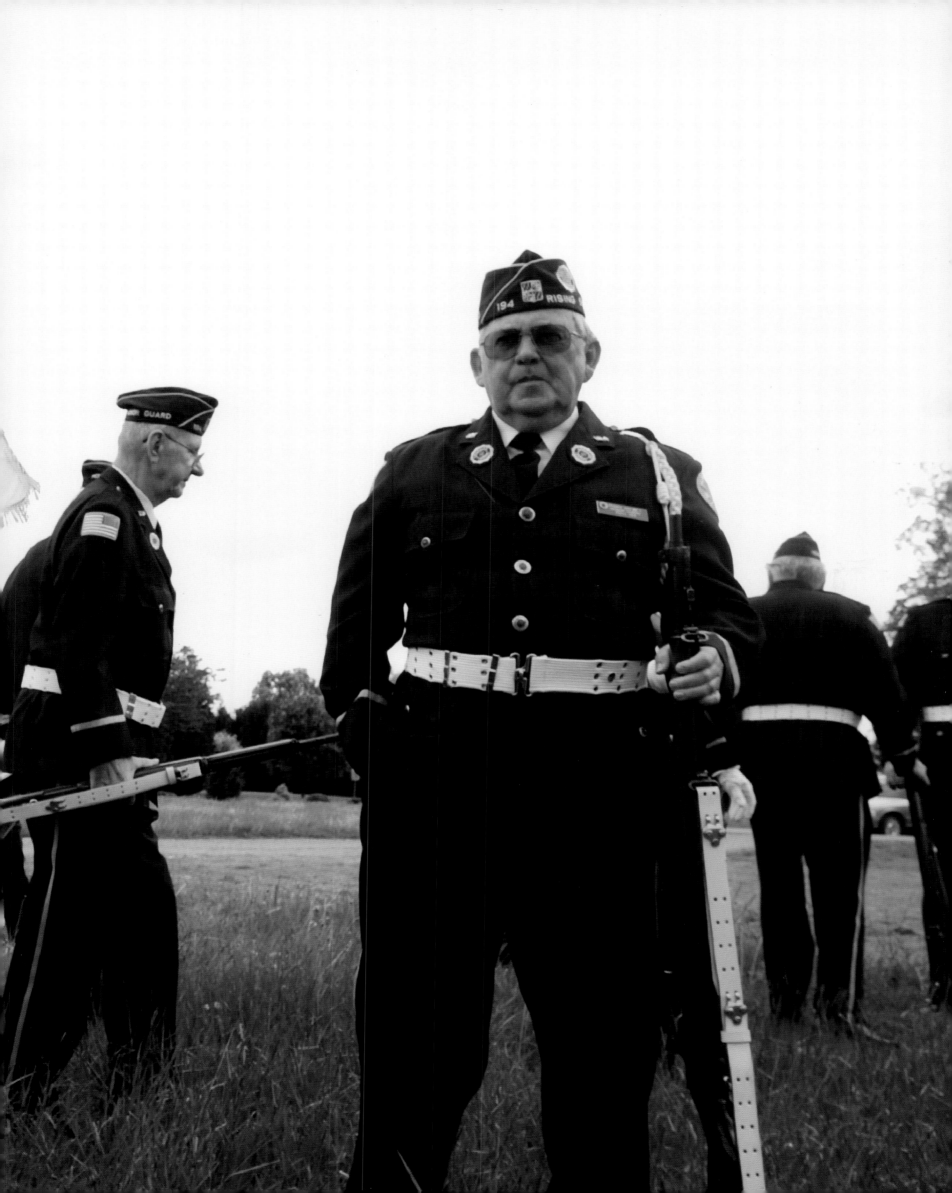

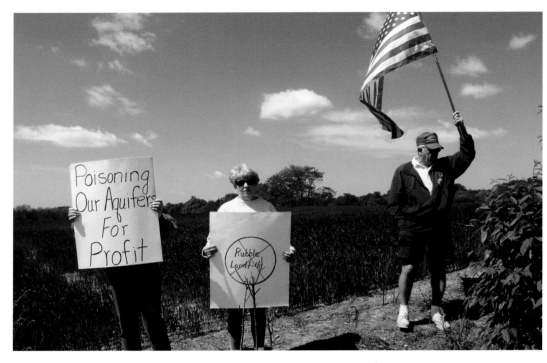

MILLINGTON

The Millington Quality of Life Preservation Coalition has spent eight years fighting a proposal to put a garbage dump next to a stream that drains into popular Unicorn Lake. It's a constant legal battle but the coalition has so far prevailed.
Photo by Carol Rose Fordonski-Ronayne

BALTIMORE

Oh, say can you claw? Harold could if it weren't for the screen on the window of owner Sandy Cleary's apartment. For now, Old Glory is safe from the 8-year-old house cat.
Photo by James W. Prichard

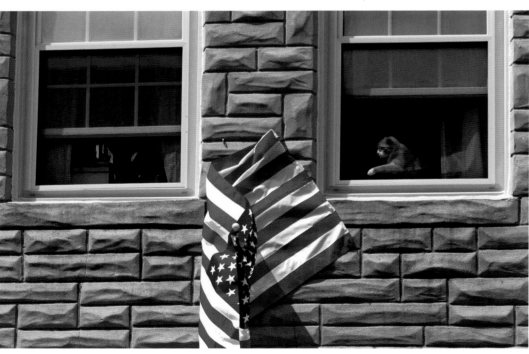

HARFORD COUNTY
Despite the fame of his 1973 Triple Crown winning grandpa, Secretariat, Red Dun Fun lives in relative anonymity in a peaceful pasture along Highway 1 in rural Harford County.
Photo by Jerry Jackson

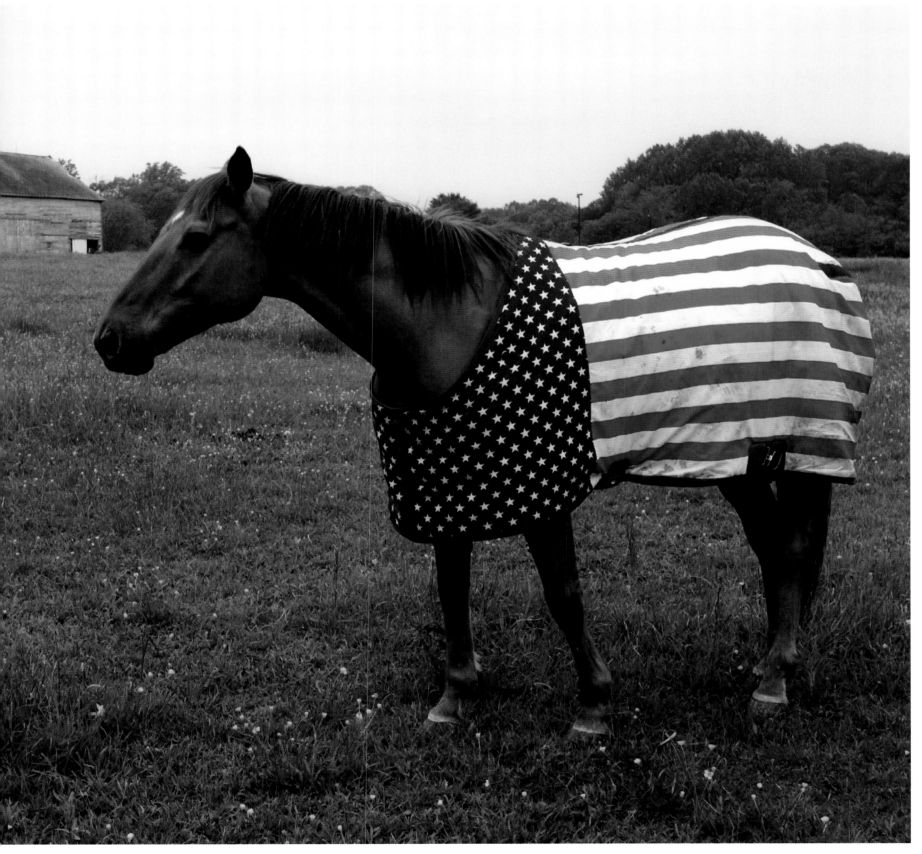

WOODLAWN

After third-grade math class at the Al-Rahmah School, the girls line up separately from the boys for lunch. Starting in fourth grade, boys and girls attend classes separately, too. Located just outside of Baltimore, the school provides a secular K–8 education, supplemented with Islamic religious and Arabic language studies. Students are predominantly Pakistani, followed by African-Americans, Indians, and Bangladeshi.

Photos by Dennis Drenner

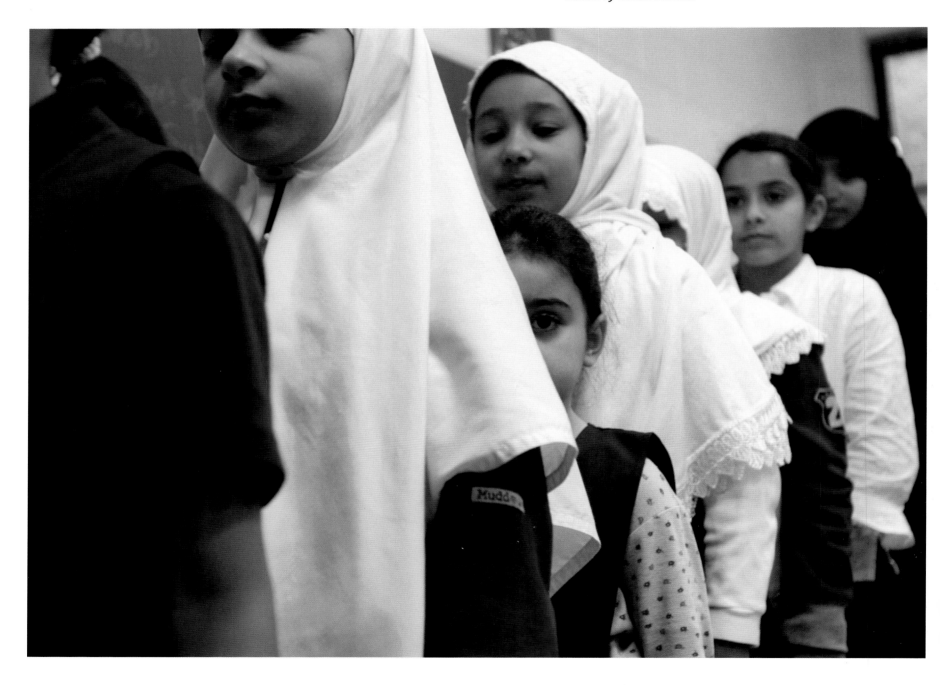

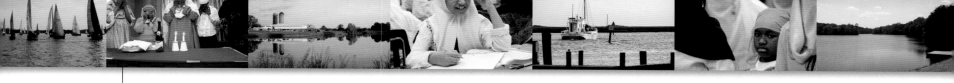

BALTIMORE

Members of the Beth Hashem congregation of black orthodox Jews welcome the Sabbath in a rented room at the Best Inn. Most Beth Hashem congregants claim to be descendants of African slaves who practiced Judaism.

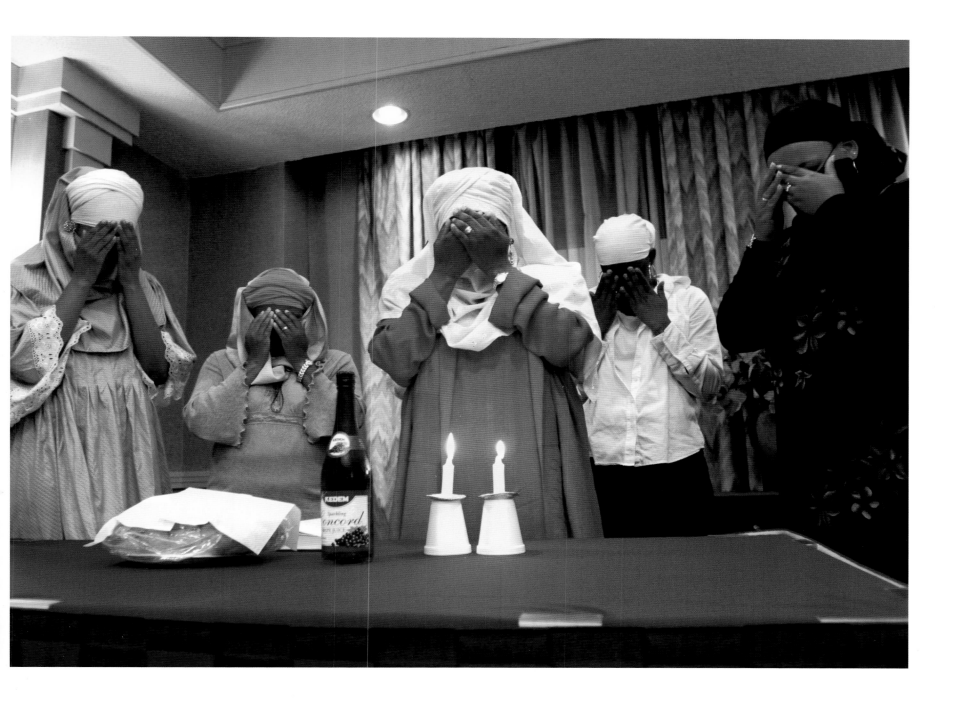

SILVER SPRING

Children of Wat Thai Temple show their respect for Lord Buddha by placing flowers on the altar. Lotus flowers symbolize the spiritual passage from ignorance to wisdom; they grow out of a murky pool but bloom pure white. When lotus are hard to come by, roses convey the message. *Photos by Laurie DeWitt*

SILVER SPRING

Thai Buddhist monks celebrate Visakha Puja—commemorating Buddha's birth, enlightenment, and death—at the Wat Thai temple. On the sixth full moon of the lunar year, they chant Buddha's five precepts of compassion and freedom from suffering.

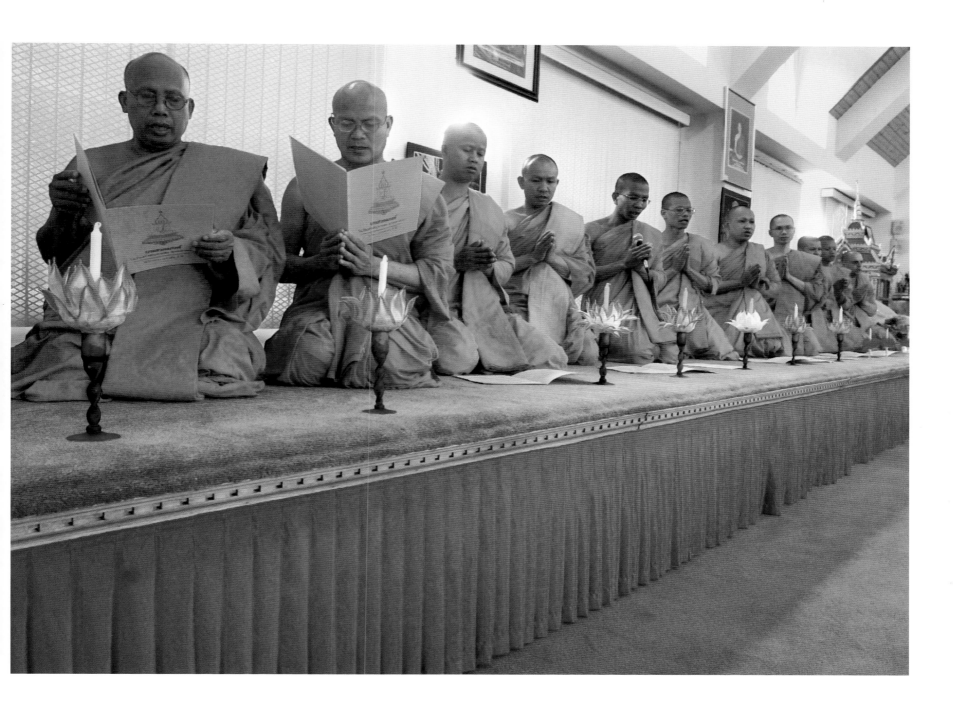

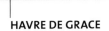

HAVRE DE GRACE

A cross memorializes the victim of a car crash along I-95 just south of the southbound Havre de Grace exit. An old European tradition, roadside crosses once marked the spots where mourners stopped to rest while carrying a coffin from the home of a deceased person to the cemetery.
Photo by Herrmann + Starke

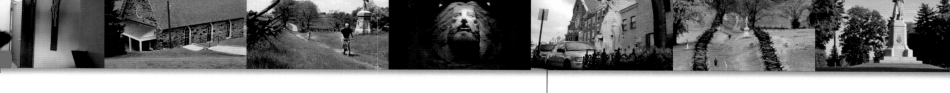

BALTIMORE

The Great Baltimore Fire of 1904 miraculously spared St. Leo the Great Church—and all of Little Italy. As burning cinders threatened the church, believers spirited the statue of St. Anthony, patron saint of lost possessions, out of the sanctuary and down to the waterfront, and prayed. The flames, which consumed most of downtown Baltimore, stopped just short of the church and neighborhood.
Photo by James W. Prichard

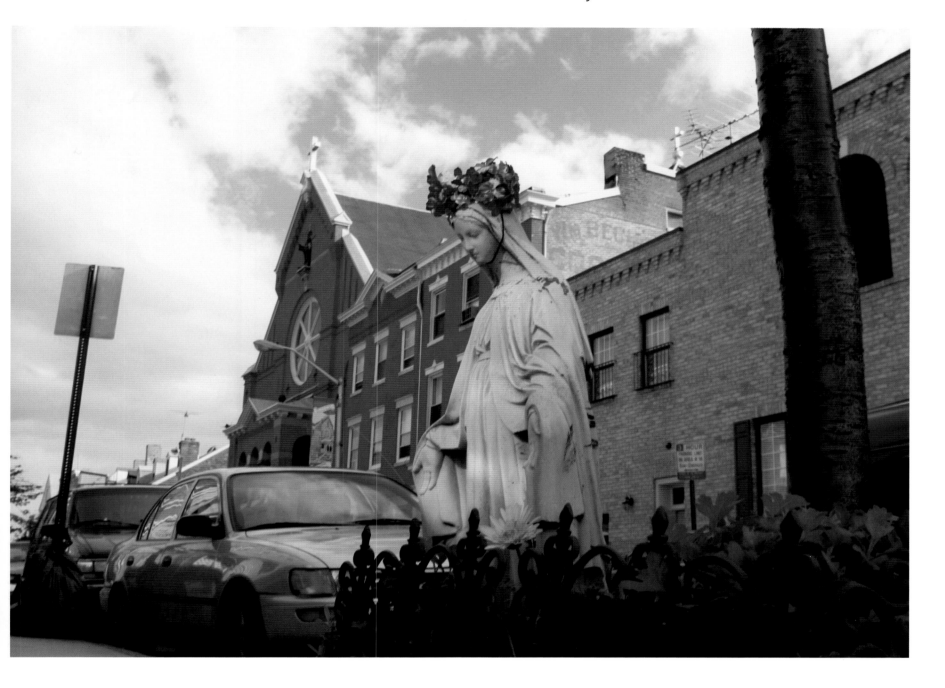

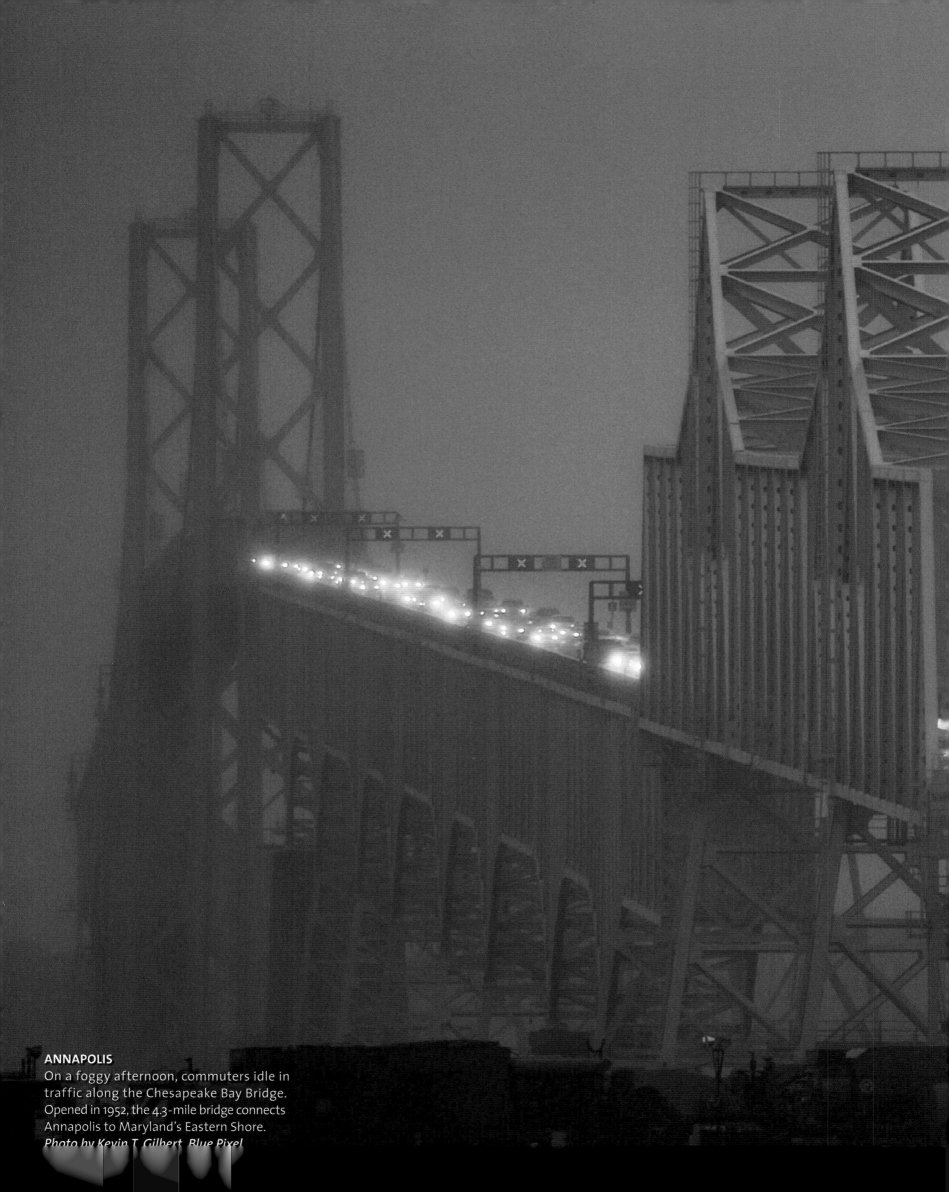

ANNAPOLIS
On a foggy afternoon, commuters idle in
traffic along the Chesapeake Bay Bridge.
Opened in 1952, the 4.3-mile bridge connects
Annapolis to Maryland's Eastern Shore.
Photo by Kevin T. Gilbert, Blue Pixel

Our Town

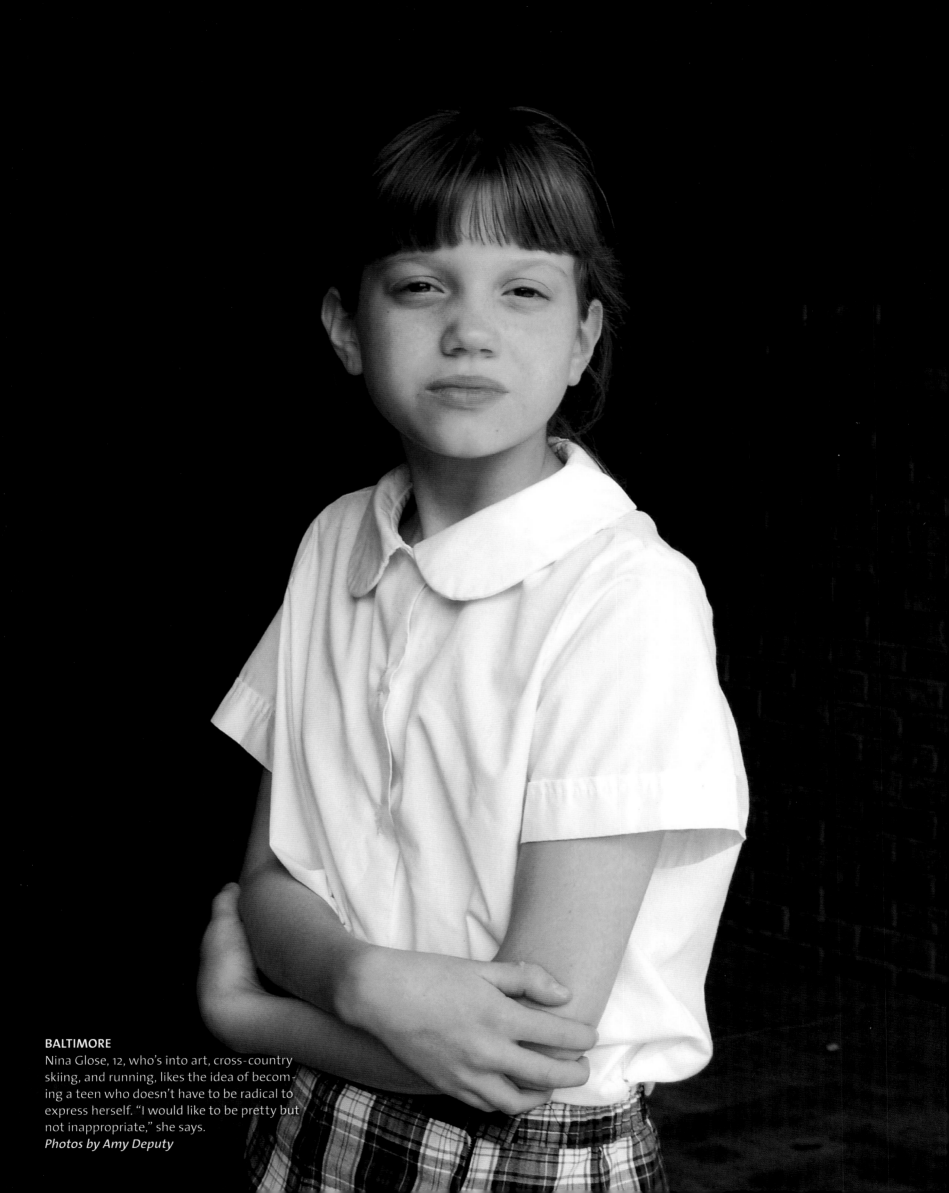

BALTIMORE
Nina Glose, 12, who's into art, cross-country skiing, and running, likes the idea of becoming a teen who doesn't have to be radical to express herself. "I would like to be pretty but not inappropriate," she says.
Photos by Amy Deputy

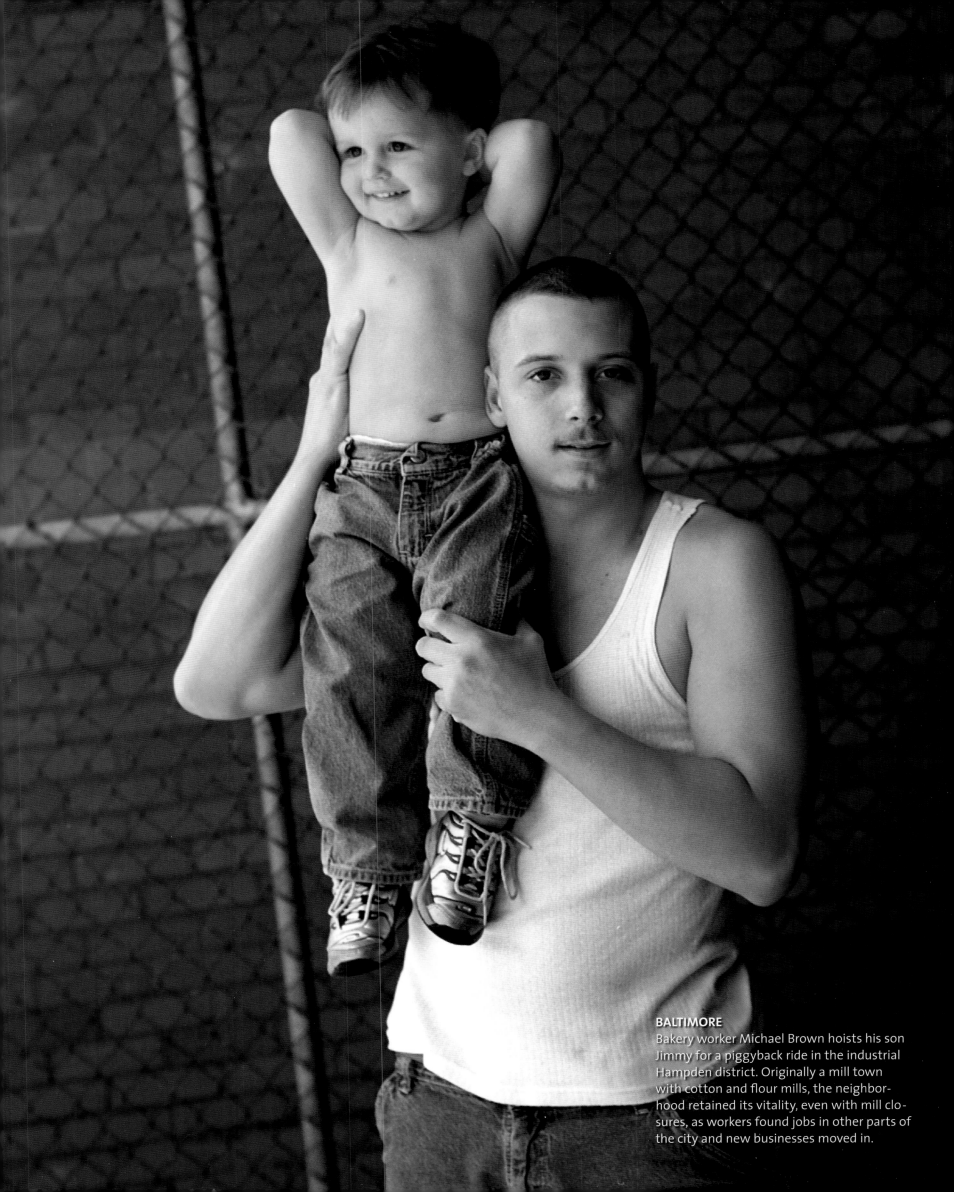

BALTIMORE
Bakery worker Michael Brown hoists his son Jimmy for a piggyback ride in the industrial Hampden district. Originally a mill town with cotton and flour mills, the neighborhood retained its vitality, even with mill closures, as workers found jobs in other parts of the city and new businesses moved in.

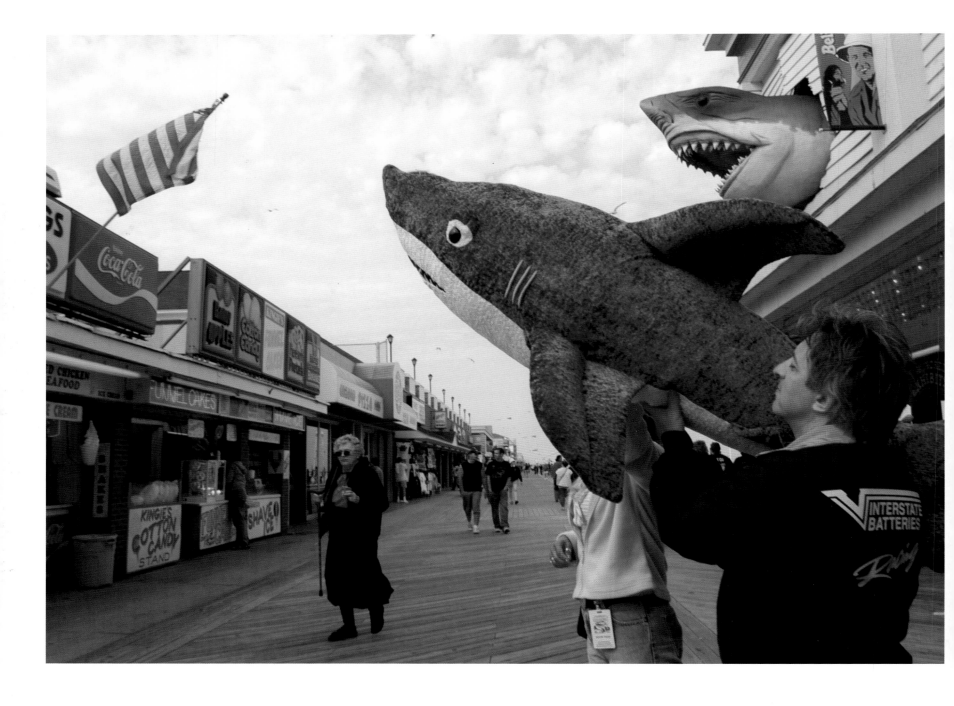

OCEAN CITY

Burt Cohen was coaxed into playing a boardwalk midway game by his sister-in-law, Rose Long. His aim was true, and the carney had to part with this big, stuffed predator.

Photo by Gunes Kocatepe

ELLICOTT CITY

Photographers Judy Herrmann and Mike Starke adopted Nick in October 2002. A month earlier, the year-old Akita was found wandering the streets of Washington, D.C., by the Humane Society, the victim of severe abuse and neglect. The dog was treated with Prozac and behavior modification training, and he got a second chance at life.

Photo by Herrmann + Starke

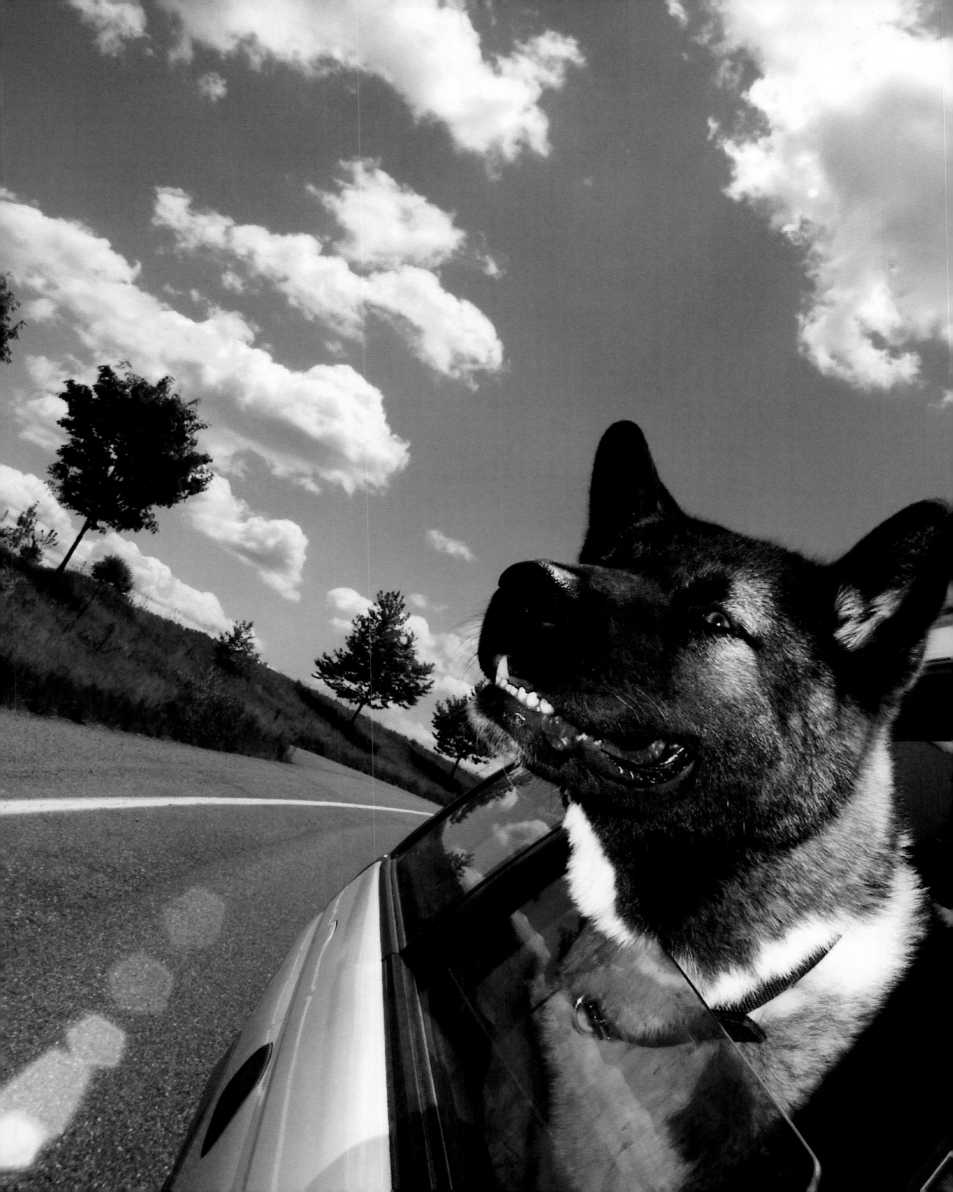

CARROLL COUNTY

Suburban sprawl threatens farmland across America. But Carroll County residents are determined to hang on to theirs. The county, northwest of Baltimore, has 1,041 active farms.

Photos by Perry Thorsvik

BALTIMORE

On weekends, sailors and powerboat owners flock to the marinas in the Canton section of Baltimore. Some of the salty dogs are live-aboards, and the harbor is their town, where the whistling wind in the rigging and the creaking of the docks is punctuated by an occasional siren's cry.

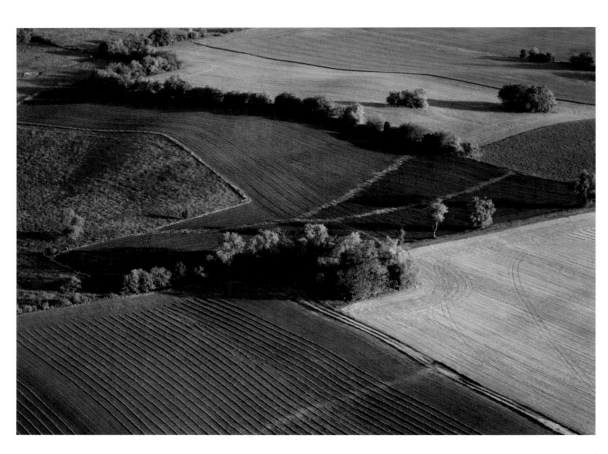

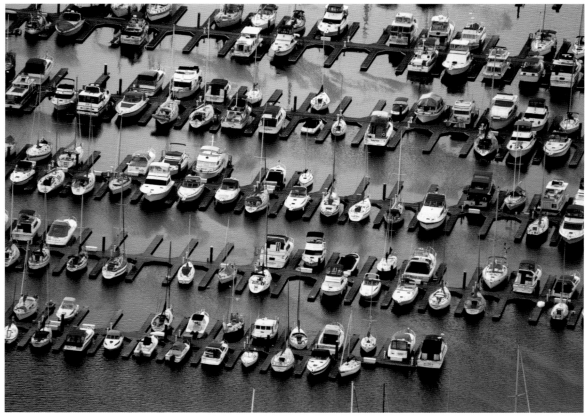

BALTIMORE

Most of the brick and Formstone rowhouses typical to the 230 square blocks of East Baltimore were built before 1900. House-proud residents of the blue-collar neighborhoods would scrub the white marble steps with bleach water to keep them bright. Some contemporary home buyers purchase two of the long narrow houses and combine them.

OCEAN CITY

Serving hundreds of thousands of beachgoers every summer, Ocean City and its beach, boardwalk, and pile of hotels typify the East Coast's city-by-the-beach resorts—from Coney Island to Atlantic City to Virginia Beach. Massive and ongoing sand replenishment efforts struggle to harness the soft shore at the edge of the stormy Atlantic.

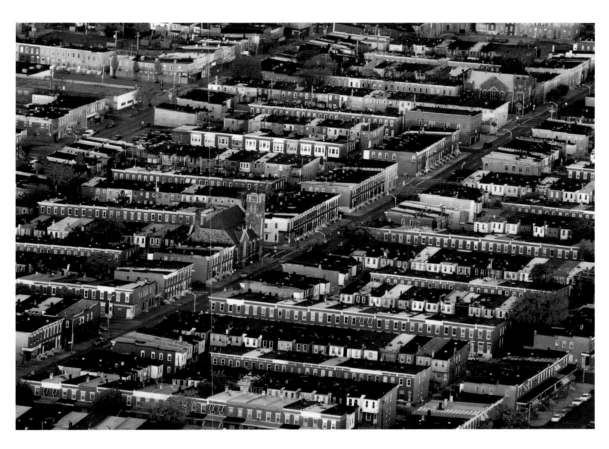

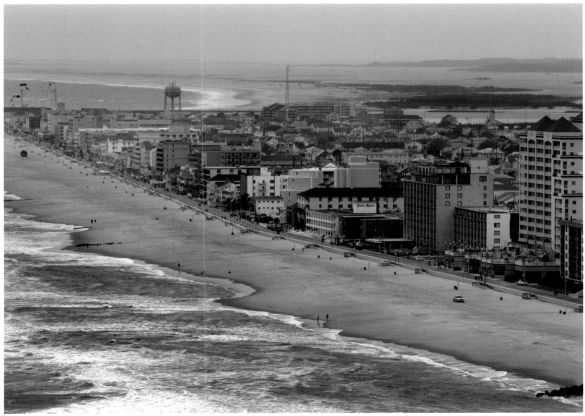

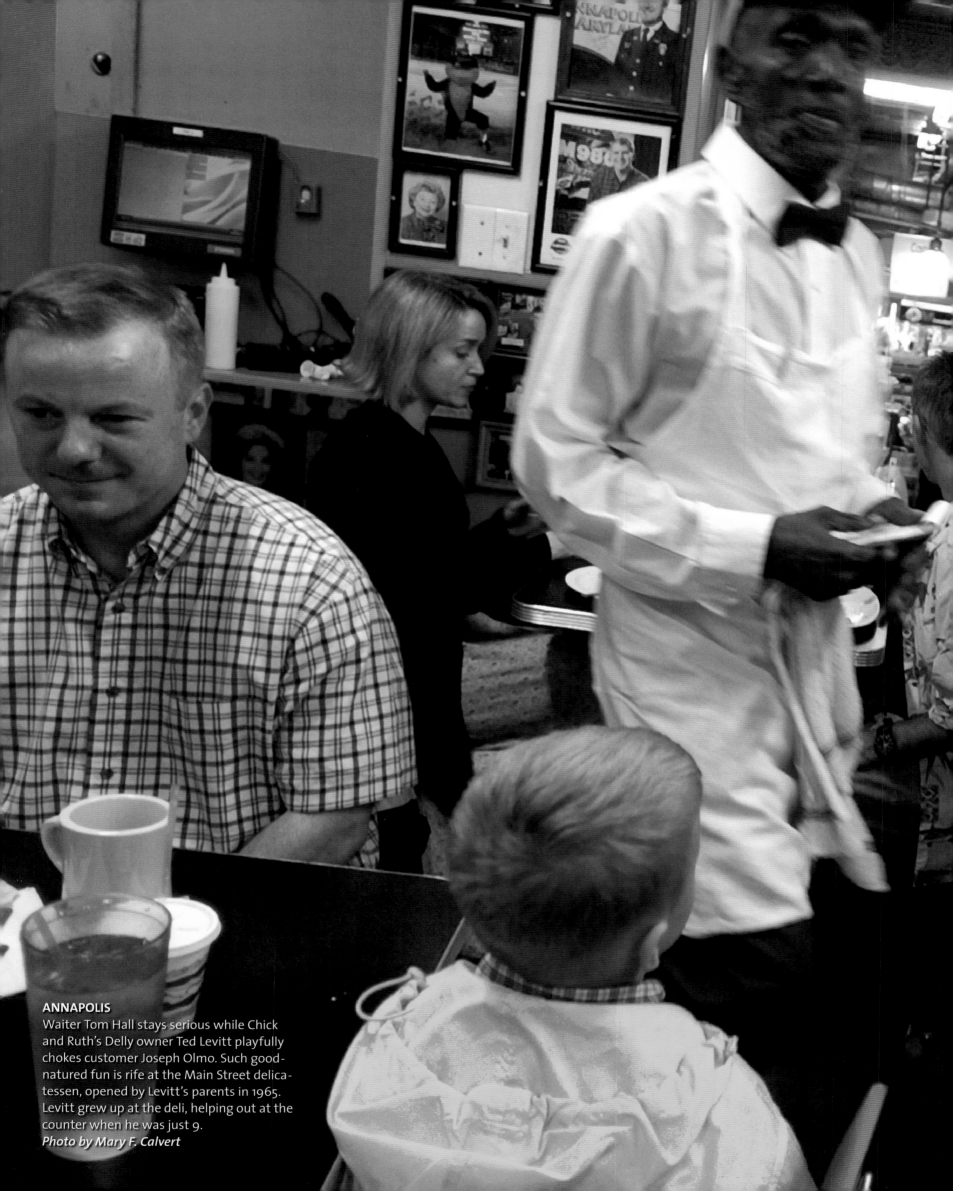

ANNAPOLIS

Waiter Tom Hall stays serious while Chick and Ruth's Delly owner Ted Levitt playfully chokes customer Joseph Olmo. Such good-natured fun is rife at the Main Street delicatessen, opened by Levitt's parents in 1965. Levitt grew up at the deli, helping out at the counter when he was just 9.

Photo by Mary F. Calvert

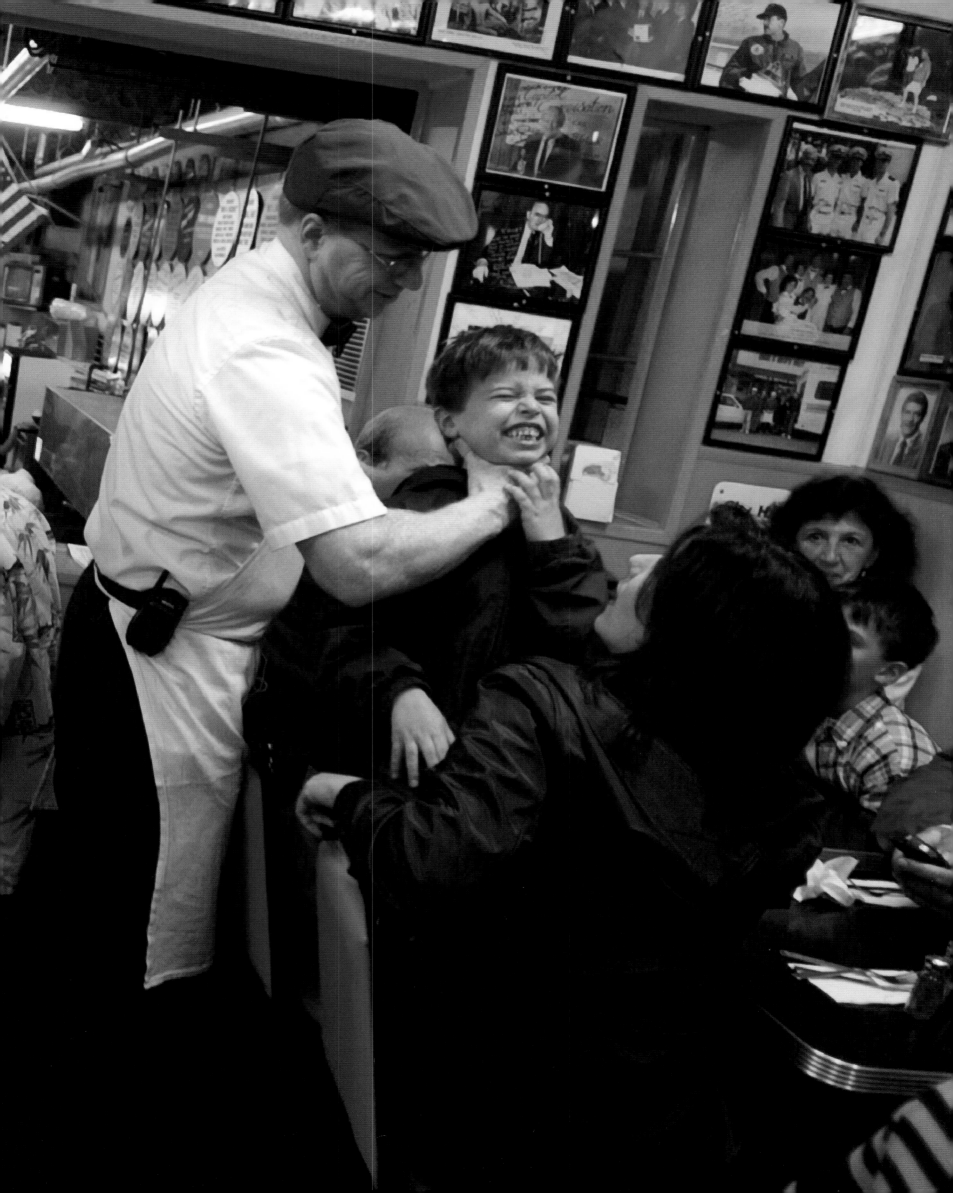

BALTIMORE

Federal Hill Park provides spectacular views of Baltimore's Inner Harbor area. A well-known lookout during the War of 1812 and the Civil War, Federal Hill got its name after the citywide celebration that followed Maryland's ratification of the U.S. Constitution. It's been a public park since 1879.
Photo by Tom Gregory

CLEAR SPRING

At the annual National Pike Days Parade, the Washington County Show Kids majorette troop marches along Route 40, aka the National Pike. Constructed in the 1920s, Route 40 ran 3,220 miles from Atlantic City to San Francisco.
Photo by Archie Carpenter

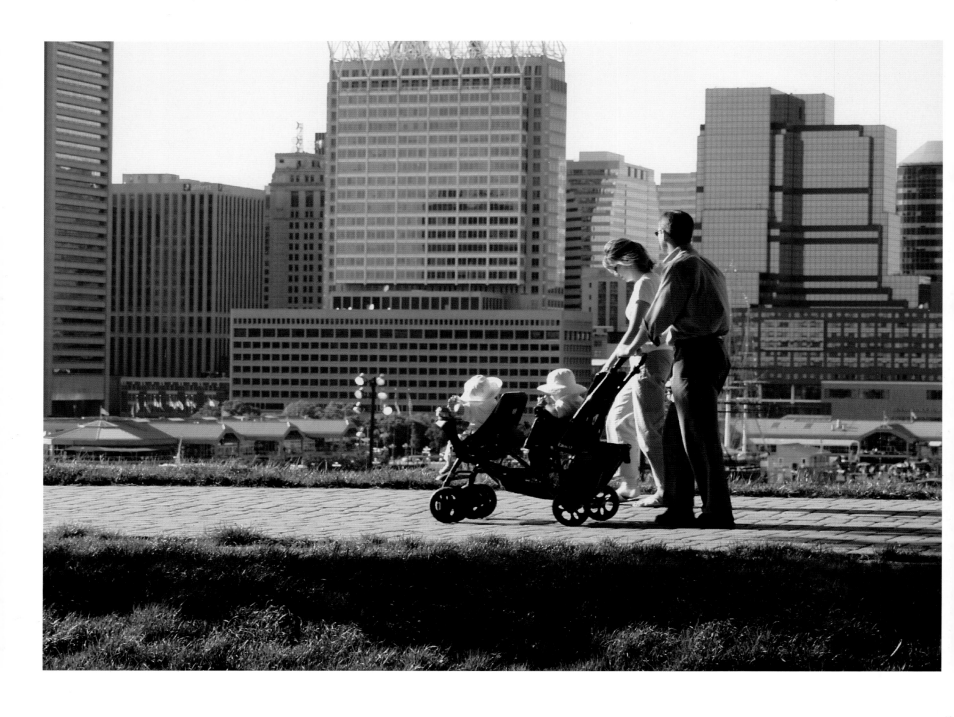

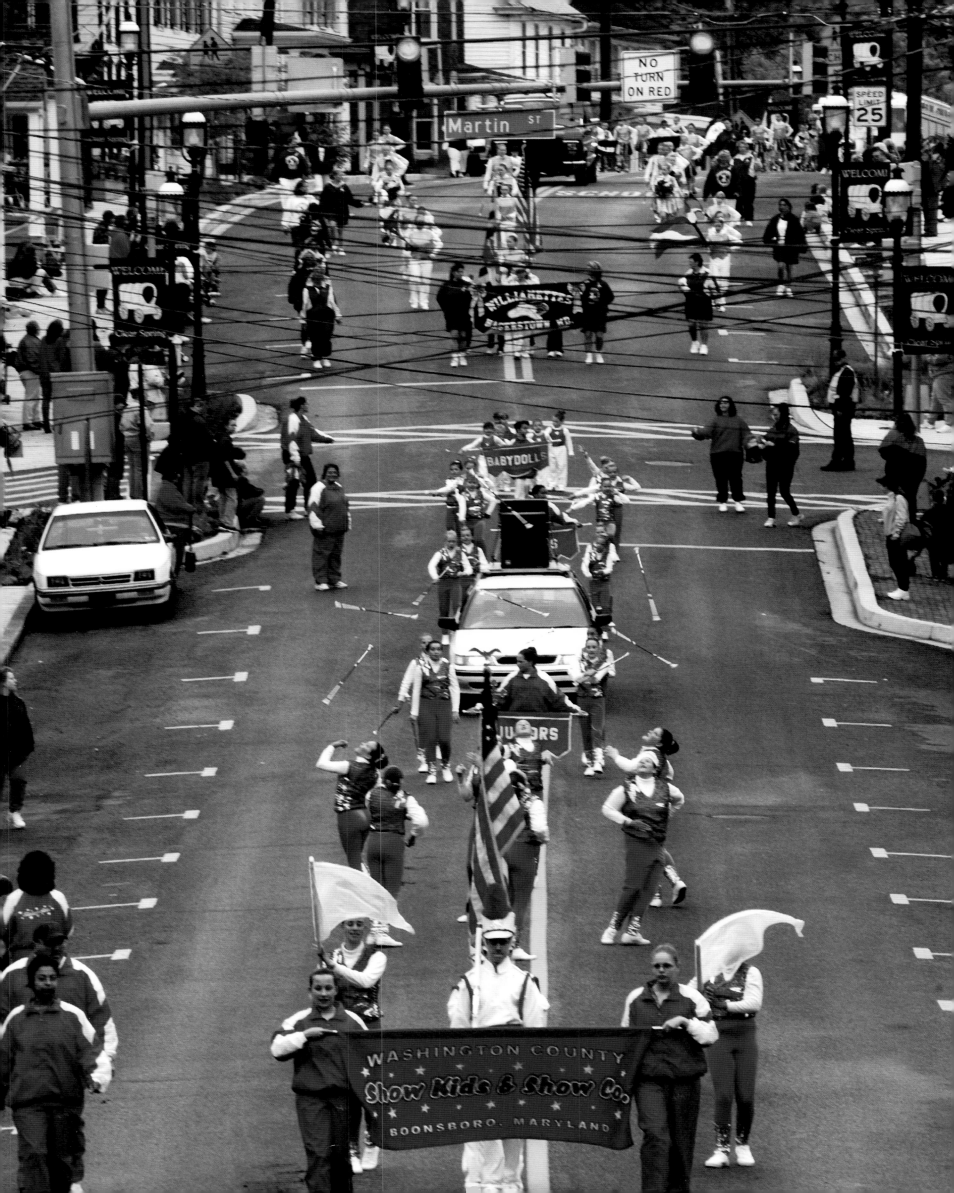

BALTIMORE/WASHINGTON AIRPORT
Four groups of travelers, one theme—they all flew into Maryland on the same day. Eighty-four-year-old Jane Briggs came from Albany, New York, to visit her granddaughter Terrell, who lives in Annapolis.
Photos by Matt Mendelsohn

BALTIMORE/WASHINGTON AIRPORT
Ann Formelier and her husband Gonzalo Redrobán, along with Nieve (Spanish for snow), stop to pose in front of the camera en route to their home in Quito, the capital of Ecuador.

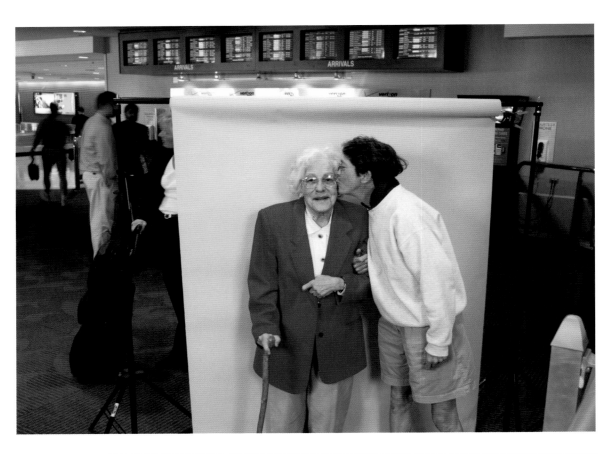

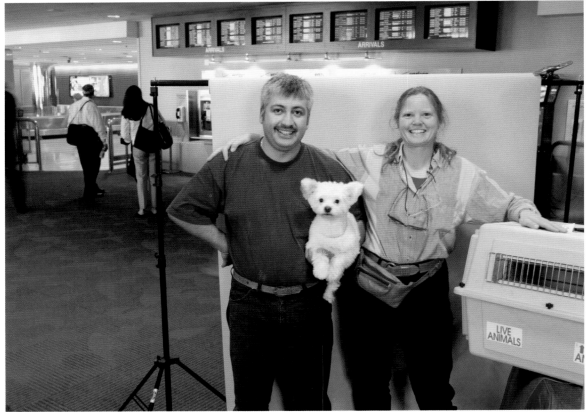

BALTIMORE/WASHINGTON AIRPORT
Pacemaker clinical specialist Randy Stephens of McCalla, Alabama, arrived for a North American Society of Pacing and Electrophysiology conference in Washington, D.C.

BALTIMORE/WASHINGTON AIRPORT
Lisa Leon flew in from Port Jefferson, New York, to visit her sister Diane Mullins of Centreville, Virginia. The young mothers visit at least four times a year.

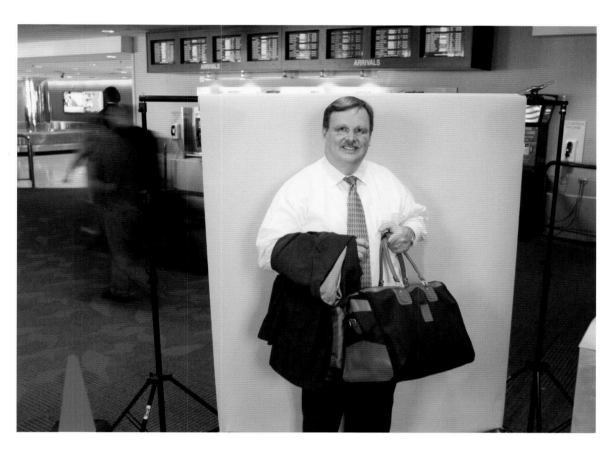

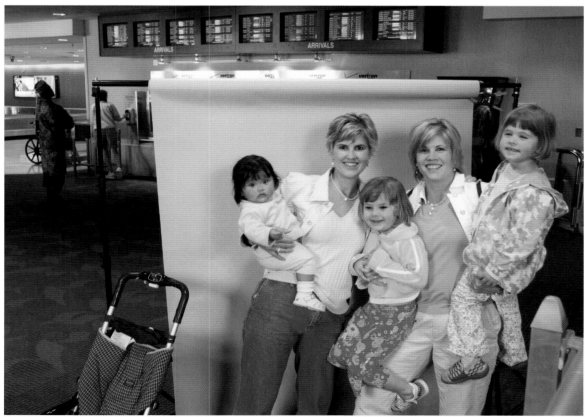

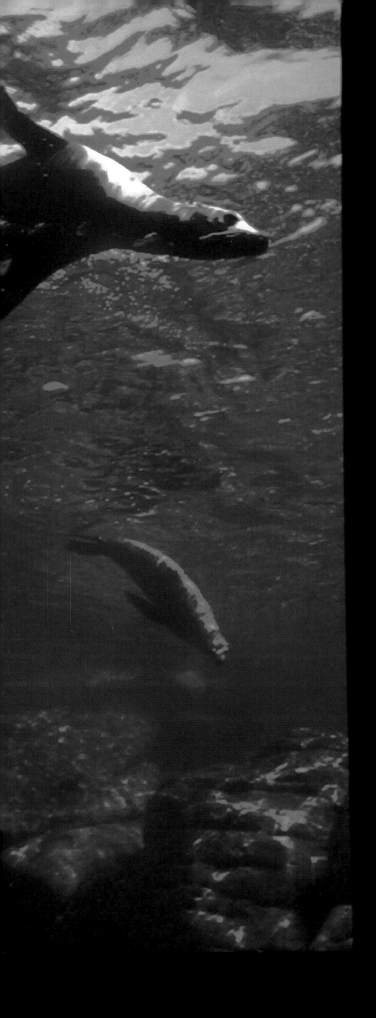

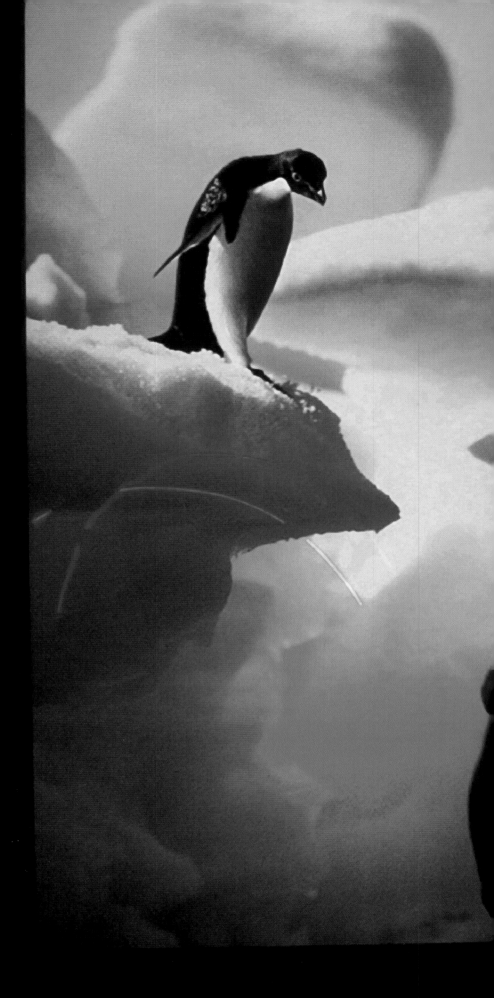

BALTIMORE
Opened in 1981, the National Aquarium has played a major role in the revitalization of downtown Baltimore as a destination. The state's biggest tourist attraction draws 1.6 million visitors annually. Here, visitors pass a backlit photo of arctic aquatic life.
Photo by Doug Kapustin, The Baltimore Sun

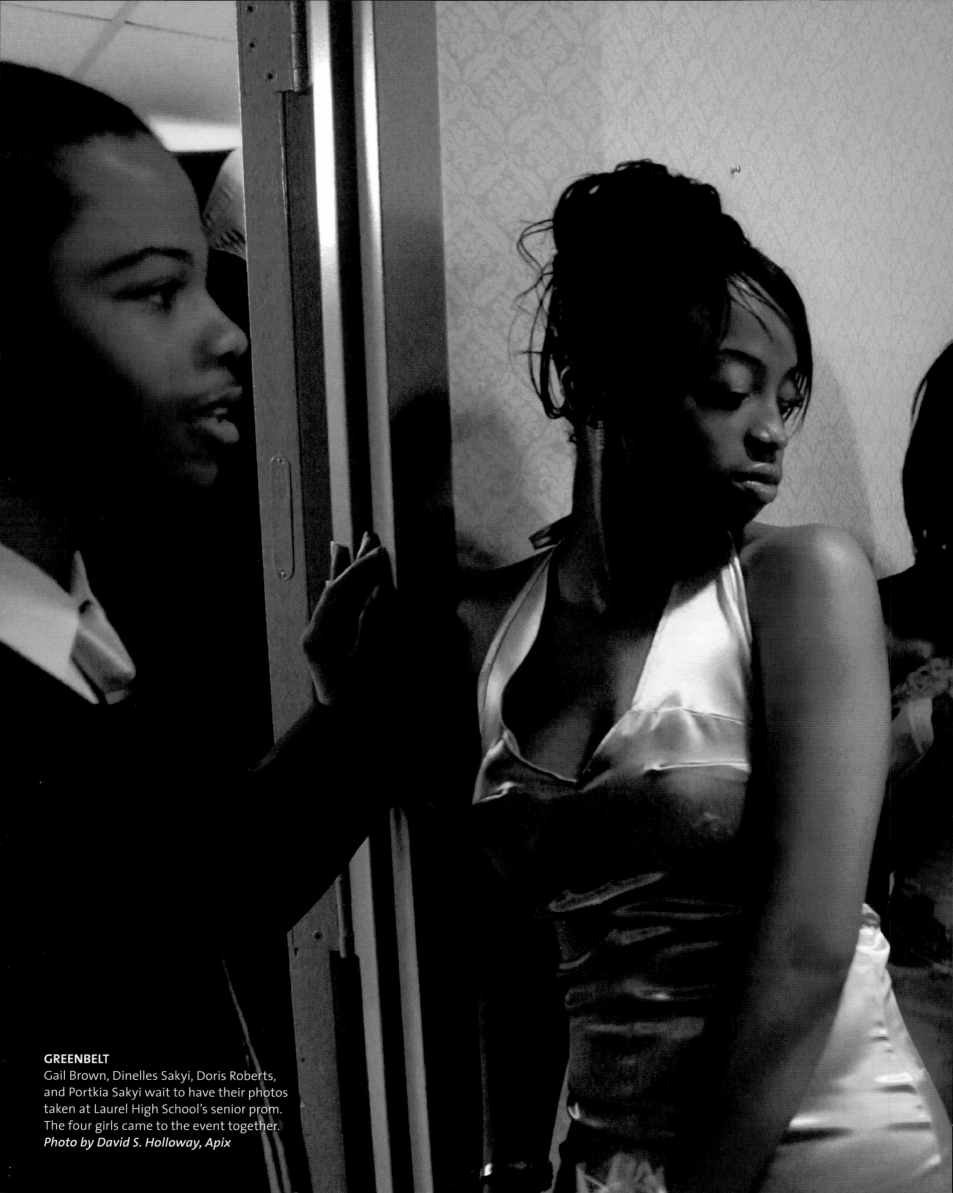

GREENBELT
Gail Brown, Dinelles Sakyi, Doris Roberts, and Portkia Sakyi wait to have their photos taken at Laurel High School's senior prom. The four girls came to the event together.
Photo by David S. Holloway, Apix

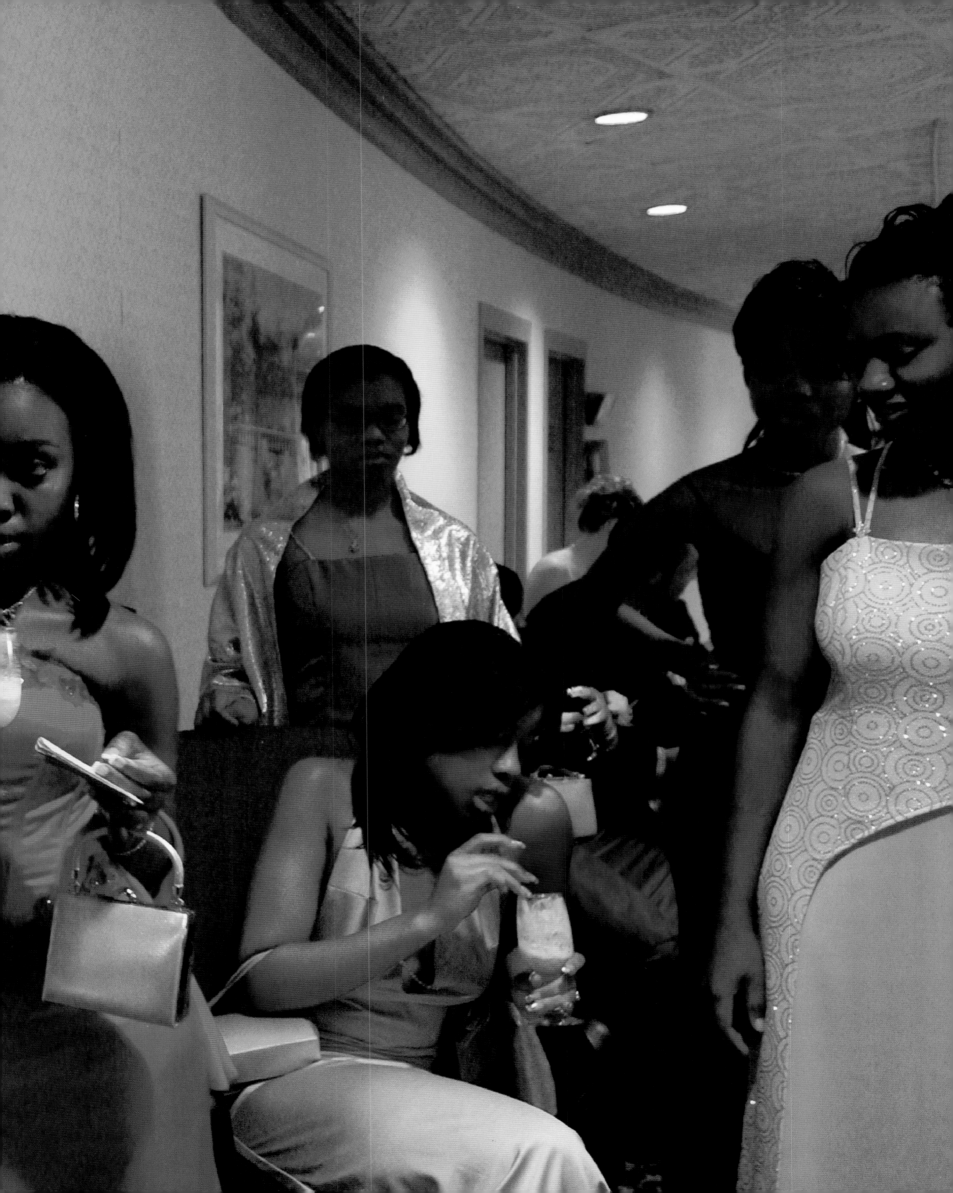

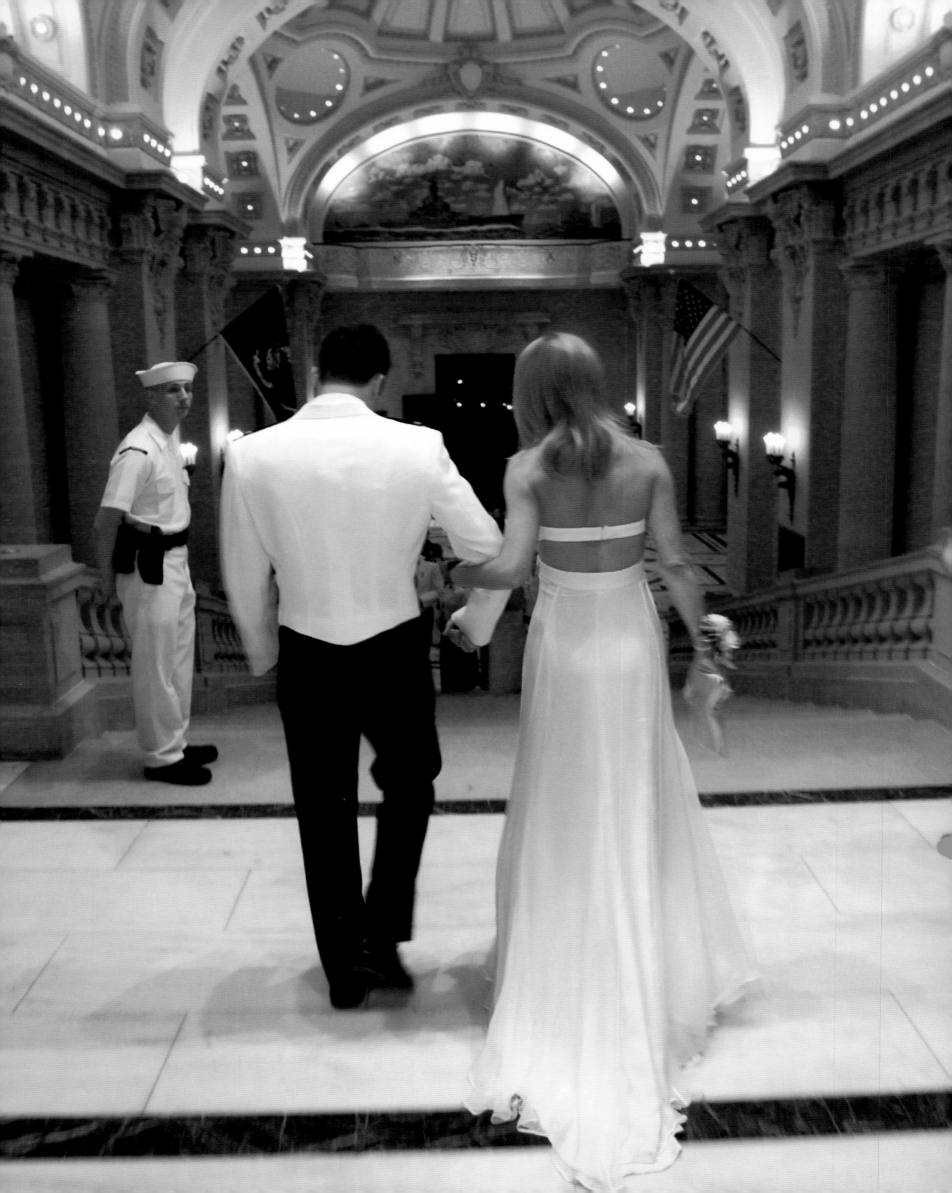

ANNAPOLIS

Midshipman Robert Madel landed himself a date with a supermodel when Estée Lauder chairman Leonard Lauder gave a speech on risk-taking at the U.S. Naval Academy. After the speech, Madel asked the cosmetics heir to arrange a date for him. Lauder was impressed, and Carolyn Murphy ("the face of Estée Lauder") said she'd be honored to attend Madel's Ring Dance with him.

Photos by John Harrington, Black Star

ANNAPOLIS

Between songs at their Ring Dance, Naval Academy juniors dip their class rings into a binnacle filled with water from the nearby Severn River and the world's oceans. The second class midshipmen wear their rings with the Naval Academy seal facing outward. After graduating, they turn them inward, facing their hearts.

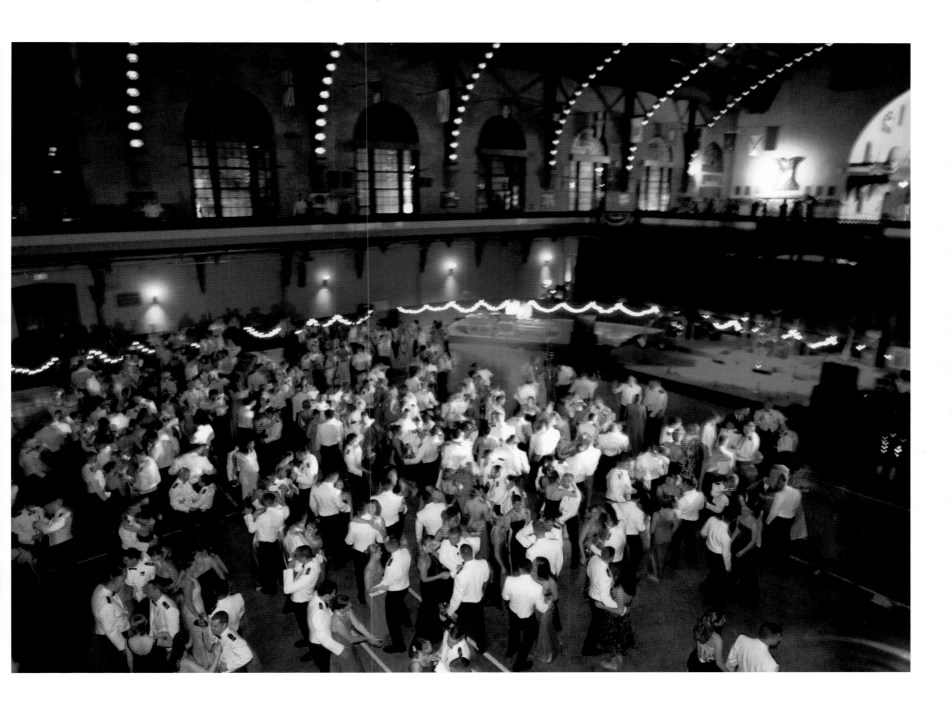

BALTIMORE
The Domino Sugar refinery on Baltimore's Inner
Harbor opened in 1922. Twenty-nine years later,
the 70-by-120-foot neon sign made its debut.
With the onset of the 1974 energy crisis, the sign
went dark and remained so until it once again lit
up the Baltimore sky in 1983.
Photos by Tom Gregory

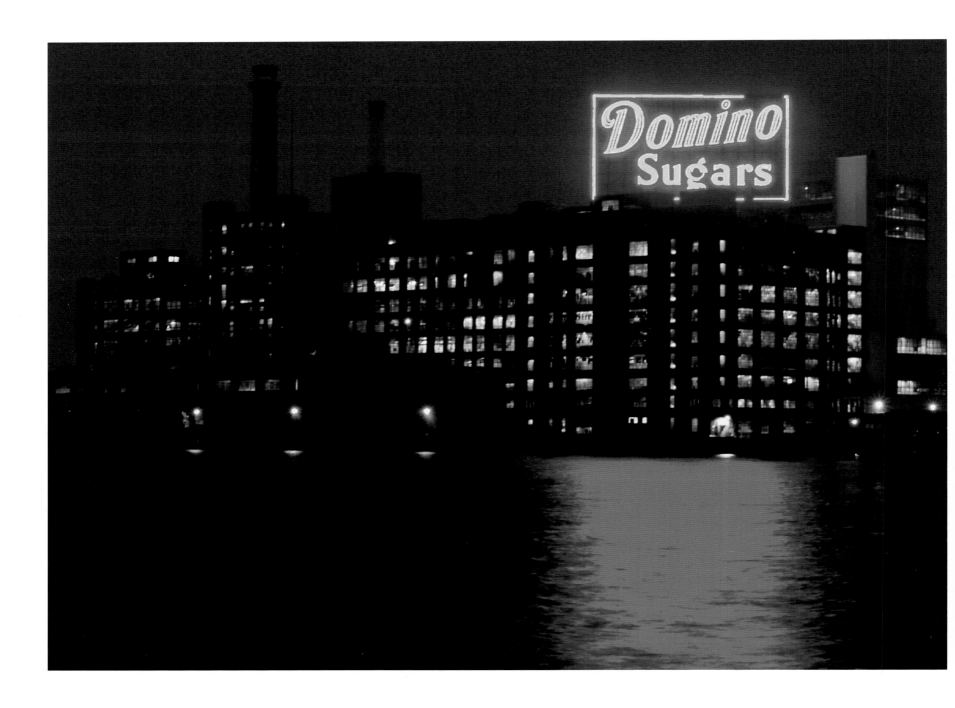

BALTIMORE

Originally used to advertise the 1998 "Love: Error and Eros" show at the American Visionary Art Museum's tall-sculpture barn, the neon love sign is now a permanent fixture. Just down the street is the main building of the museum, which only exhibits work done by self-taught artists, such as a 15-foot replica of the *Lusitania*—made from 193,000 toothpicks.

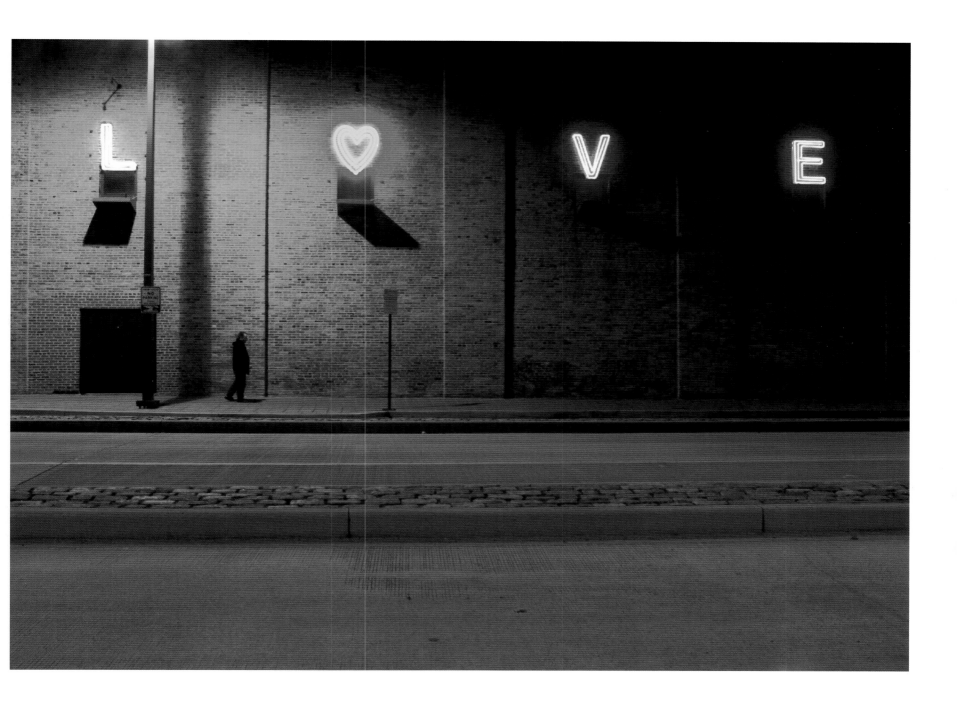

BALTIMORE

The Club Charles on North Charles Street is one of Baltimore's most atmospheric and hippest bars. Its eclectic crowd—ad execs, artsy types, jocks in baseball caps, celebs—is matched by its eclectic jukebox.

Photos by Dennis Drenner

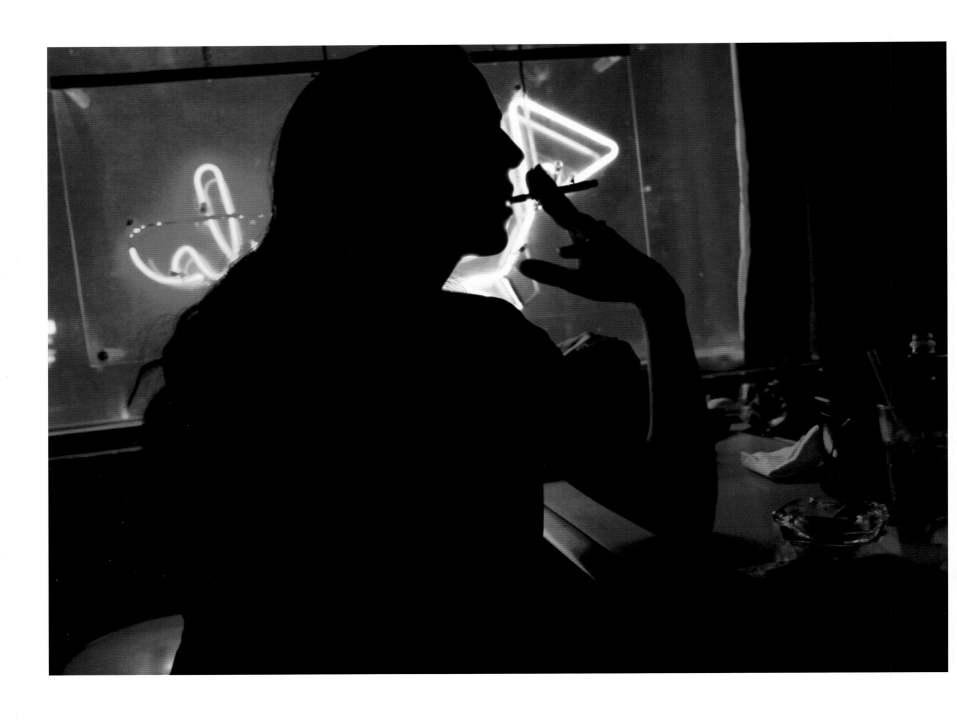

BALTIMORE

The Latin Palace is located on Broadway, in the heart of Baltimore's growing Latino district. On weekend nights, salsa and merengue junkies pack the large dance floor.

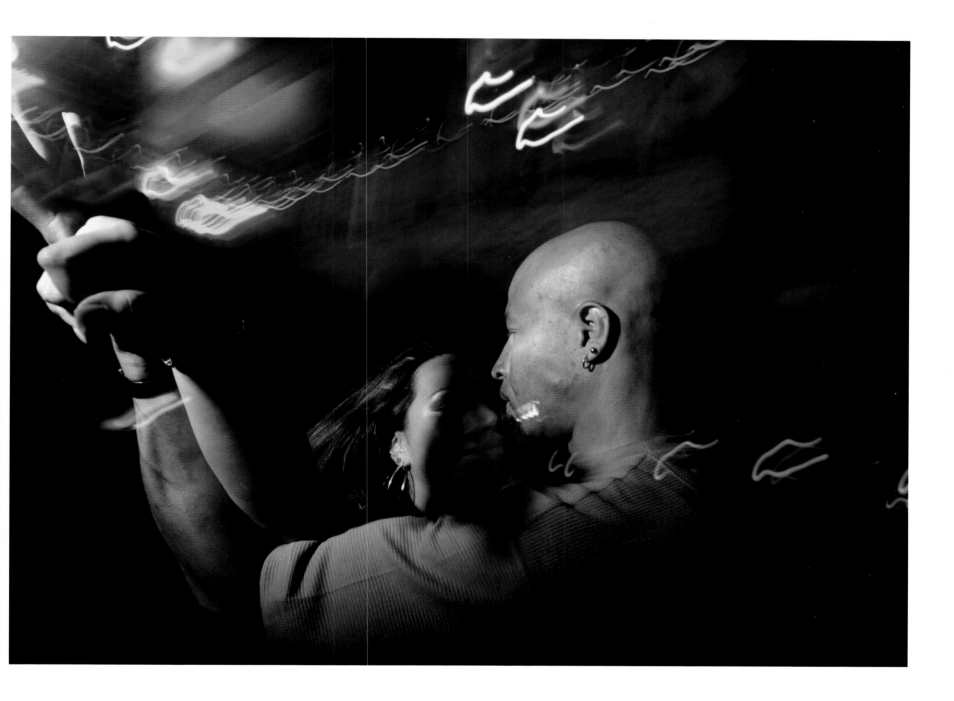

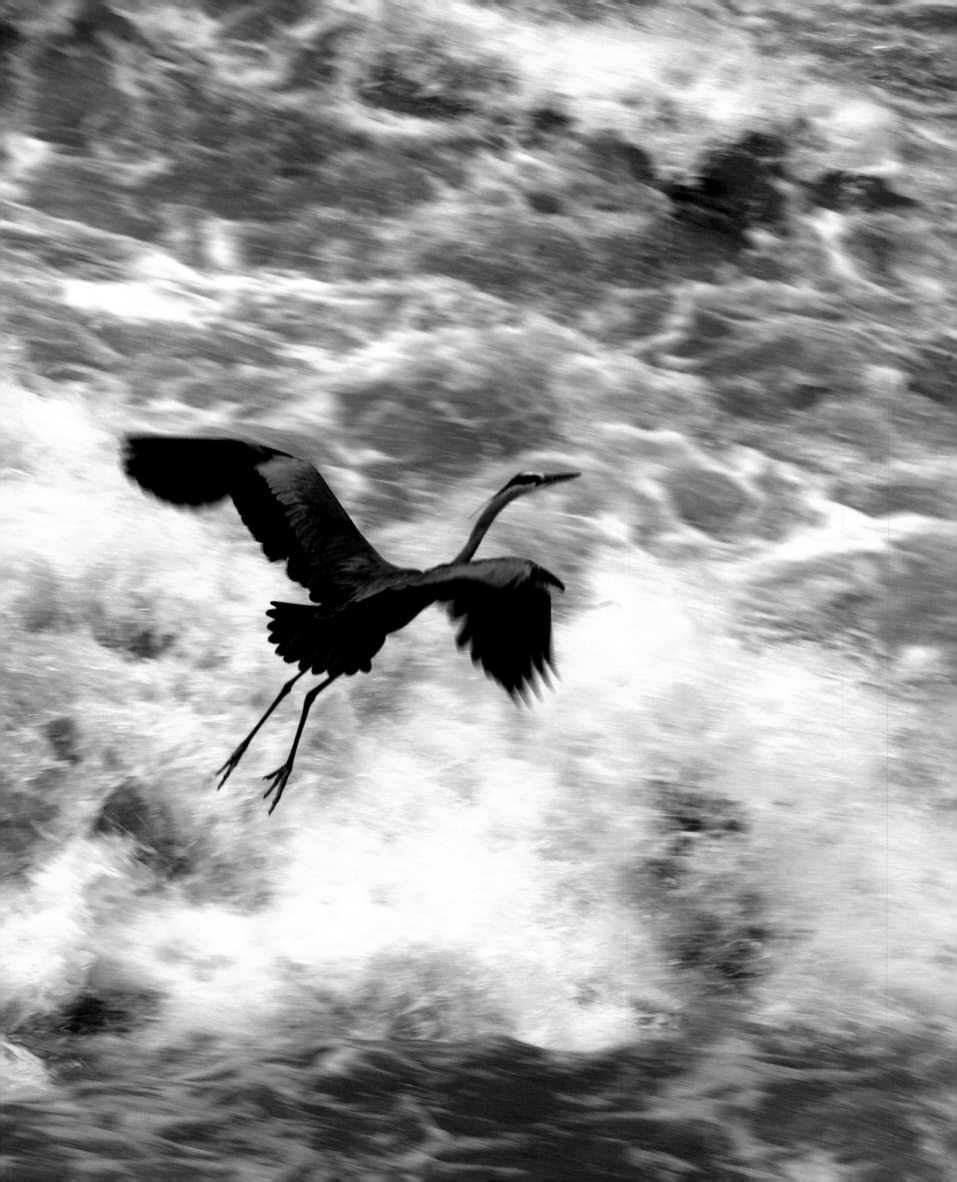

MONTGOMERY COUNTY

A blue heron takes off over the Great Falls of the Potomac. Dropping 76 feet over a course of two-thirds of a mile, the series of cascades and rapids is located upstream from Washington, D.C.
Photo by Susana Raab

SMITH ISLAND

An old oyster "buy boat" chugs out of Levins Creek toward Chesapeake Bay and the setting sun. The state's only inhabited island is home to a centuries-old community of watermen, but weekenders, polluted oyster beds, and rising water levels threaten their way of life.
Photo by David Harp,
Chesapeake Photos

HARFORD COUNTY

On a rainy Sunday morning, fishermen cast their flys into the Susquehanna River just below the Conowingo Dam. Named for the Susquehannocks people, the river rises in New York and drains 27,500 square miles of Pennsylvania and Maryland before emptying into Chesapeake Bay.
Photo by Jerry Jackson

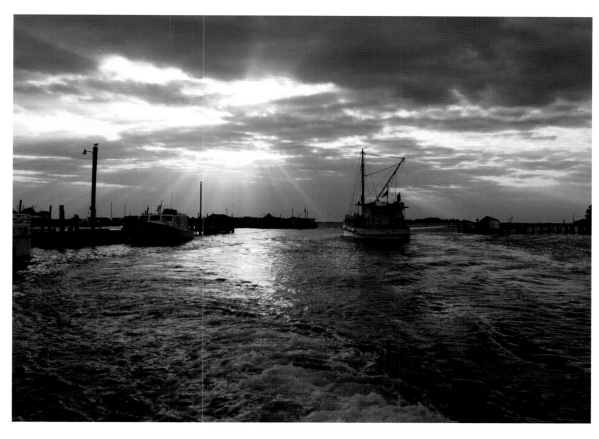

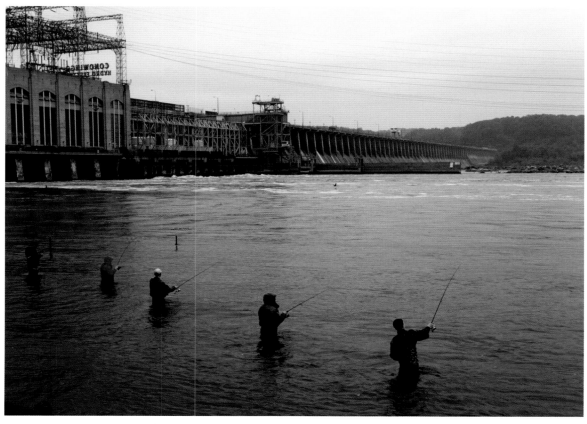

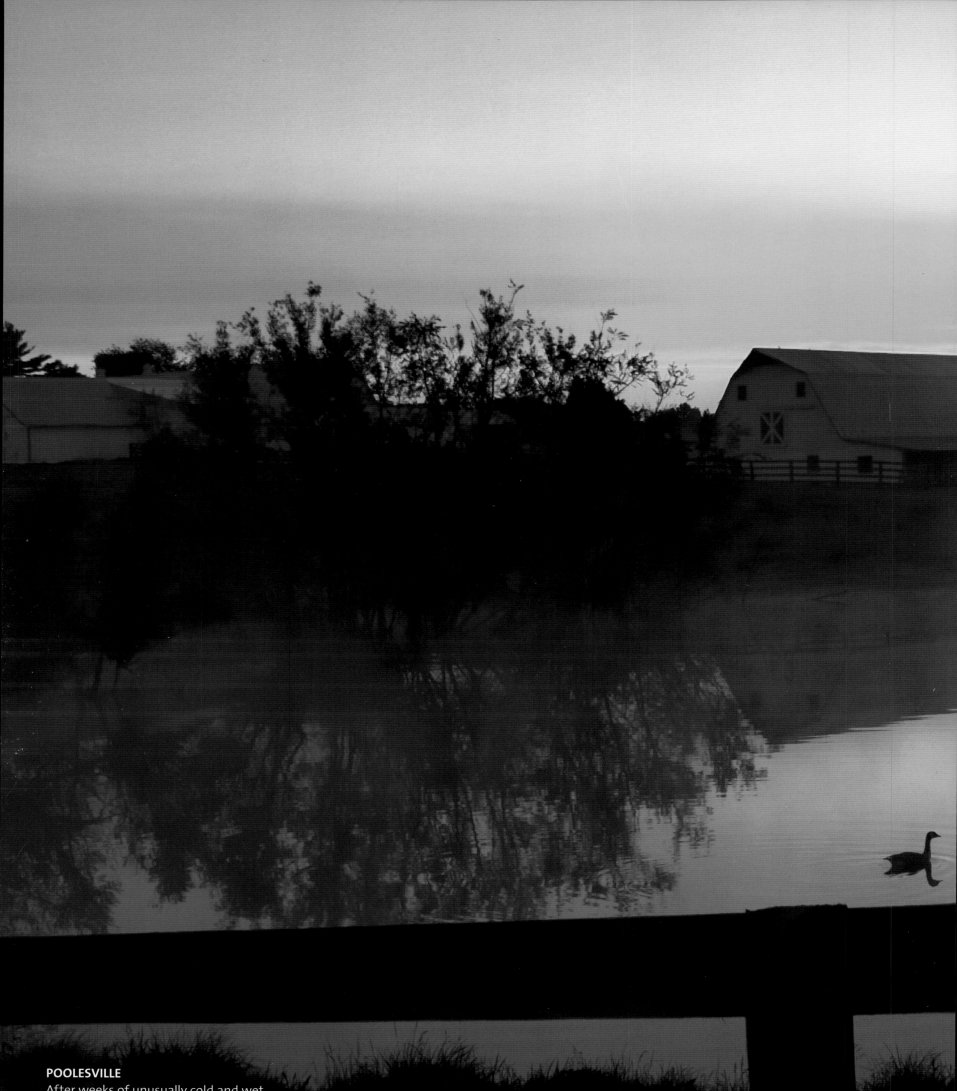

POOLESVILLE
After weeks of unusually cold and wet
spring weather, a clear daybreak blooms
over a Montgomery County farm.
Photo by Hugh Allan Flick

How It Worked

The week of May 12-18, 2003, more than 25,000 professional and amateur photographers spread out across the nation to shoot over a million digital photographs with the goal of capturing the essence of daily life in America.

The professional photographers were equipped with Adobe Photoshop and Adobe Album software, Olympus C-5050 digital cameras, and Lexar Media's high-speed compact flash cards.

The 1,000 professional contract photographers plus another 5,000 stringers and students sent their images via FTP (file transfer protocol) directly to the *America 24/7* website. Meanwhile, thousands of amateur photographers uploaded their images to Snapfish's servers.

At *America 24/7*'s Mission Control headquarters, located at CNET in San Francisco, dozens of picture editors from the nation's most prestigious publications culled the images down to 25,000 of the very best, using Photo Mechanic by Camera Bits. These photos were transferred into Webware's ActiveMedia Digital Asset Management (DAM) system, which served as a central image library and enabled the designers to track, search, distribute, and reformat the images for the creation of the 51 books, foreign language editions, web and magazine syndication, posters, and exhibitions.

Once in the DAM, images were optimized (and in some cases resampled to increase image resolution) using Adobe Photoshop. Adobe InDesign and Adobe InCopy were used to design and produce the 51 books, which were edited and reviewed in multiple locations around the world in the form of Adobe Acrobat PDFs. Epson Stylus printers were used for photo proofing and to produce large-format images for exhibitions. The companies providing support for the *America 24/7* project offer many of the essential components for anyone building a digital darkroom. We encourage you to read more on the following pages about their respective roles in making *America 24/7* possible.

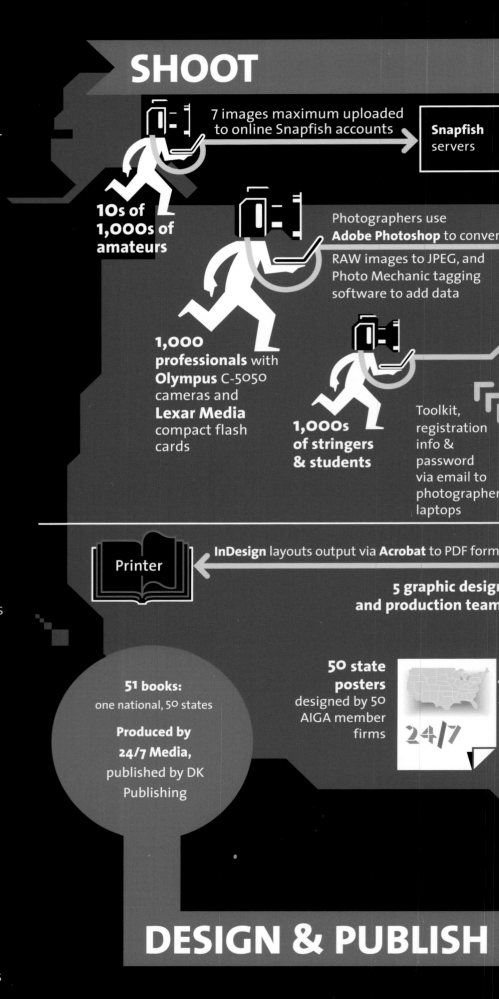

SHOOT

7 images maximum uploaded to online Snapfish accounts → **Snapfish** servers

10s of 1,000s of amateurs

Photographers use **Adobe Photoshop** to convert RAW images to JPEG, and Photo Mechanic tagging software to add data

1,000 professionals with **Olympus** C-5050 cameras and **Lexar Media** compact flash cards

1,000s of stringers & students

Toolkit, registration info & password via email to photographer laptops

Printer ← **InDesign** layouts output via **Acrobat** to PDF format

5 graphic design and production team

51 books: one national, 50 states

Produced by 24/7 Media, published by DK Publishing

50 state posters designed by 50 AIGA member firms

24/7

DESIGN & PUBLISH

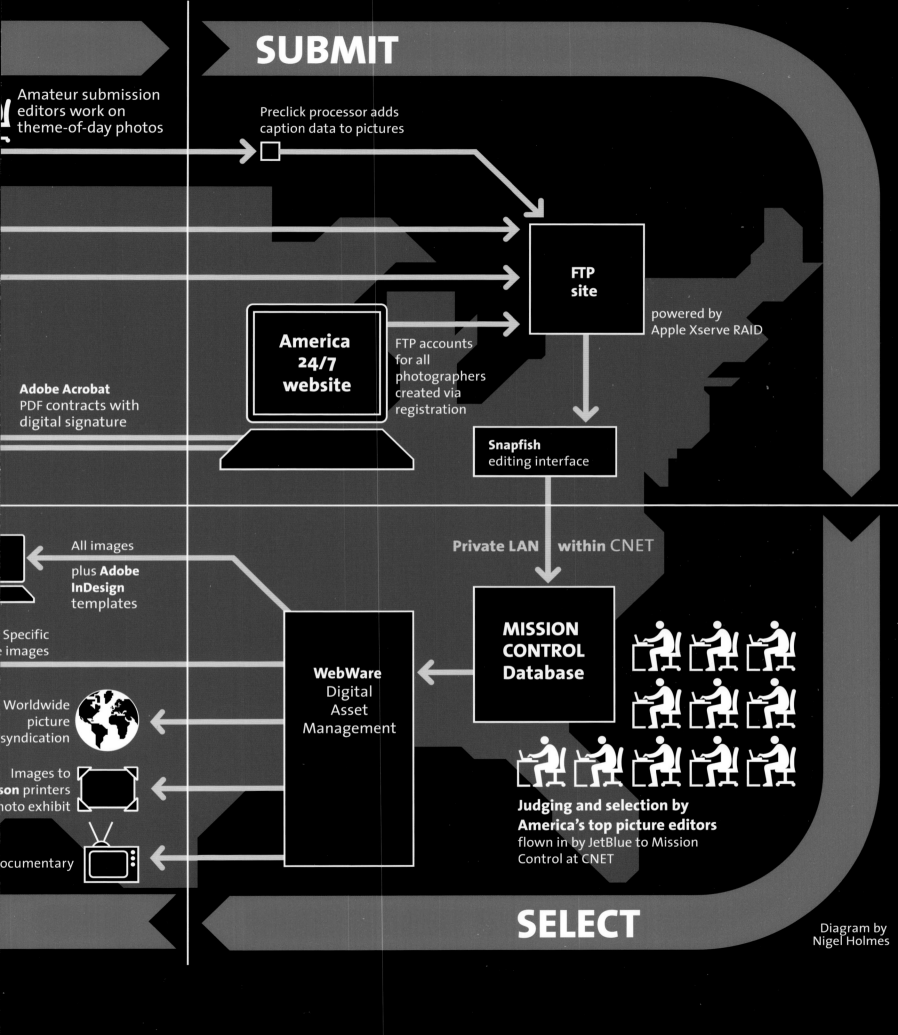

SUBMIT

Amateur submission editors work on theme-of-day photos

Preclick processor adds caption data to pictures

FTP site

powered by Apple Xserve RAID

Adobe Acrobat PDF contracts with digital signature

America 24/7 website

FTP accounts for all photographers created via registration

Snapfish editing interface

All images

plus **Adobe InDesign** templates

Specific images

Private LAN **within** CNET

MISSION CONTROL Database

WebWare Digital Asset Management

Worldwide picture syndication

Images to **son** printers **oto** exhibit

Judging and selection by America's top picture editors flown in by JetBlue to Mission Control at CNET

ocumentary

SELECT

Diagram by Nigel Holmes

Maryland 24/7

About Our Sponsors

America 24/7 gave digital photographers of all levels the opportunity to share their visions of what it means to live in the United States. This project was made possible by a digital photography revolution that is dramatically changing and improving picture-taking for professionals and amateurs alike. And an Adobe product, Photoshop®, has been at the center of this sea change.

Adobe's products reflect our customers' passion for the creative process, be it the photographer, graphic designer, layout artist, or printer. Adobe is the Publishing and Imaging Software Partner for *America 24/7* and products such as Adobe InDesign®, Photoshop, Acrobat®, and Illustrator® were used to produce this stunning book in a matter of weeks. We hope that our software has helped do justice to the mythic images, contributed by well-known photographers and the inspired hobbyist.

Adobe is proud to be a lead sponsor of *America 24/7*, a project that celebrates the vibrancy of the American spirit: the same spirit that helped found Adobe and inspires our employees and customers to deliver the very best.

Bruce Chizen
President and CEO
Adobe Systems Incorporated

Olympus, a global technology leader in designing precision healthcare solutions and innovative consumer electronics, is proud to be the official digital camera sponsor of *America 24/7*. The opportunity to introduce Americans from coast to coast to the thrill, excitement, and possibility of digital photography makes the vision behind this book a perfect fit for Olympus, a leader in digital cameras since 1996.

For most people, the essence of digital photography is best grasped through firsthand experience with the technology, which is precisely what *America 24/7* is about. We understand that direct experience is the pathway to inspiration, and welcome opportunities like this sponsorship to bring the power of the digital experience into the lives of people everywhere. To Olympus, *America 24/7* offers a platform to help realize a core mission: to deliver and make accessible the power of the digital experience to millions of American photographers, amateurs, and professionals alike.

The 1,000 professional photographers contracted to shoot on the America 24/7 project were all equipped with Olympus C-5050 digital cameras. Like all Olympus products, the C-5050 is offered by a company well known for designing, manufacturing, and servicing products used by professionals to perform their work, every day. Olympus is a customer-centric company committed to working one-to-one with a diverse group of professionals. From biomedical researchers who use our clinical microscopes, to doctors who perform life-saving procedures with our endoscopes, to professional photographers who use cameras in their daily work, Olympus is a trusted brand.

The digital imaging technology involved with *America 24/7* has enabled the soul of America to be visually conveyed, not just by professional observers, but by the American public who participated in this project—the very people who collectively breath life into this country's existence each day.

We are proud to be enabling so many photographers to capture the pictures on these pages that tell the story of who we are as a nation. From sea to shining sea, digital imagery allows us to connect to one another in ways we never dreamed possible.

At Olympus, our ideas have proliferated as rapidly as technology has evolved. We have channeled these visions into breakthrough products and solutions to meet the demands of our changing world-products like microscopes, endoscopes, and digital voice recorders, supported by the highly regarded training, educational, and consulting services we offer our customers.

Today, 83 years after we introduced our first microscope, we remain as young, as curious, and as committed as ever.

Lexar Media has grown from the digital photography revolution, which is why we are proud to have supplied the digital memory cards used in the America 24/7 project. Lexar Media's high-performance memory cards utilize our unique and patented controller coupled with high-speed flash memory from Samsung, the world's largest flash memory supplier. This powerful combination brings out the ultimate performance of any digital camera.

Photographers who demand the most from their equipment choose our products for their advanced features like write speeds up to 40X, Write Acceleration technology for enabled cameras, and Image Rescue, which recovers previously deleted or lost images. Leading camera manufacturers bundle Lexar Media digital memory cards with their cameras because they value its performance and reliability.

Lexar Media is at the forefront of digital photography as it transforms picture-taking worldwide, and we will continue to be a leader with new and innovative solutions for professionals and amateurs alike.

Snapfish, which developed the technology behind the *America 24/7* amateur photo event, is a leading online photo service, with more than 5 million members and 100 million photos posted online. Snapfish enables both film and digital camera owners to share, print, and store their most important photo memories, at prices that cannot be equaled. Digital camera users upload photos into a password-protected online album for free. Users can also order film-quality prints on professional photographic paper for as low as 25¢. Film camera users get a full set of prints, plus online sharing and storage, for just $2.99 per roll.

Founded in 1995, eBay created a powerful platform for the sale of goods and services by a passionate community of individuals and businesses. On any given day, there are millions of items across thousands of categories for sale on eBay. eBay enables trade on a local, national and international basis with customized sites in markets around the world.

Through an array of services, such as its payment solution provider PayPal, eBay is enabling global e-commerce for an ever-growing online community.

JetBlue Airways is proud to be *America 24/7's* preferred carrier, flying photographers, photo editors, and organizers across the United States.

Winner of Condé Nast Traveler's Readers' Choice Awards for Best Domestic Airline 2002, JetBlue provides friendly service and low fares for travelers in 22 cities in nine states across America.

On behalf of JetBlue's 5,000 crew members, we're excited to be involved in this remarkable project, and for the opportunity to serve American travelers each and every day, coast to coast, 24/7.

DIGITAL POND

Digital Pond has been a leading creator of large graphic displays for museums, corporations, trade shows, retail environments and fine art since 1992.

We were proud to bring together our creative, print and display capabilities to produce signage and displays for mission control, critical retouching for numerous key images for the book, and art galleries for the New York Public Library and Bryant Park.

The Pond's team and SplashPic® Online service enabled us to nimbly design, produce and install over 200 large graphic panels in two NYC locations within the truly "24/7" production schedule of less than ten days.

WebWare Corporation is pleased to be a major sponsor of the America 24/7 project. We take pride in being part of a groundbreaking adventure that is stretching the boundaries—and the imagination—in digital photography, digital asset management, publishing, news, and global events.

Our ActiveMedia Enterprise™ digital asset management software is the "nerve center" of *America 24/7*, the central repository for managing, sharing, and collaborating on the project's photographs. From photo editors and book publishers to 24/7's media relations and marketing personnel, ActiveMedia provides the application support that links all facets of the project team to the content worldwide.

WebWare helps Global 2000 firms securely manage, reuse, and distribute media assets locally or globally. Its suite of ActiveMedia software products provide powerful media services platforms for integrating rich media into content management systems marketing and communication portals; web publishing systems; and e-commerce portals.

Google's mission is to organize the world's information and make it universally accessible and useful.

With our focus on plucking just the right answer from an ocean of data, we were naturally drawn to the America 24/7 project. The book you hold is a compendium of images of American life distilled from thousands of photographs and infinite possibilities. Are you looking for emotion? Narrative? Shadows? Light? It's all here, thanks to a multitude of photographers and writers creating links between you, the reader, and a sea of wonderful stories. We celebrate the connections that constitute the human experience and are pleased to help engender them. And we're pleased to have been a small part of this project, which captures the results of that interaction so vividly, so dynamically, and so dramatically.

Special thanks to additional contributors: FileMaker, Apple, Camera Bits, LaCie, Now Software, Preclick, Outpost Digital, Xerox, Microsoft, WoodWing Software, net-linx Publishing Solutions, and Radical Media. The Savoy Hotel, San Francisco; The Pan Pacific, San Francisco; Four Seasons Hotel, San Francisco; and The Queen Anne Hotel. Photography editing facilities were generously hosted by CNET Networks, Inc.

Participating Photographers

Maryland Coordinator: Jim Preston, Assistant Managing Editor for Photography, *The Baltimore Sun*

Richard Baillieul
Susan Biddle
Shannon Bishop
Jim Burger
Mary F. Calvert
Archie Carpenter
Amy Deputy
Laurie DeWitt
Dennis Drenner
John Ficara
Joel Fisher
Hugh Allan Flick
Carol Rose Fordonski-Ronayne
Kevin T. Gilbert, Blue Pixel
Tom Gralish*, *The Philadelphia Inquirer*
Tom Gregory
Alison Harbaugh
David Harp, Chesapeake Photos
John Harrington, Black Star
Nanine Hartzenbusch*,
The Baltimore Sun
Craig Herndon
Judy Herrmann, Herrmann + Starke
David S. Holloway, Apix
Jerry Jackson
Karen Jackson

Joel Jang
MaryLou Jones
Doug Kapustin, *The Baltimore Sun*
Chiaki Kawajiri
Sari Klaff
Gunes Kocatepe
Rick Kozak, kofoto
Kenn Macintosh
Harvey Mateo
Matt Mendelsohn
Alexander Morozov
Jonathan Newton
Shell M. O'Connor
Dzung Pham
T. Prendergast, The Sensory Workshop
Jim Preston, *The Baltimore Sun*
James W. Prichard
Susana Raab
Edwin Remsberg
Scott Robinson
Neil Rothman
Michael Starke, Herrmann + Starke
Perry Thorsvik

*Pulitzer Prize winner

Thumbnail Picture Credits

Credits for thumbnail photographs are listed by the page number and are in order from left to right.

18 Timothy Jacobsen
Jonathan Newton
Scott Robinson
Joel Jang
Karen Jackson
Jerry Jackson
Timothy Jacobsen

19 T. Prendergast, The Sensory Workshop
Scott Robinson
Matt Mendelsohn
Tom Gralish, *The Philadelphia Inquirer*
Scott Robinson
Shannon Bishop
Alexander Morozov

20 Laurie DeWitt
Jerry Jackson
Laurie DeWitt
James W. Prichard
Kevin T. Gilbert, Blue Pixel
C. Barton-Lewis
Laurie DeWitt

21 Shell M. O'Connor
James W. Prichard
Scott Robinson
Shell M. O'Connor
Alexander Morozov
Sherry DiBari
Shell M. O'Connor

24 Edwin Remsberg
Kurtis Hartley
Herrmann + Starke
Jonathan Newton
Susan Biddle
Herrmann + Starke
James W. Prichard

25 Nanine Hartzenbusch, *The Baltimore Sun*
James W. Prichard
Nanine Hartzenbusch, *The Baltimore Sun*
James W. Prichard
Stacey Cramp
James W. Prichard
Nanine Hartzenbusch, *The Baltimore Sun*

26 J.M. O'Grady
Jonathan Newton
J.M. O'Grady
Scott Robinson
J.M. O'Grady
T. Prendergast, The Sensory Workshop
Hugh Allan Flick

27 Herrmann + Starke
T. Prendergast, The Sensory Workshop
Hugh Allan Flick
Hugh Allan Flick
Kurtis Hartley
L.S. King
James W. Prichard

30 Nanine Hartzenbusch, *The Baltimore Sun*
Amy Deputy
Nanine Hartzenbusch, *The Baltimore Sun*
Edwin Remsberg

Jonathan Newton
Hugh Allan Flick
James W. Prichard

31 Nanine Hartzenbusch, *The Baltimore Sun*
Edwin Remsberg
Laurie DeWitt
James W. Prichard
Laurie DeWitt
Shannon Bishop
Jonathan Newton

32 Amy Deputy
Edwin Remsberg
James W. Prichard
Becky A. Mullings
Alexander Morozov
Jonathan Newton
David Harp, Chesapeake Photos

33 Laurie DeWitt
Sherry DiBari
Joel Jang
James W. Prichard
Joel Jang
T. Prendergast, The Sensory Workshop
Shell M. O'Connor

36 Barbara L. Salisbury
Chiaki Kawajiri
Jonathan Newton
Chiaki Kawajiri
Barbara L. Salisbury
Chiaki Kawajiri
David S. Holloway, Apix

37 James W. Prichard
Jonathan Newton
Chiaki Kawajiri
Joel Jang
Sherry DiBari
Susana Raab
Edwin Remsberg

47 Doug Kapustin, *The Baltimore Sun*
Doug Kapustin, *The Baltimore Sun*
Doug Kapustin, *The Baltimore Sun*
Doug Kapustin, *The Baltimore Sun*
Doug Kapustin, *The Baltimore Sun*
Alison Harbaugh
Brien Aho

48 Jerry Jackson
Jerry Jackson
C. Barton-Lewis
Jerry Jackson
Mike Thorpe
Shannon Bishop
Jerry Jackson

49 Jerry Jackson
Jerry Jackson
C. Barton-Lewis
Jerry Jackson
Mike Thorpe
Jerry Jackson
James W. Prichard

52 Gunes Kocatepe
Gunes Kocatepe
John Ficara
Gunes Kocatepe
Gunes Kocatepe
Jerry Jackson
Nanine Hartzenbusch, *The Baltimore Sun*

53 John Ficara
Loretta K. Wilson
Gunes Kocatepe
John Ficara
Gunes Kocatepe
John Ficara
John Ficara

56 Doug Kapustin, *The Baltimore Sun*
David Harp, Chesapeake Photos
Jim Preston
David Harp, Chesapeake Photos
David Harp, Chesapeake Photos
David Harp, Chesapeake Photos
James W. Prichard

57 Herrmann + Starke
Herrmann + Starke
Herrmann + Starke
James W. Prichard
Laurie DeWitt
Herrmann + Starke
Herrmann + Starke

60 Herrmann + Starke
Jim Burger
Herrmann + Starke
Karen Jackson
Shell M. O'Connor
Laurie DeWitt
Karen Jackson

61 Herrmann + Starke
Herrmann + Starke
Jim Burger
Jim Burger
Jim Burger
Scott Robinson
Jim Burger

64 Rick Kozak, kofoto
Rick Kozak, kofoto
Kurtis Hartley
David Harp, Chesapeake Photos
David Harp, Chesapeake Photos
Shannon Bishop
Rick Kozak, kofoto

65 Kurtis Hartley
Kurtis Hartley
Shannon Bishop
Shannon Bishop
Shannon Bishop
Shannon Bishop
Shannon Bishop

70 James W. Prichard
James W. Prichard
Jim Preston
James W. Prichard
James W. Prichard
James W. Prichard
James W. Prichard

71 James W. Prichard
James W. Prichard
James W. Prichard
James W. Prichard
James W. Prichard
James W. Prichard
James W. Prichard

72 Gunes Kocatepe
Gunes Kocatepe
Laurie DeWitt
Craig Herndon
Craig Herndon
Susana Raab
Craig Herndon

73 Craig Herndon
Laurie DeWitt
Craig Herndon
Susana Raab
T. Prendergast, The Sensory Workshop
T. Prendergast, The Sensory Workshop
Craig Herndon

76 Gunes Kocatepe
Alexander Morozov
Gunes Kocatepe
Alexander Morozov
Herrmann + Starke
Gunes Kocatepe
Herrmann + Starke

77 Alexander Morozov
Herrmann + Starke
Alexander Morozov
Gunes Kocatepe
Alexander Morozov
Gunes Kocatepe
Herrmann + Starke

78 Dennis Drenner
Doug Kapustin, *The Baltimore Sun*
Dennis Drenner
James W. Prichard
James W. Prichard
David Scull, Apix
Dennis Drenner

79 James W. Prichard
Beverly Logan
James W. Prichard
Doug Kapustin, *The Baltimore Sun*
James W. Prichard
Doug Kapustin, *The Baltimore Sun*
James W. Prichard

80 Matt Mendelsohn
Doug Kapustin, *The Baltimore Sun*
Doug Kapustin, *The Baltimore Sun*
Matt Mendelsohn
Doug Kapustin, *The Baltimore Sun*
Doug Kapustin, *The Baltimore Sun*
Matt Mendelsohn

81 Kevin T. Gilbert, Blue Pixel
Laurie DeWitt
Pat Crowe II, *The News Journal*
Kevin T. Gilbert, Blue Pixel
James W. Prichard
Kevin T. Gilbert, Blue Pixel
Laurie DeWitt

84 Chiaki Kawajiri
Alison Harbaugh
Chiaki Kawajiri
Chuck Kennedy, Knight-Ridder, *Tribune*
Doug Kapustin, *The Baltimore Sun*
Nanine Hartzenbusch, *The Baltimore Sun*
Doug Kapustin, *The Baltimore Sun*

85 Laurie DeWitt
Alison Harbaugh
David Harp, Chesapeake Photos
Laurie DeWitt
David Harp, Chesapeake Photos
Kevin T. Gilbert, Blue Pixel
David Harp, Chesapeake Photos

87 Mary F. Calvert
Perry Thorsvik
Mary F. Calvert
Susana Raab
James W. Prichard
Susana Raab
Mary F. Calvert

90 Gunes Kocatepe
Alexander Morozov
Gunes Kocatepe
Gunes Kocatepe
Gunes Kocatepe
Gunes Kocatepe
Ron Agnir

91 Jerry Jackson
Rick Kozak, kofoto
Ron Agnir
Gunes Kocatepe
Gunes Kocatepe
Archie Carpenter
Rick Kozak, kofoto

96 Gunes Kocatepe
Gunes Kocatepe
Gunes Kocatepe
Gunes Kocatepe
Gunes Kocatepe
Gunes Kocatepe
Gunes Kocatepe

97 Gunes Kocatepe
Gunes Kocatepe
Gunes Kocatepe
Gunes Kocatepe
Gunes Kocatepe
Gunes Kocatepe
Gunes Kocatepe

98 Barbara L. Salisbury
Kevin T. Gilbert, Blue Pixel
C. Barton-Lewis
Kevin T. Gilbert, Blue Pixel
Kevin T. Gilbert, Blue Pixel
Barbara L. Salisbury
Kevin T. Gilbert, Blue Pixel

99 Kevin T. Gilbert, Blue Pixel
Kevin T. Gilbert, Blue Pixel
David Harp, Chesapeake Photos
Kevin T. Gilbert, Blue Pixel
Kevin T. Gilbert, Blue Pixel
Barbara L. Salisbury
Kevin T. Gilbert, Blue Pixel

102 Edwin Remsberg
Carol Rose Fordonski-Ronayne
Barbara L. Salisbury
James W. Prichard
Barbara L. Salisbury
Tom Gregory
Nanine Hartzenbusch, *The Baltimore Sun*

103 Jerry Jackson
Nanine Hartzenbusch, *The Baltimore Sun*
J.M. O'Grady
C. Barton-Lewis
Jerry Jackson
Jerry Jackson
C. Barton-Lewis

104 Dennis Drenner
Edwin Remsberg
Dennis Drenner
C. Barton-Lewis
Dennis Drenner
Jerry Jackson
Jerry Jackson

105 Kevin T. Gilbert, Blue Pixel
Dennis Drenner
Rick Kozak, kofoto
Dennis Drenner
David Harp, Chesapeake Photos
Dennis Drenner
Carol Rose Fordonski-Ronayne

107 Laurie DeWitt
Laurie DeWitt
Laurie DeWitt
Laurie DeWitt
Laurie DeWitt
Laurie DeWitt
Laurie DeWitt

108 Laurie DeWitt
David Harp, Chesapeake Photos
Kevin T. Gilbert, Blue Pixel
Herrmann + Starke
Sherry DiBari
Ron Agnir
Tom Gregory

109 James W. Prichard
C. Barton-Lewis
Susana Raab
Gunes Kocatepe
James W. Prichard
Susana Raab
Susana Raab

114 Gunes Kocatepe
Gunes Kocatepe
Gunes Kocatepe
Gunes Kocatepe
Herrmann + Starke
Gunes Kocatepe
Gunes Kocatepe

116 Perry Thorsvik
Perry Thorsvik
Perry Thorsvik
Perry Thorsvik
Perry Thorsvik
Perry Thorsvik
Perry Thorsvik

117 Perry Thorsvik
Perry Thorsvik
Perry Thorsvik
Perry Thorsvik
Perry Thorsvik
Perry Thorsvik
Perry Thorsvik

120 Archie Carpenter
Tom Gregory
Archie Carpenter
Tom Gregory
Archie Carpenter
Tom Gregory
Archie Carpenter

122 Matt Mendelsohn
Matt Mendelsohn
Matt Mendelsohn
Matt Mendelsohn
Matt Mendelsohn
Matt Mendelsohn
Matt Mendelsohn

123 Matt Mendelsohn
Matt Mendelsohn
Matt Mendelsohn
Matt Mendelsohn
Matt Mendelsohn
Matt Mendelsohn
Matt Mendelsohn

129 John Harrington, Black Star
David S. Holloway, Apix
John Harrington, Black Star
David S. Holloway, Apix
John Harrington, Black Star
David S. Holloway, Apix
John Harrington, Black Star

130 Doug Kapustin, *The Baltimore Sun*
Tom Gregory
James W. Prichard
Scott Robinson
Doug Hill, PhotoAssist, Inc.
Herrmann + Starke
L.S. King

131 Mary F. Calvert
Mary F. Calvert
James W. Prichard
Scott Robinson
Tom Gregory
Mary F. Calvert
Herrmann + Starke

132 Amy Deputy
Amy Deputy
Dennis Drenner
Dennis Drenner
L.S. King
Amy Deputy
Dennis Drenner

133 Dennis Drenner
T. Prendergast, The Sensory Workshop
Dennis Drenner
Gunes Kocatepe
Tom Gralish, *The Philadelphia Inquirer*
Dennis Drenner
Alexander Morozov

135 David Harp, Chesapeake Photos
Susana Raab
Jerry Jackson
David Harp, Chesapeake Photos
Susana Raab
Jerry Jackson
Chuck Kennedy, Knight-Ridder, *Tribune*

Staff

The *America 24/7* series was imagined years ago by our friend Oscar Dystel, a publishing legend whose vision and enthusiasm have been a source of great inspiration.

We also wish to express our gratitude to our truly visionary publisher, DK.

Rick Smolan, Project Director
David Elliot Cohen, Project Director

Administrative
Katya Able, Operations Director
Gina Privitere, Communications Director
Chuck Gathard, Technology Director
Kim Shannon, Photographer Relations Director
Erin O'Connor, Photographer Relations Intern
Leslie Hunter, Partnership Director
Annie Polk, Publicity Manager
John McAlester, Website Manager
Alex Notides, Office Manager
C. Thomas Hardin, State Photography Coordinator

Design
Brad Zucroff, Creative Director
Karen Mullarkey, Photography Director
Judy Zimola, Production Manager
David Simoni, Production Designer
Mary Dias, Production Designer
Heidi Madison, Associate Picture Editor
Don McCartney, Production Designer
Diane Dempsey Murray, Production Designer
Jan Rogers, Associate Picture Editor
Bill Shore, Production Designer and Image Artist
Larry Nighswander, Senior Picture Editor
Bill Marr, Sarah Leen, Senior Picture Editors
Peter Truskier, Workflow Consultant
Jim Birkenseer, Workflow Consultant

Editorial
Maggie Canon, Managing Editor
Curt Sanburn, Senior Editor
Teresa L. Trego, Production Editor
Lea Aschkenas, Writer
Olivia Boler, Writer
Korey Capozza, Writer
Beverly Hanly, Writer
Bridgett Novak, Writer
Alison Owings, Writer
Fred Raker, Writer
Joe Wolff, Writer
Elise O'Keefe, Copy Chief
Daisy Hernández, Copy Editor
Jennifer Wolfe, Copy Editor

Infographic Design
Nigel Holmes

Literary Agent
Carol Mann, The Carol Mann Agency

Legal Counsel
Barry Reder, Coblentz, Patch, Duffy & Bass, LLP
Phil Feldman, Coblentz, Patch, Duffy & Bass, LLP
Gabe Perle, Ohlandt, Greeley, Ruggiero & Perle, LLP
Jon Hart, Dow, Lohnes & Albertson, PLLC
Mike Hays, Dow, Lohnes & Albertson, PLLC
Stephen Pollen, Warshaw Burstein, Cohen, Schlesinger & Kuh, LLP
Rick Pappas

Accounting and Finance
Rita Dulebohn, Accountant
Robert Powers, Calegari, Morris & Co. Accountants
Eugene Blumberg, Blumberg & Associates
Arthur Langhaus, KLS Professional Advisors Group, Inc.

Picture Editors
J. David Ake, Associated Press
Caren Alpert, formerly *Health* magazine
Simon Barnett, *Newsweek*
Caroline Couig, *San Jose Mercury News*
Mike Davis, formerly *National Geographic*
Michel duCille, *Washington Post*
Deborah Dragon, *Rolling Stone*
Victor Fisher, formerly Associated Press
Frank Folwell, *USA Today*
MaryAnne Golon, *Time*
Liz Grady, formerly *National Geographic*
Randall Greenwell, *San Francisco Chronicle*
C. Thomas Hardin, formerly *Louisville Courier-Journal*
Kathleen Hennessy, *San Francisco Chronicle*
Scot Jahn, *U.S. News & World Report*
Steve Jessmore, *Flint Journal*
John Kaplan, University of Florida
Kim Komenich, *San Francisco Chronicle*
Eliane Laffont, *Hachette Filipacchi Media*
Jean-Pierre Laffont, *Hachette Filipacchi Media*
Andrew Locke, MSNBC
Jose Lopez, *The New York Times*
Maria Mann, formerly AFP
Bill Marr, formerly *National Geographic*
Michele McNally, *Fortune*
James Merithew, *San Francisco Chronicle*
Eric Meskauskas, *New York Daily News*
Maddy Miller, *People* magazine
Michelle Molloy, *Newsweek*
Dolores Morrison, *New York Daily News*
Karen Mullarkey, formerly *Newsweek, Rolling Stone, Sports Illustrated*
Larry Nighswander, Ohio University School of Visual Communication
Jim Preston, *Baltimore Sun*
Sarah Rozen, formerly *Entertainment Weekly*
Mike Smith, *The New York Times*
Neal Ulevich, formerly Associated Press

Website and Digital Systems
Jeff Burchell, Applications Engineer

Television Documentary
Sandy Smolan, Producer/Director
Rick King, Producer/Director
Bill Medsker, Producer

Video News Release
Mike Cerre, Producer/Director

Digital Pond
Peter Hogg
Kris Knight
Roger Graham
Philip Bond
Frank De Pace
Lisa Li

Senior Advisors
Jennifer Erwitt, Strategic Advisor
Tom Walker, Creative Advisor
Megan Smith, Technology Advisor
Jon Kamen, Media and Partnership Advisor
Mark Greenberg, Partnership Advisor
Patti Richards, Publicity Advisor
Cotton Coulson, Mission Control Advisor

Executive Advisors
Sonia Land
George Craig
Carole Bidnick

Advisors
Chris Anderson
Samir Arora
Russell Brown
Craig Cline
Gayle Cline
Harlan Felt
George Fisher
Phillip Moffitt
Clement Mok
Laureen Seeger
Richard Saul Wurman

DK Publishing
Bill Barry
Joanna Bull
Therese Burke
Sarah Coltman
Christopher Davis
Todd Fries
Dick Heffernan
Jay Henry
Stuart Jackman
Stephanie Jackson
Chuck Lang
Sharon Lucas
Cathy Melnicki
Nicola Munro
Eunice Paterson
Andrew Welham

Colourscan
Jimmy Tsao
Eddie Chia
Richard Law
Josephine Yam
Paul Koh
Chee Cheng Yeong
Dan Kang

Chief Morale Officer
Goose, the dog

COLORADO 24/7
DK

CONNECTICUT 24/7
DK

DELAWARE 24/7
DK

FLORIDA 24/7
DK

GEORGIA 24/7
DK

KANSAS 24/7
DK

KENTUCKY 24/7
DK

LOUISIANA 24/7
DK

MAINE 24/7
DK

MARYLAND 24/7
DK

MONTANA 24/7
DK

NEBRASKA 24/7
DK

NEVADA 24/7
DK

NEW JERSEY 24/7
DK

NEW HAMPSHIRE 24/7
DK

OKLAHOMA 24/7
DK

OREGON 24/7
DK

PENNSYLVANIA 24/7
DK

RHODE ISLAND 24/7
DK

SOUTH CAROLINA 24/7
DK

VIRGINIA 24/7
DK

WASHINGTON 24/7
DK

WEST VIRGINIA 24/7
DK

WISCONSIN 24/7
DK

WYOMING 24/7
DK